MAN RAY'S MONTPARNASSE

MAN RAY'S

HARRY N. ABRAMS, INC.
PUBLISHERS

MONTPARNASSE

By Herbert R. Lottman

HARRY N. ABRAMS, INC., PUBLISHERS

Project Manager: Harriet Whelchel
Editor: Deborah Aaronson
Designer: Brankica Kovrlija

Library of Congress
Cataloging-in-Publication Data
Lottman, Herbert R.
Man Ray's Montparnasse / by Herbert R. Lottman.
 p. cm.
Includes bibliographical references and index.
 ISBN 0-8109-4333-6
 1. Ray, Man, 1890–1976.
 2. Artists—United States—Biography.
 3. Photographers—United States—Biography.
 4. Expatriate artists—France—Biography.
 5. Montparnasse (Paris, France)—
Intellectual life—20th century.
 I. Ray, Man, 1890–1976. II. Title.
 N6537.R3 L67 2001
 709'.2—dc21

 2001000633

Published in 2001 by Harry N. Abrams,
Incorporated, New York

Printed and bound in the United Kingdom
10 9 8 7 6 5 4 3 2 1

Harry N. Abrams, Inc.
100 Fifth Avenue
New York, N.Y. 10011
www.abramsbooks.com

CONTENTS

Preface

ON MY FIRST ATTEMPT to draw up a plan for a history of Montparnasse, some ten years before I actually sat down to produce this book, I came up against what I felt to be an insurmountable barrier. For even if it seemed possible to define the Quarter by its character—to delimit the boundaries of what in fact is a boundless urban land mass was problematic—I found it difficult to encompass all of the movements, all the motivations, the diverse nationalities, the native French with the visiting foreigners, the visitors with the permanent residents, in what I saw as a single story.

Yet I had wanted to write about Montparnasse for a long time— ever since I settled in Paris in the late 1950s and began my explorations into its cultural life. My earlier book on the Left Bank had focused on its politics, but of course there was more to it than that.

I even took to sketching circles, placing my personae inside them, recreating groups in a sense. One of my first circles would contain the Dada group, consisting of still-young writers and poets, even an occasional artist, who gave themselves the mission to destroy everything that had preceded them; the group had taken shape, if shape it had, during World War I in neutral Switzerland, and consisted largely of war resisters. In Paris, to which their ringleader, Tristan Tzara, repaired

shortly after the end of hostilities, they had soon won over an equal-ly angry group of young Frenchmen—although most of them had served in the war.

A separate circle was to house the next movement to spring to life in post-World War I Paris, the Surrealists, many of whom had actual-ly taken part in Dada but turned away from its nihilism toward a doc-trine they thought would be constructive. It was an art born of the unconscious, and its first product would be an experiment in auto-matic writing. Later members of the movement introduced intention, and there would be Surrealist movies and self-conscious clownery, the latter exemplified by the antics of Salvador Dalí.

I would make little circles for Surrealist split-offs, say toward Socialist Realism, Soviet style, or (when the Surrealists took to Communism) to an anti-Stalinist Trotskyism.

But Montparnasse wasn't all doctrine. There could not have been a freer bunch than the painters and sculptors collectively known as the École de Paris. None of them was a native Parisian, for the name was applied to émigrés, notably from Russia and eastern Europe; they included painters such as Marc Chagall and Chaim Soutine, who seemed to have brought the life of the shtetl with them, but also Jules Pascin and Moise Kisling, who quickly adopted to between-the-wars modernism, not to overlook ground-breaking Brancusi. Then there were the painters, like Picasso and Joan Miró, of France's nearest neighbors. And then of course there was a French school, with the likes of Henri Matisse, Georges Braque, and André Derain. Were this not a book about artists and writers, I might also have mentioned the musicians of the modern movement, whose earliest manifestations took place around the corner from the Café du Dôme.

One would have to draw a rather large circle for the Anglo-Americans, many of whom first tasted the pleasures of France during military duty and who came back for more, they and their fellows attracted by freedoms they could enjoy there and not at home ("enjoy" is the word, for a favorable currency exchange made it possible for

them to live in postwar Paris on very little money). There were also the heirs and heiresses: Peggy Guggenheim and Nancy Cunard, fixtures of Montparnasse, belong in this circle. I decided to create a separate circle for the weekly open house of Gertrude Stein and Alice B. Toklas, their paintings and painters, and the eager visitors from France and abroad who found their way to their little house in a courtyard on rue de Fleurus alongside the Luxembourg Garden.

And a gilded circle, perhaps, for the counts and countesses who recruited from the denizens of Montparnasse for their elegant parties. A circle for the humble models, including the irrepressible Kiki, who came up from a small town in Burgundy to show that she could not only model, but also create her own works, and sing and dance, and exchange repartee with the best of them. There was even a circle for the café owners and the barmen (including one who wrote his memoirs).

But how to link the circles? For it was not enough to allow their perimeters to brush against one another; that wouldn't make a book. How to find points in common among a half-starved Lithuanian painter and Ernest Hemingway, Ezra Pound, Sinclair Lewis, James Joyce? Between an art collector like Peggy Guggenheim and that small-town girl from Burgundy making her way among the bars and bistros? Among art movements hostile to each other?

Of course there could be no connections. . . . Until I found one.

Man Ray could talk to everybody, and he made it a point to do so. And not surprisingly, everybody was ready to talk to this friendly New Yorker, not necessarily for his conversation but for his camera, which he was eager to use. He would make the first group portraits of the Dada crowd, and then the Surrealists (when they split, both sides remained close to Man Ray and his lens). His camera was ready not only at the opening of a new bar, but also to record the goings on of the rich. A visit to his studio became a must for visiting foreigners—a Soviet poet, or T. S. Eliot, or a Nobel prize–winning novelist from America.

Man Ray could not have known that his arrival in Paris would coincide with the beginning of an era. The Great War was well over;

the two decades separating the peace conference in Versailles from the onset of the next massacre could be devoted to private affairs. In fact these private affairs often became very public ones, for these were years of passionate artistic ferment and experimentation, of mad schemes and desperate gestures, accompanied by an explosion of talent that occasionally produced masterworks. Even when no masterpiece appeared, the attempts usually proved to be unique, and the writer or artist could always try again.

And then they always had Montparnasse, with its cheap and abundant studios, whether collective or individual, modestly decorated cafés adapted both for mixing with one's peers—and for solitary writing, sketching, or simply brooding.

Nor could Man Ray have known that when at last he left Montparnasse—shown to the door by the Nazi occupation forces in 1940—the Quarter as he had come to know it would cease to exist.

1 *The Visitor*

THE ENCOUNTER WAS SINGULAR, more significant in the end than any of the individuals concerned could have imagined. This plucky little American with the odd name (in itself sounding like a symbol) had not come as just another tourist intent on soaking up atmosphere, although he did hope to obtain some hints as to what had made this city the center of his universe. Yet he was older than any of the assembled group, and Marcel Duchamp, the Frenchman who had brought him to the meeting, was senior both to Man Ray and to the half-dozen young men and one woman waiting for them.

The setting was a banal café hidden in a shopping arcade in bourgeois-business Paris, a café chosen precisely because it was remote from Bohemia or, as one member of the contrarian little group, Louis Aragon, explained it, "out of hatred for Montparnasse and Montmartre." Aragon and his comrade in arms André Breton had stumbled upon the passage de l'Opéra in 1919 and knew at once that this obscure corridor connecting bustling boulevard des Italiens to narrow rue Chauchat belonged to them. It became the Paris headquarters of Dada. "The decor is wood-brown," recalled Aragon, "and wood wasn't spared in furnishing it." With rustic wine barrels serving as tables, it was hardly the modish café the American had expected.

Here they could be alone with their dreams. And when none of the group was present, Aragon knew, the cashier would reply to a telephone call: "None of the Dadas is around, Monsieur." The gentle people who operated the place intended no harm by their use of the term. For them it signified neither anarchy nor anti-art as the popular press would have it, but only "a group of regular customers, young people who are sometimes a bit noisy, perhaps, but quite agreeable."

Their guest arrived with the best possible credentials. Man Ray's iconoclastic initiatives in New York had often anticipated rather than imitated the antics of Dada. He carried with him solid proofs of his achievement in the form of paintings, absurd objects, and photographic improvisations. Duchamp had discovered Man Ray in New York—as Man Ray had discovered Duchamp, a celebrity since the revelation of his *Nude Descending a Staircase* in the Armory Show in 1913, that watershed event which revealed the best contemporary art—largely a European import—to the one American metropolis that could be receptive to it.

A reluctant painter, Duchamp had sat out part of the recent world war in New York, where he had met and been drawn to the absolute contrary, irrepressible Man Ray—himself still unknown (and unsold) in his own country. Determined to try a more hospitable climate, Man Ray sailed from New York harbor on Bastille Day 1921, arriving on July 22 at the Channel port of Le Havre, boarding a train later the same day for Paris. Duchamp greeted him at the Gare Saint-Lazare, and after dropping off the traveler's hand baggage at a hotel they made their way to the passage de l'Opéra.

In the absence of a camera—Man Ray not quite ready to become the group's unofficial portraitist—one can only imagine the scene at the moment Duchamp introduced the new arrival, at 5 feet 3 ½ inches considerably shorter than any American they might have met before. His high forehead was topped by a shock of hair that seemed to grow straight up, as if to give him extra inches. Besides Breton and Aragon, self-elected leaders of the proto-Surrealists, he was now to meet Paul

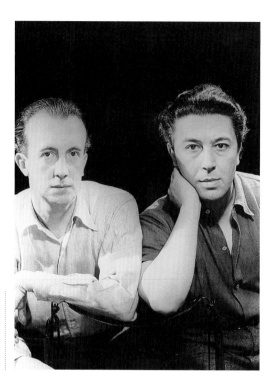

Paul Eluard and André Breton, taken at one of the times that the two Surrealists were friends working together

Eluard, who with Aragon would produce the most enduring poetry to come out of their movement, and Eluard's ebullient spouse, Helena Diakonova, better known as Gala (who would remain Eluard's muse long after her defection to Salvador Dalí). Also there was the undisciplined Philippe Soupault, who had collaborated with André Breton on an ambitious experiment in automatic writing (*Les Champs magnétiques*), anticipating literary Surrealism.

On one side, Marcel Duchamp, handsome and lean-fleshed, who would soon celebrate his thirty-fourth birthday, with his American guest Man Ray, not quite thirty-one. Of the passage de l'Opéra group the oldest, Eluard, was twenty-six. Good-looking young men for the most part, at least three of them were lady-killers.

All of them were writers and poets or desired to be, which, if a splendid vocation, also made for a one-sided art movement. Duchamp, who could have been the exemplary artist of the move-

ment, was unwilling to lend himself to a collective. In this he resembled that other painter Francis Picabia, who at forty-two would have been their senior member if he were not so obstinately an individualist (he would not have minded being part of a school if he could be its leader). It happened that as a painter Man Ray did have a counterpart in Germany. But Max Ernst, although a willing convert to Dada and a prodigy of creativity, was simply not available. Breton and his companions had invited him to bring his work to Paris, and an exhibition had taken place just a few weeks before Man Ray's arrival. But as a national of a recent enemy state, and a radical besides, Ernst had not been able to obtain a visa to attend his own show. Man Ray *was* available—his paintings and his person.

Hence the welcoming atmosphere that evening. From the rustic café the group made its way to an Indian restaurant nearby. The visitor noticed that his new friends, as they sat before their curry dishes,

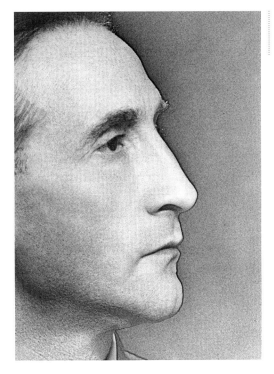

The playful, enigmatic Marcel Duchamp in the unsmiling pose he favored

seemed to be regretting more familiar French cuisine, and to com-
pensate for their discomposure consumed inordinate quantities of
wine, rendering them lightheaded and loose-tongued. Then a merry
trek to Montmartre—not to the art colony atop the hill but only as
far as the gaudy amusement park stretching along the ring of boule-
vards; Breton and his friends "rushed from one attraction to another
like children."

Then clownish Philippe Soupault—a son of the upper middle-
class who consequently had no need to behave—hoisted himself to
the top of a lamppost, from where he harangued passersby with what
sounded to Man Ray like "Dadaistic" poems. Soon Soupault began to
run ahead of the others, disappearing into an open gateway to knock
violently at a concierge's door. He came out slowly, shaking his head,
then rushed forward to repeat the act at another street door. Seeing
Man Ray's puzzlement, someone explained that Soupault had been
asking whether Soupault lived there, and of course had been getting

Philipe Soupault,
one of the original
band of pre-Surrealist
Dadaists, who
willingly lent himself
to its antics

negative replies. "I looked on, bewildered by these people who other-wise took themselves so seriously," the new boy was to remember. He had indeed entered a different world, and resolved that night to mas-ter its language.[1]

With hindsight we know that the group's favorable reception of Man Ray was not preordained. Indeed, there had to be a lot to like in Man Ray for him to be adopted by this particular crowd of self-con-tained young men. André Breton, born in February 1896, who was to become the gendarme of the Surrealists, was actually the son of a gen-darme (but a gendarme who went on to become a bookseller, going on to a remunerative career in real estate). Young André attended good schools, showing an early penchant for the arcane in art, choos-ing medical studies to buy time for his poetry. On leave from wartime service in a military hospital, he would rush off to the rue de l'Odéon, site of a bookstore and informal literary salon run by an intense young woman named Adrienne Monnier. She opened her shop on the literary Left Bank only a year earlier, at the pert age of twenty-two, having abandoned her job at a stuffy magazine on the Right Bank—because she knew that this side of the river was where she belonged.

In 1917, Breton's assignment to the Val-de-Grâce military hospital on the frontiers of Montparnasse reinforced his tie to another intern he had met on rue de l'Odéon, and who also preferred literature to medicine. Breton's junior by a year and eight months, Louis Aragon was to have a still easier entry to life as the son (albeit born out of wedlock) of a high-ranking official, an outspoken member of the Chamber of Deputies, eventually the police commissioner of Paris and ambassador. (Aragon was a made-up name, but at least his ini-tials were the same as his father's). "Slim, elegant, seductive, with fine features, an insolent manner, his eyes sparkling with intelligence; witty, but above all—insolent." So Aragon would be remembered by a younger contemporary, Marcel Duhamel, whose ramshackle house on the quiescent rue du Château below the Montparnasse station served for a time as the Surrealists's unofficial headquarters.

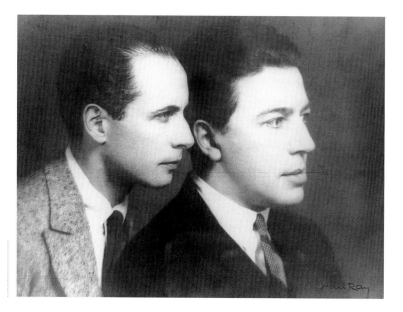

Louis Aragon and
André Breton in
the days before
ideology separated
them forever

Like Breton, Aragon pursued his medical studies with one eye and all his heart on literature. Adrienne Monnier heard him say that he was so offended by the obscenities of fellow students at the medical faculty that he felt like weeping. And if in 1919 Aragon readily joined Breton and Soupault in publishing a magazine called *Littérature,* which despite its traditional title was designed to combat tradition, his best biographer saw him in essence as a loner, while Breton was "a leader of men."

"Massive bearing, heavy build, the perfect head of a tribune, classic profile—or rather leonine," was the way Breton would be remembered by Marcel Duhamel, who also described him as "imposing, intimidating, even to people who didn't know him. [He] knew how to cast a spell." Man Ray's startling portraits of Breton say the rest.

One member of Dada had missed the reception of Man Ray at the passage de l'Opéra. Also a foreigner, the Romanian-born Tristan Tzara was then traveling in Czechoslovakia. The most garrulous element of the Zurich circle that unleashed the movement and gave it a name, Tzara first appeared in Paris at the beginning of 1920, deter-

mined to reenact the Zurich pranks before a wider audience. He had been living at a hotel in a dullish residential district, and it was to this hotel that Marcel Duchamp had taken Man Ray on his arrival. Man Ray got Tzara's room.

Writing to Tzara soon after his encounter with the newcomer from America, Breton tossed in a gratuitous remark: "I'm unlikely to forget you because of Man Ray. Nor because of Duchamp, who doesn't show himself very often."

Was this just another Dadaist putdown? Earlier that year, in their magazine *Littérature,* the editors (who were then Aragon, Breton, and Soupault), published a ranking of "famous names." Those doing the grading were members of the passage de l'Opéra group, together with Gabrielle Buffet (Picabia's ex-wife), Pierre Drieu La Rochelle (another iconoclast and Aragon's friend), the soldier-poet Benjamin Péret, painter-poet Georges Ribemont-Dessaignes, and (last but hardly least) Tzara.

These ten men and one woman had been asked to judge both ancestors and contemporaries—including Alcibiades, Beethoven, Einstein, and Shakespeare, using a classification running from 20 to minus 25. In keeping with his personality Tzara produced the greatest number of minus 25s. But all of the young judges had it in for the tiresome celebrities among their immediate predecessors: the writer-diplomat Paul Claudel averaged a minus 2.81, Henri Matisse—a modern, but much too popular for these rebels—minus 3.27, the self-advertising Gabriele D'Annunzio minus 7.86, the humanitarian Anatole France and war leader Marshal Ferdinand Foch each earned a severe minus 18. The true heroes among contemporaries were Charles Chaplin, who averaged 16.09, and Chaplin's French precursor Max Linder with 15.63.

At the time of this survey Man Ray was only a name to the assessors. He obtained a modest 3.90 points, the average dragged down by the insolent zero Aragon gave him and a token 1 from Breton. He was saved by Gabrielle Buffet—the only one of the group who had actu-

ally met him—for she gave him the maximum 20, but also by the positive 15 points from Paul Eluard (anticipating their fast friendship), and a generous 11 from the habitually ferocious Tristan Tzara (by then Tzara and Man Ray were corresponding). Another indication of the group's wickedness: their accomplished elder Marcel Duchamp, who should have been their role model, came out with a passable 9.18, Picabia with a still lower 8.63, Max Ernst with an ungenerous 8.54—considering that like Man Ray he was actually making art.[2]

About a month after his first encounter with the Breton group, Man Ray was delivered from his lonely Right Bank lodgings, though without getting any closer to the Left Bank. Marcel Duchamp had been staying at the apartment of his friend Yvonne Chastel near the boulevard de Clichy. The flat came with an independent room, offered rent-free to Duchamp's American guest.

For he still thought of himself as a transient. He had come to Paris, Man Ray told an interviewer much later, "only for a visit, to look around the museums and meet some other people who were doing advanced work." He explained further at a Paris seminar on expatriates: "I had a very peculiar problem in New York, where I was rejected, criticized, attacked, refused exhibitions. . . . I thought that if I changed the landscape . . . I didn't particularly think about Paris except that there were museums here where I wanted to see the originals of paintings I had doted on . . . when I was an art student. Unfortunately, when I got over here I got tied up with the avant-garde movement which despised museums, which wanted to destroy them."

Yet funds were running low. He had arrived in France with a generous advance payment from a collector, representing paintings to be produced during his Paris stay. Soon he had to ask for more help from the same source, which did not stop him from begging funds from his family in Brooklyn.

Some time after his arrival, he found his way to the French customs depot in Paris to claim the large case of artworks that had fol-

lowed him across the ocean. "Cubist," the inspector said knowingly—and cleared the paintings. But a narrow box containing materials such as wire, colored wooden strips, and a zinc washboard—and bearing a title, *Catherine Barometer*—presented more of a problem. Rather than try to explain that this was a Dada object, he invented a story that it was a guide for his color combinations. Then, after some difficulty, his big trunk was opened. Its contents, airbrush paintings, again posed no problem. But what about a jar filled with steel ball bearings in oil, also with a title, *New York 1920*. A decoration for his studio, he explained—and that sufficed.

These oddities were in fact examples of Man Ray's "objects," each an assemblage of two or more unrelated elements. That other notorious pre-Dada creator, Marcel Duchamp, would often put his own title on a preexisting object—like his famous porcelain urinal, which he called *Fountain*. These were his ready-mades.[3]

Tristan Tzara, the man who graded most people minus 25, became a fast friend and a willing promoter. Using his imperfect but adventurous French, Man Ray informed Tzara, traveling on holiday: "I am very busy—life here is dear, temptations are many—I've got to earn money to maintain the one and pay for the other." Perhaps he would go to Brussels to arrange a show. "But if I do something in Paris I'll stay here. That's what I'm hoping for!"

He discovered that there was a section of Paris that welcomed people speaking his kind of French. So one evening he made his way down the subway steps, direction "Montparnasse"—to plunge into "a cosmopolitan world," where "all languages were spoken including French as terrible as my own." ("The whole of Greenwich Village is walking up and down Montparnasse," Duchamp had recently informed an American friend.)

Man Ray wandered from one café to another, observing how they seemed to specialize: one café exclusively French, another a mix of nationalities, a third inhabited by Americans and Britons who stood

at the bar, talking loudly. He decided that he preferred the first two cafés, where clients sat at tables, changing places occasionally to talk to friends. And he liked the neighborhood—"the Quarter," as English-speaking contemporaries referred to it.

Anyway, it was time to move out of the room that Duchamp had arranged for him to use, for Duchamp himself was moving—back to New York. Just around the corner from the Café du Dôme on boulevard du Montparnasse, halfway down the street at number 15, rue Delambre, the Hôtel des Écoles beckoned to him; until recently, after all, it had been the elected domicile of André Breton.[4]

2 | *The Quarter*

MAN RAY'S FIRST IMPRESSION of a cosmopolitan Montparnasse is about as good a description of the Quarter as one can hope for. On the opposite side of Paris, old Montmartre sat atop its hill, old houses and makeshift studios and working-class cafés setting the tone. On the Seine as it flowed through the center of the city, the connecting Île de la Cité and Saint-Louis were striking natural features, dominated by the towers of Notre Dame cathedral. The Latin Quarter was marked by venerable schools and their chapels, Saint-Germain-des-Prés by its millennial Romanesque abbey church dominating labyrinthine streets winding down to the Seine.

But Montparnasse? The problem of successive generations has been to circumscribe the place, for it is less a neighborhood or urban district than a state of mind. Depending on whom one talks to, Montparnasse may extend northward around the sprawling Luxembourg Garden or spill over as far south as cheap rents might draw penniless young artists. A short stroll from the Latin Quarter schools, the area offered a pastoral meeting ground for scholars and poets, becoming all the more inviting when outdoor cafés with music and dance floors began to dot the landscape.

Once there had actually been a "Mount Parnassus," a nondescript

hill named (apparently with irony) for the sacred dwelling place of Apollo, Dionysus, and the Muses—patrons of the arts. But although the hill appears under the designation Montparnasse on old maps, even that was derisory, for the best evidence is that this sacred mound consisted of rubble, chiefly debris from the demolished houses of changing Paris.

A map drawn in the middle of the seventeenth century shows the hill sliced down the middle to allow the passage of a road—the future boulevard du Montparnasse. Early in the eighteenth century, the mound was demolished, the rubble carted off, to make room for a boulevard fit for King Louis XV.

Local historians point out that the heap of debris called Parnassus stood on the site of the intersection of today's boulevards du Montparnasse and Raspail—the crossroads that came to be known as carrefour Vavin. One street branching out from the intersection is the rue Delambre, where the hotel that served as Man Ray's first Montparnasse home still stands.

By the nineteenth century, artists and writers came to appreciate the advantages of this poorly urbanized district within strolling distance of the center of the city. Vacant lots fronted the boulevard du Montparnasse itself until the last years of the nineteenth century. Even when proper streets were laid out and housing fit for solvent rent payers began to go up, one could always find shelter in a more humble lane with shacks and sheds good enough for artists just behind or beyond the residential blocks. A few of the old lanes survive to this writing.

Long before the Cubists and the Futurists and the Surrealists arrived, the open spaces and relatively cheap closed spaces had drawn nineteenth-century artists to Montparnasse, among them Manet, Gauguin, Cézanne, Whistler, and the sculptor of the Statue of Liberty, Auguste Bartholdi, with poets and writers from Chateaubriand to Baudelaire. Apparently even in an era of stern morality, the authorities closed their eyes to the fleshy goings-on in the studios, going so

far as to tolerate an outdoor model market on Monday mornings at the corner of the boulevard du Montparnasse and rue de la Grande-Chaumière, where statuesque Italian beauties, athletic young men, and the picturesque elderly waited to be hired. Local historians have it that the Italians were repatriated at the outbreak of the first World War, after which the field was left to the French—remunerated in love or money or both.[1]

But of course Montparnasse became Montparnasse as we know it in the early years of the twentieth century, made famous by the Symbolists of the Closerie des Lilas (by then a comfortably modest, inexpensive café large enough for banquets or an occasional raucous demonstration). Although they do not seem to have been photographed or painted together, one hears so often of the table at which Guillaume Apollinaire, bard of the Cubists, sat with Picasso that one can still picture them together, perhaps in the company of Max Jacob, a man of Montmartre who made occasional forays into Montparnasse, hating every minute of them. "The orgy is to the South!" he would declaim. "The orgy is in Montparnasse! In a studio is the orgy of Montparnasse. . . ."

Apollinaire, the tastemaker of modernism, spokesman for the Cubists, and promoter of talents that still matter, announced the moment on the eve of the Great War. In 1914, so he wrote in March of that year, Montparnasse—with its artists, their cabarets, and even the occasional drug-sniffing—had become for painters and poets what Montmartre had been at the turn of the century: "the refuge of simplicity, beautiful and free. . . . The truth is that Montparnasse is replacing Montmartre." Wild tribes had invaded the now-famous Montparnasse-Raspail intersection, with the Rotonde café on one corner and the Dôme across the way. He had a severe word for the Dôme, invaded by American aestheticians . . . and "kraut millionaires," a more tender thought for "the studio barracks of rue Campagne-Première"—the extraordinary ensemble at Number 9, whose doors and stairways opened to more than one hundred comfortless studios, large and small. (It had been Picasso's first recourse.)

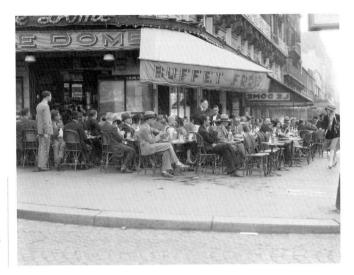

The Café du Dôme (just up the street from Man Ray's first Montparnasse lodgings), then a favorite of Americans in Paris and their French friends

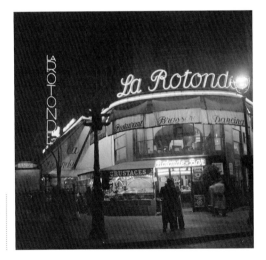

La Rotonde, the biggest and brassiest of the carrefour Vavin cafés

Apollinaire showed a fondness not only for the humble eating places known as dairies, but also for the ritual gatherings of artists and writers at the Closerie des Lilas.[2]

One difference between the northern hill called Montmartre and the southern upstart Montparnasse was the clamorous internationalism of Paris's new center of the arts. Apollinaire observed it but could

hardly deplore it, as the Rome-born natural son of an Italian officer and the daughter of a Polish nobleman attached to the Vatican. The old guard of native French artists was sometimes less charitable as it observed the influx of foreigners who "accept no constraints" and "occasionally abuse our generous hospitality."

The author of this dyspeptic observation wrote a popular history of the district; as it happened, his grandfather Emile Bayard had been an illustrator of the old school who had lived in Montparnasse in the last half of the nineteenth century (which in 1927 his grandson continued to describe as the "great artistic period" of Montparnasse).

What had spoiled the place, in the opinion of the illustrator's grandson Jean Emile-Bayard, was the presence of Germans and Americans in the years prior to World War I. They composed a "cosmopolitan culture" where "Cubism raged," encouraged by seemingly flourishing art dealers. For Emile-Bayard these dealers were Germans who not incidentally engaged in spreading propaganda, seeking "to corrupt traditional French art."

At that time—on the eve of the 1914 war—the Dôme was "the quarter's chic café," while La Rotonde, although recently enlarged by its owner Victor Libion, was more "democratic." Emile-Bayard saw Libion as a decent man unable to handle the Germans (whom he also blames for introducing narcotics). So his café became a hangout for "lovers, writers, sluggards, failures, rubbernecks, perverts, policemen, and too many foreigners. . . ." Blows were exchanged after ideas, sometimes loose women and their protectors fought pitched battles—all this to the consternation of poor Libion and his properly brought up daughters.

Indeed, these were places that young French girls did not enter unless they were accompanied by their parents. Whereas young *American* damsels, "cigarettes glued to lips, bare-headed, cross-legged, flaunted their debonair manners and high spirits—alone at last—in Montparnasse." It was evident that right-thinking citizens in nearby residential streets were shocked by such scenes.

Following World War I, tensions were exacerbated by a new foreign invasion of the cafés, while "French Montparnasse," as Emile-Bayard called it, "labored in dignity." Worse still, the foreigners were taking studios and apartments away from Frenchmen, obliging them to move elsewhere. Sometimes several foreigners shared a flat, paying exorbitant rents that Frenchmen could not match. French food shops were being replaced by grocery stores, cafés by bars, restaurants by grill rooms; shopkeepers were speaking better English or German than French.

Something else that Emile-Bayard had been too polite to say was being said by others. Many of the immigrants in the decade prior to the Great War—Emile-Bayard's "Germans"—actually came from Central and Eastern Europe, and many of them were Jews. They were the painters who would become known as the École de Paris. Among the first was Louis Marcus who arrived from Poland in 1903, becoming a French citizen through service in the French army during the war. Apollinaire had him change his name to Marcoussis. Bulgarian-born Jules Pincas, known as Pascin, migrated in 1905 via Vienna and Munich. Sculptors Jacques Lipchitz and Ossip Zadkine (respectively from Lithuania and Russia) both reached Paris in 1909; Marc Chagall came from Russia and Moise Kisling from Poland the following year; Chaim Soutine arrived from Lithuania and Mané-Katz from the Ukraine, in 1912 and 1913. Another early arrival was the Italian Jew Amedeo Modigliani.

Writing in the mid-1920s, an observer of the scene indulgently presented two widely heard opinions: for some, the immigrants represented "a foreign takeover, the undermining of French art and thought by universal vice." For others, their presence was "a splendid homage to Paris as the capital of the plastic arts." Cynics felt it was more likely a tribute to the favorable exchange rate at a time when French francs went cheap.

In truth, most of the migrants came with little foreign currency to exchange, and stayed poor. That apparently did not save them from

opprobrium, notably in the pages of the once-respected *Mercure de France,* in which an art critic observed that although there was no Jewish art in the Louvre, or in the history of Western art, suddenly Jewish painters were everywhere; he attributed that to the decline of the French pictorial tradition—and to Jewish greed. Violent diatribes began to appear—often written by or for French-born artists—against the "barbarian hordes" that had overrun Montparnasse.[3]

It made for a lively scene if one included those seemingly rich Americans (who were often quite dollar-poor even if franc-rich), and the variegated men and women of the École de Paris, who, in addition to the chronically poor such as Modigliani, numbered among them a handful of successes who created their own legends (such as the rakish Pascin and the dashing Kisling). If we accept the testimony of some diarists, many of the café tables, and probably most of the sidestreet bars, were filled by Americans fleeing Prohibition—the ban on alcoholic beverages on American territory that was voted as a constitutional amendment following World War I. Clearly this was not Man Ray's motivation. On the contrary, it was only when Prohibition took effect in 1920 that he began drinking. As a proper puritan, he explained, he had to do what it was forbidden to do. But the whiskey that flowed liberally, if illegally, in New York was vile and in France he learned to prefer wine.

The most vibrant part of the Quarter continued to be the intersection of boulevards Montparnasse and Raspail, just down from the street and subway stop that gave the junction a name, Vavin. A five-minute walk to the east of carrefour Vavin, where boulevard du Montparnasse met boulevard Saint-Michel, stood the frontier post of the Closerie des Lilas, then undergoing the first of a succession of transformations that would make Ernest Hemingway's choice for a cheap and quiet cup of coffee into a fashionable restaurant. "People from the Dôme and the Rotonde never came to the Lilas," Hemingway later remembered. "There was no one there they knew, and no one would have stared at them if they came."

A ten-minute stroll westward along the boulevard, adjacent to the old Montparnasse railway station, were two grand restaurants, Le Lavenue and Le Versailles, which would have been equally at home on the Right Bank. Their clients came from the French bourgeoisie (even the artists who frequented them were bourgeois and French).

The cafés Man Ray favored in his first years in the Quarter were more accessible places: the Dôme on the south side of boulevard du Montparnasse and La Rotonde just across the way. Founded in 1898, the Dôme was the older. As early as 1902, so the Quarter's best historians tell us, the café's back room featured two billiard tables which drew American artists and art students (not so much for billiards as for the continuous poker game they found there). Henceforth the backroom was American territory. Meanwhile, the first arrivals from Eastern Europe, the avant-garde of the École de Paris, brought their café habits with them to Montparnasse. As a rule they did not mix with other foreign groups that began to visit the café.

As for that other place, La Rotonde, it first opened its doors in 1910, expanding with each renovation, so that by the time Man Ray first saw it, it was an imposing café cum restaurant cum elegant grill room cum dance hall. On the carrefour Vavin, it was then the only alternative on the scale of the Dôme, since Le Select would not open its doors until 1925, La Coupole until 1927. But already little bars with counter stools and cigarette smoke and Anglo-American atmosphere were mushrooming along the boulevard's tributary streets.

Obviously the Germans vanished with the outbreak of war in 1914, and so eventually did the Americans. But under friendly new management, the postwar Dôme became as inviting as ever it had been.[4]

3 *Flashback*

BY THE TIME HE WAS READY to write his memoirs, Man Ray thought of himself as a man for all ages, so what need of a family and an identity? That universally recognized signature "Man Ray" would do. In fact, he was born Emmanuel Radnitsky, the first of four children of Max and Minnie, as his Russian Jewish immigrant parents preferred to see their first names on official papers in America. Although Max and Minnie had first settled in New York, Emmanuel was born in Philadelphia, where his father had found work as a tailor; the date was the 27th of August 1890.

Manny, as they called him, was seven by the time his parents moved to Brooklyn, New York—again to improve job prospects for this unprosperous but growing family. There he grew up bright and talented, adroit with his hands, manifesting a precocious resolve to choose a career for himself. He drew, painted with watercolors, copied anything in sight. He also read poetry and wrote with pleasure, enjoyed designing and constructing his own toys, and taught himself chess. (All of these things, even playing chess, would mark his life.)

Obviously nothing in the environment he grew up in interfered with this single-minded development, although in looking back he remembered that his parents feared for him (if art was the only thing

on his mind how would he ever earn a living?). For a while, he acquired paints and other art supplies in secret. By the time he entered high school, he was determined to shape his own career; he did poorly in most things but won a scholarship to study architecture. Yet painting was what he wanted to do and he did not think he needed college for that.

He was lucky (so was American art). He "came of age" in 1911, just at the right moment, when New York was setting its clocks to Paris time. Somehow he found his way to 291 Fifth Avenue and the gallery of the innovative photographer Alfred Stieglitz. Besides promoting contemporary photography, Stieglitz offered Americans their first opportunity to see paintings by Pablo Picasso.

The intrepid young Brooklyner managed to get to know Stieglitz, acquiring his first notions of camera technique such as it then was. Through Stieglitz he met other artists. With a day job for subsistence he could take evening art courses at the Ferrer School, named for an anarchist executed for subversion in his native Spain in 1909. Once he brought a model home to pose for himself and several fellow artists, who shared her fee. But he was too troubled by the presence of a real woman, naked and proximate, to be able to concentrate, and in any case his parents did not seem ready to accept Bohemia at home.

For a while he camped in the midtown-Manhattan studio of a friend, Adolf Wolff, a Belgian-born sculptor seven years his senior who taught at the Ferrer School. Then Samuel Halpert, a painter who had spent some years in Paris, took Man Ray on a ferry ride across the Hudson River to Ridgefield, New Jersey, to visit an enclave of old farm houses serving as an artists' colony. Man Ray was quickly won over; they would share the rent on one of them. That was in 1913, a watershed year for Man Ray, when he met the woman he later acknowledged as the most important influence on the artist he was to be.

But first, a landmark exhibition for everyone concerned with the arts: the Armory Show. Conceived by American artists to display their own new work and the newest from Europe, its sheer boldness

brought two energetic reactions: catcalls from the philistines (which only served to excite curiosity), and astonishment and admiration from those who cared. Organized by a rump group of independent artists, the International Exhibition of Modern Art opened in mid-February 1913, housed in one of those peculiar New York grotesques, an outsized red-brick structure inspired by medieval European fortifications, built to house the volunteer National Guard at 26th Street and Lexington Avenue—hence the "Armory" Show.

The biggest shocker was the work of an unknown Frenchman named Marcel Duchamp. His Cubist *Nude Descending a Staircase,* despite the irresistible title, revealed very little nudity or indeed anything else that was recognizable. But it made a name for Duchamp.

Until then the attention of wealthy American collectors had been drawn by academic painters who had long since faded from view abroad; at best they might accept Impressionists of a recent generation. When prices were set for works to be exhibited in the Armory Show, for example, a safe painting by Pierre Bonnard was listed at $2,700, a reasonably safe Camille Pissarro of a snowscape sunrise at $4,400. But one could buy a Constantin Brancusi bronze for $540, an oil by Georges Braque for $202.50, while paintings by Picasso ranged from $486 to $1,350. Marcel Duchamp's *Nude Descending a Staircase* was priced at $324 (and found a buyer).

The Armory Show proved a heady experience for Man Ray, then twenty-three, and aware that he still had a lot to learn. It gave him, as he put it, "the courage to tackle larger canvases." It was time to set up housekeeping in earnest in the little art colony at Ridgefield, New Jersey.[1]

One room of the cottage—facing north—became the studio, which Man Ray shared with his co-renter Samuel Halpert. Halpert also brought a third man to Ridgefield, Alfred Kreymbourg, a poet closer to Halpert's age than to Man Ray's. Kreymbourg had a vision of how Ridgefield could develop into a center of the arts, and he was quickly taken in as a tenant. Ridgefield had become something of a center for

the new in arts and letters, almost a rural appendage of Greenwich Village. Yet the isolation and modest dimensions of the cottage community in easy reach of the big city allowed considerably more cohesion; it was more like a large café than a town. Man Ray's painting now evolved rapidly, bridging the years from Fauve to Cubist in a matter of months; he was, if anything, acutely receptive to his moment. Then an event occurred to project him ahead of his time, into the era of Surrealism not quite ready to be born.

One fine summer Sunday a group came over from Man Ray's art school, among them his former teacher and temporary host Adolf Wolff. Wolff was accompanied by a striking woman introduced as his divorced wife, Adon Lacroix, like Wolff a French-speaking Belgian. She was slightly older than Man Ray—three years as it happened—"beautiful with her golden hair and gray eyes," and with an accent he thought charming. She did indeed seem to be free of Wolff, although she was raising their seven-year-old daughter. She found New York a difficult place to live in, she said, and she desperately wanted to get away from the city. Why not Ridgefield? Man Ray explained that he was alone in the house all week and could give her one of the rooms (Halpert and Kreymbourg only showed up on weekends).

She accepted at once. When could she come? He replied, brashly, that she could move in that very day. In an instant they were locked in an embrace.

Obviously Adon was to make life in Ridgefield more interesting. Even without her it was an intoxicating time, with the comings and goings of artists and writers, projects were conceived and as quickly abandoned. Some of the visitors were already making a name for themselves (like that New Jersey doctor, the poet William Carlos Williams). But the primordial influence on still-impressionable Man Ray was Adon.

Twenty years later, when Man Ray was a successful artist, the Surrealists André Breton and Paul Eluard, in one of the periodic surveys that had become a tradition in their movement, asked a selected

group of contemporaries to reveal "the most important encounter of your life." Man Ray, who by then knew a great many people, and had lived with more than one woman, replied without reservation: "On August 27, 1913 I met Adon Lacroix, who became my wife."

Later, when Adon shipped her household goods to Ridgefield, he sat with her as she opened a case filled with books, and watched as she removed the volumes with care: old, inexpensive paper-covered books, French-style. She would pick up a volume, read a few lines aloud, and then translate for him. Man Ray was not only ignorant of French but made no progress when his beloved tried to teach it to him. She gave up trying, but not before telling him that he had a horrible accent (which he still had in the last years of his life, when he told this story to an interviewer). He was hearing Baudelaire, Mallarmé, Rimbaud, and Apollinaire for the first time. She also read passages from *Les Chants de Maldoror* signed by the "Comte de Lautréamont"— pseudonym of an amateur poet named Isidore Ducasse who published it in 1869 when he was not quite twenty-three and died half a year after his twenty-fourth birthday. The little book was rarer than rare, admired by a small circle of avant-garde readers; it identified the possessor as an unusual person.

Maldoror was to become the sacred book of Surrealism. The sequence of satanic monologues, and the fusing of contemporary objects and concepts with hallucinatory imagery, would fire up the young poets of Dada. They read the first canto as early as 1916, when copies of a remaindered literary magazine reprinting of it were found in a sidewalk stall outside a favorite Left Bank bookshop. Man Ray was introduced to *Maldoror* in New Jersey three years before that.

One gratuitous image delivered up by Ducasse was of particular delight to the Dada crowd. The poet describes one of his personages as "handsome as . . . the fortuitous encounter on a dissection table of a sewing machine and an umbrella." As early as 1920 the Breton group in Paris paid homage to that image in a play whose characters included Umbrella and Sewing Machine. On the other side of the Atlantic,

that same year, the self-taught photographer of Dada, Man Ray, had clumsily wrapped and tied a sewing machine and an umbrella in a blanket, and then photographed it as *The Riddle of Isidore Ducasse.*

Such simultaneity in the world of art, and at a time of slow-moving sailing ships and still slower circulation of ideas, is worthy of *Maldoror.*[2]

They married in Ridgefield on the third of May, 1914. The wedding certificate indicates that neither bride nor groom had been married before—throwing a different light on Adon's earlier relationship with Adolf Wolff. The newlyweds stayed on in Ridgefield, of which they were virtually the only permanent residents. Man Ray began working with ever-larger canvases. Having decided once and for all that academic attempts to reproduce reality had been solved by photography, which had "liberated" painting, he produced liberated paintings— many inspired by the Cubists he had encountered at the Armory. Intrigued by the collages of Picasso and Braque shown at the Stieglitz gallery, this inventive man, so comfortable experimenting with new materials, began to make his own.

That Man Ray was now taken seriously as an artist is clear: Stieglitz had him write a testimonial of Gallery 291 for *Camera Work* (dated July 1914, it was published only the following January). "The gray walls of the little gallery are always pregnant," Man Ray began. "A new development greets me at each visit. I am never disappointed. Sometimes I am pleased, sometimes surprised, sometimes hurt, but I always possess the situation." He found a "unity" in the contrasting painters shown—"Cézanne the naturalist; Picasso the mystic realist; Matisse of large charms and Chinese refinement; Brancusi the divine machinist; Rodin the illusionist; Picabia surveyor of emotions" It was the first utterance of Man Ray to see print.

Visitors were drawn to Ridgefield—for its idyllic setting certainly, its promise that anyone who wished to could construct a similar paradise for artistic creation, but surely also to meet this young man who was assimilating and replicating the best that was new. One Sunday

afternoon the unannounced guests were two men—a still-young Frenchman (actually Man Ray's senior by three years), and an older American. The Frenchman turned out to be Marcel Duchamp and his escort the already legendary Walter Arensberg, heir to a steel fortune who was more concerned with the arts than business. With his wife, Louise (heir to a fortune of her own), Arensberg presided over New York's most sympathetic meeting place for artists and writers native and foreign—their living room.

Did it suddenly seem that New York City was the place to be? Was it the happy ending for Man Ray's first one-man show in November 1915 that persuaded him to return to the city? (Happy ending, for after total failure—negative reviews, failure to sell a single painting—at its close, a wealthy Chicago collector dropped by and offered a more than reasonable sum for half a dozen of the scorned canvases.) In his autobiography, Man Ray admits that the unexpected sale put more money in his pocket than he had ever had; now he was determined to move back to a studio in town which would give him more time for working "along new lines."

While preparing for his one-man show he had made a momentous decision (although he did not know it at the time). Dissatisfied with the reproductions of his work that had been made by professional photographers, he resolved to make his own—who but the painter himself was better qualified? He was far from sharing the contempt or rivalry for photography expressed by other painters. He had only admiration for photographers who were also painters.

His graphic work had entered a new phase, mechanistic and geometric (it horrified his Chicago collector when he got a glimpse of it). In the early weeks of 1916 Man Ray was to conceive one of his most successful canvases, a semi-abstract *The Rope Dancer Accompanies Herself with Her Shadows*. "The satisfaction and confidence this work gave me was greater than anything I had experienced heretofore," he would remember, "although it was incomprehensible to any of our visitors who saw it." (Today, looking at it hanging in New York's Museum

of Modern Art, it seems so much at home among its fellows.)

Then another leap into the void, with a *Self Portrait* combining a painted background with real objects—electric bells and what should have been their push-button. But when visitors to his next one-man show pushed the button, the bells did not ring. On another wall a panel hung by one corner, tempting visitors to set it straight, but it always fell back. He did not want to be funny, he explained later, he simply wished the spectator to take an active part in the creation. Next he was to innovate by painting with an airbrush of the kind he used in commercial work. He found that the results—when he worked with ink or a gouache mixture on cardboard—had "a photographic quality, although the subjects were anything but figurative." With these eerily evocative paintings—aerographs—his future was cut out for him.

In New York he was seeing more of Marcel Duchamp, that shy genius who seemed to prefer doing anything, anything—even teaching French at two dollars an hour for a living—to painting, but there is no doubt that he opened the door to the future for Man Ray. Although they had liked each other at first sight, and admired each other's work, they were natural opposites, Duchamp's biographer decided. One, the diminutive, hyperactive American, the other, the elegant and detached Frenchman who was quite capable of spending years on a single production (*The Bride Stripped Bare by Her Bachelors, Even*), without ever quite completing it. By the time the two met, Duchamp had seen everything there was to see in New York, had gotten to know everybody interesting, had done everything he could imagine doing. Now he only wanted to play chess, and Man Ray did not mind joining in.[3]

Thanks to the Arensberg salon, the modernists quickly found soul mates. One of the most conspicuous and least restrained of the group was another Frenchman, Francis Picabia, who had a chameleon-like ability to assimilate tendencies while leaving the impression that he was the innovator. Although Man Ray, Duchamp, and Picabia hardly

formed a school, a Dada pioneer, German-born Hans Richter, sized up the situation from a distance (from the official birthplace of Dada, Zurich), and grouped the three artists "F.P., M.D., and M.R." as a triumvirate. He called them the founders of New York Dada.

If so, it was a Dada born of humor, an iconoclasm inspired by the futility of progress, a peacetime Dada, unlike in Zurich where the Dada group was largely made up of Europeans in violent reaction to the Great War then in its second year. From the outset, New York Dada transformed rejection into creative energy. In the end, all of its practitioners had work to show, Man Ray and Picabia a little more perhaps, Duchamp a little less. In this triumvirate, remembered Richter, "Picabia is the passionate destroyer, Duchamp the aloof anti-creator." In comparison, Man Ray was "the pessimistic and tireless inventor."

Tireless indeed. And it was this trait more than any other that explained how much he was to be needed by blood-drained Europeans, belligerents and neutrals alike consumed by war, whose anti-art was often merely sterility. Did Zurich influence Man Ray, Duchamp, and Picabia? At least one historian of the modern movement, Marcel Jean, argued that New York came first: Man Ray, Duchamp, and Picabia having "contributed to prime the bomb that would go off in Switzerland."

In January 1917, Duchamp and the benevolent Arensberg were the driving forces in the founding of a Society of Independent Artists, which created a Salon and declared it open to all without screening by a jury; it was to be the biggest art show ever held in the United States. Yet Duchamp, who was in charge of the hanging, did not hesitate to sabotage it. With Arensberg and another accomplice, the painter Joseph Stella, Duchamp visited the showroom of a manufacturer of plumbing equipment to purchase a porcelain urinal, which he submitted to the show under the title *Fountain,* signed "R. Mutt."

The entry provoked a split in the Society's board of directors. Although Arensberg pointed out that their own rules did not allow for rejection of a submission, *Fountain* was rejected. In a little maga-

zine called *The Blind Man* published by Duchamp soon after that, an editorial made the case for ready-mades, Duchamp-style: "Whether Mr. Mutt with his own hands made the fountain or not has no importance. He CHOSE it. He took an ordinary article of life, placed it so that its useful significance disappeared under the new title and point of view—created a new thought for that object."

Man Ray, who had withdrawn his own striking work, *The Rope Dancer,* in protest against the banning of *Fountain,* was by now fully committed to the creation of his own objects—the juxtaposed kind, his "plastic poetry." And now he sometimes photographed the object, after which the photograph and not the original became the work of art. Two of the pictures, the image of an eggbeater captured by his camera and titled *Man,* and a juxtaposition of light reflectors and clothes pin used as studio equipment which he called *Woman* (or *Shadows*), were later judged to be "unconscious" Dada—or in the words of Dada historian Francis Naumann, "among the most significant and exemplary works of the dada and surrealist movements."[4]

Perhaps the closest Man Ray came to the young men of Zurich, Berlin, and Paris who were employing nonsense as a weapon against what they saw as a crazy world, was the production of a single-issue magazine called *TNT* in March 1919. It was something of a family affair, with the reproduction of a bronze by Adolf Wolff on the cover and contributions by, among others, Man Ray, Adon Lacroix, Walter Arensberg, and Marcel Duchamp (a sketch for his *Large Glass*). In addition to Duchamp, another Frenchman was represented whom Man Ray would come to know well: the Surrealist-to-be Philippe Soupault.

As for family. . . . In his autobiography Man Ray provides what we can guess to be a frank description of his marriage, for it deals graphically with his humiliation as Adon flirted openly with other men, and then went beyond flirting. He knew that he had been leaving her alone too much, and that she was happiest in the company of French-speakers (in such cases he was the only one who got bored). Once

they went out shopping and she stole a coat; when he expressed disapproval she made it clear that she found him timid. But it was her infidelity that made the relationship impossible. He soon moved out.

It helped ease the pain that Marcel Duchamp was now close by. Duchamp had gone off with a woman friend to Argentina in August 1918, spending the better part of a year there before sailing home to postwar France, where he had his first encounter with Dada. Back in New York, he not only had a lot to tell but also a project that could keep Man's mind off the collapse of his marriage.

The catalyst was Katherine Dreier, a collector who had early been won over to contemporary art. Seduced by Marcel Duchamp—by his ideas at the very least—she had voted with the minority in support of exhibiting his *Fountain* at the Independent Artists show. Now they were conspiring to set up the first American modern art museum. Until its first formal annual meeting, the directors would be Dreier, Duchamp, and Man Ray. While searching for a name for their undertaking, Man Ray mentioned having seen the term "Société Anonyme" in a French magazine—and an anonymous society seemed just right for what they were doing. He did not know that Société Anonyme, or S.A., simply meant "corporation" in French. Duchamp did know, and still loved the idea.

Katherine Dreier leased a floor in a brownstone off Fifth Avenue to serve as their gallery. The first show opened on April 30, 1920, with a Van Gogh to introduce the modern age, alongside less expected works of Brancusi, Juan Gris, Jacques Villon (Duchamp's brother), Duchamp himself, Stella, Picabia, and Man Ray. Man Ray's contribution was *Lampshade,* consisting simply of an unraveled paper shade hanging from its stand, a work subsequently acquired by Dreier.

It was an intoxicating moment. Man Ray plunged ahead with the construction-destruction of objects, each a riddle that only a modernist could decipher. He himself was now definitely a subject of curiosity to his peers. Francis Picabia, who admired no school but his own, published Man Ray's photograph of the unraveled *Lampshade*

in his personal Dada magazine called *391* (inspired by *291*, the magazine Stieglitz published from 291 Fifth Avenue).

By now Man and Marcel were very much a team, afflicted with the same mischievous inventive spirit, and compatible humor; it just happened that one was a hare and the other a tortoise. Once, noticing the dust that had accumulated on his friend's beloved but never-finished *Bride Stripped Bare,* Man Ray took a close-up photograph, resulting in what seemed to be an aerial view of a desert. It was subsequently labeled *Dust Breeding.*

Another time, Duchamp decided to give himself a second identity. Born Catholic, he wondered if he should take a Jewish name, but he could not find one that tempted him. So he chose to be a woman named Rose (later Rrose) Sélavy, and this quintessential lady's man was photographed as a woman more than once by Man Ray.[5]

Man Ray's best friend, Marcel Duchamp, a lady's man who for Dada's sake would dress as Rrose Sélavy (pronounced "c'est la vie")

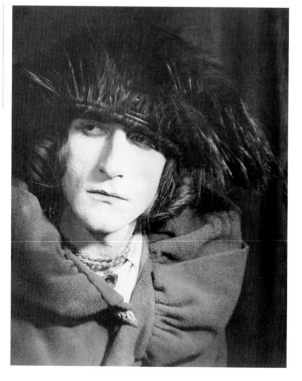

4 *Dada Interlude:*
Zurich–Paris–New York

HOW DIFFICULT TO TRY TO MAKE SENSE of a movement that wished itself meaningless. The better way to present Dada is simply to indicate the time and the place of its genesis, and perhaps to identify its chief personae. All of them were refugees of a kind, voluntary exiles from the war that consumed Europe in 1914; they had found each other in neutral Switzerland, and it did not seem to matter whether their countries were on one side of the war or the other. Hugo Ball, who opened the literary cabaret in Zurich where it all began, was a German pacifist, which in theory made him the enemy of Romanian-born Tristan Tzara, the cabaret's best poet-provocateur, for Romania was soon to join the war on the side of the Allies against Germany. Ball had a countryman in the expressionist painter Hans Richter, Tzara a fellow self-exile from Romania, Marcel Janco. Then there was the muddled identity of the Alsatian expressionist Hans Arp, French on his mother's side, German on his father's.

Born on the 16th of April 1896, and only twenty when he began ranting and raving at the Cabaret Voltaire, Tristan Tzara soon became first among equals, initiating relations with like-minded enemies of war in the belligerent countries (for it was occasionally possible, in the pre-totalitarian era, to speak and write subversively in wartime Paris or Berlin).

Bantamweight Tzara, bespectacled, with the appearance of a timorous bank clerk and the behavior of a fearless boxer, would simply recite his poetry in Romanian. Or members of the group would read aloud together, and the louder the better—different works in different languages—and at the same time. Noise was the point, disorder was the point. They claimed to have picked the group's name at random out of a French dictionary; in its distant origin a child's word for a donkey, *dada* came to mean hobby-horse both in its literal and figurative senses.

Almost at once, a troublesome contradiction became manifest in the Dada crowd. Tzara really meant what he proclaimed in the Dada manifesto of December 1918: "Dada means nothing." Even good art

Tristan Tzara, founder of the Dada movement, in one of Man Ray's more solemn portraits of him

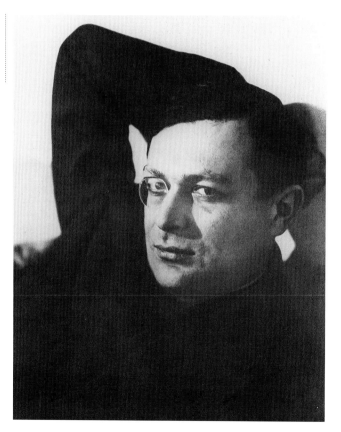

was bad; being modern did not help. "We recognize no theory. We've had enough of cubist and futurist academies. . . . Does one practice art to make money and to pat kindly bourgeois patrons?" Their key words were "abolition" and "dadaist disgust," which made it difficult, when the time came to turn from negation to creation, to avoid the appearance of betraying their original nihilism. "In order to understand this preference for scandal fully," one of their number, Philippe Soupault, later explained, "one has to remember the abrupt rupture between our childhood and our adolescence. We had been aroused from our childhood by the war, and then from the war into a kind of euphoria mixing a rage to live with a will to forget." He compared their movement to dancing the Charleston.

When the subversive spirit of Dada arrived quickly in Paris, it carried with it the Zurich problematic. When André Breton and Louis Aragon frequented the bookshop cum literary salon of Adrienne Monnier on rue de l'Odéon they were hardly associating with revolutionaries, unless one considered Paul Valéry one. Breton and his friends were about to begin publication of a magazine to be called *Littérature*, with the intention of placing their own work alongside contributions by established writers and poets—those they could still respect such as Paul Valéry and André Gide, Valéry Larbaud and Max Jacob. Contrary to what the Zurich Dadaists preached, this project was decidedly lacking in scandal.

Clearly the French Dadaists had no desire to sever relations with their elders. Breton, for example, had met that wild man Philippe Soupault through their common master, the pre-Dada Guillaume Apollinaire. Breton even engaged in an early experiment in automatic writing with Soupault, published in the October, November, and December 1919 issues of *Littérature*. In retrospect, Breton—the best historian of his own movement—was to argue that Surrealism was not the successor of Dada but coexisted with it. In *Littérature*, as in the productions of the Tzara group, Surrealist and Dada texts regularly ran side by side.[1]

Decidedly, something else had to happen before Dada could detonate in Paris. That something was the arrival of Tristan Tzara in person. The circumstance called for parades, for trumpets and fireworks, as one of his comrades in arms from Zurich imagined the scene. "The truth was quite another thing," confessed Hans Richter later. "He simply rang the doorbell one evening, coming straight from the East station with a small suitcase in hand, of the Picabias, who had indeed invited him to come but did not expect him. Although surprised, they nevertheless had a divan for him to sleep on." Gregarious Francis Picabia, although he later turned his back on Tzara with vehemence, was clearly delighted to be—or to be seen to be—at the core of the new movement.

It did not take Tzara long to set Paris clocks to Dada time. He had turned up at Picabia's door on January 17, 1920, a Saturday. The first literary event sponsored by Breton and his friends, a matinée of art and poetry sponsored by *Littérature,* was scheduled for the following Friday—but it seemed to have been invented for Tzara. Despite the subversive support of Picabia and Tzara, Breton held the center stage, introducing contemporary art from the brushes of Juan Gris, Giorgio De Chirico, Fernand Léger, and of course Picabia, and readings by Max Jacob, Jean Cocteau, Paul Eluard—and again versatile Picabia. But to make clear how the moderns felt about art, even about their own, Breton stood before the audience with a sponge, effacing a chalk composition by Picabia from a blackboard. And that was only the beginning.

After a musical interlude, with piano pieces by the moderns Georges Auric, Darius Milhaud, and Francis Poulenc, Tzara was introduced to recite a poem. Instead he read out a virulent polemic written by the detested Léon Daudet of royalist-reactionary daily *Action Française,* his voice drowned out by bells and rattles operated by Breton and Aragon. Whatever the message they were trying to convey, even their friends in the audience found it a bit much.

So Paris Dada was launched. There was another turbulent demon-

stration a fortnight later, this time at the Salon des Indépendants, with more disorderly poeticizing, speechifying, and chanting, provoking the audience—however well-intentioned it had been at the outset— to exasperation. There would be more of the same and in each case Tzara would take center stage to goad the spectators—goading them until he had exceeded acceptable limits. The result was the negation of instruction or entertainment, to say nothing of art.

A Dada manifesto published now in *Littérature* made this clear enough: "No more painters, no more writers, no more musicians, no more sculptors, no more religions, no more republicans, no more royalists, no more imperialists, no more anarchists, no more social- ists, no more bolsheviks, no more politicians, no more proletarians, no more democrats, no more armies, no more police forces, no more nations, in other words enough of all these stupidities, nothing more, nothing more, nothing, *nothing, nothing, nothing.*"

In retrospect, Philippe Soupault was obliged to admit that, at the time, Tzara's antics did have extraordinary impact, while construc- tive things, such as exhibitions of the works of Man Ray and Max Ernst, failed to set off sparks.[2]

Actually Man Ray, when still far off across the ocean, could be as provocative as the next one. And thanks to Duchamp and Picabia, who were never out of touch with Paris when in New York, or with New York when in Paris, his activities, both serious and unserious, had come to the attention of the most alert of the Dada crowd. Tzara knew of this enterprising New Yorker and his work, and he and Picabia hoped to publish some of it in an international anthology (which never saw the light) to be called *Dadaglobe.* "I shall be glad to help you in any way," Man Ray wrote them in December 1920, "although I am very poor at collaboration when a movement involves more than two people. Yours for 'DADA.'" One thing he could do was to let his new friends publish the work he was doing in their vein, and Francis Picabia, in *391,* now reproduced the most

phantasmal of Man Ray's airbrush paintings, *Admiration of the Orchestrelle for the Cinematograph.*

"DADA" WILL GET YOU IF YOU DON'T
WATCH OUT; IT IS ON THE WAY HERE

read the three-column headline in a New York daily, the *Evening Journal,* in January 1921. A smaller typeface was used for the subheads: "Paris Has Capitulated to New Literary Movement," "New York's Surrender is Just a Matter of Time." The reporter managed to track down Marcel Duchamp, Joseph Stella, and Man Ray, who explained that "Dada is a state of mind. It consists largely of negations."

Back in Paris, the next Dada manifesto—dated January 21, 1921— included an endorsement by Man Ray. "The signers of this manifesto reside in France, America, Spain, Germany, Italy, Switzerland, Belgium, etc.," it proclaimed, "but have no nationality."

DADA overthrows EVERYTHING, it was titled. "DADA knows everything. DADA spits out everything." Dada never spoke of inconsequential matters such as art, or vice, or mustaches—nor of Massachusetts, for that matter.

WHAT DOES DADA DO?
50 FRANCS REWARD FOR ANYONE WHO FINDS THE WAY TO EXPLAIN US

But there was an explanation: "Dada is the bitterness that turns its smile on everything that has been done consecrated forgotten in our language in our mind in our habits. It tells you: Thus is Humanity and the lovely stupidities that kept it happy until old age."

And more of the same. Besides Man Ray, the foreign signers of *DADA overthrows EVERYTHING* included Walter Arensberg, Max Ernst, Hans Arp, and Tzara, while among the French one found all of the usual suspects: Breton, Aragon, Eluard, Duchamp, Picabia. . . .

On his side, Man Ray replied with another single-issue magazine, calling it *New York Dada.* It was dated April 1921. "You ask for authorization to name your periodical Dada," began a letter from Tristan

Tzara, printed in the little magazine. "But Dada belongs to everybody. . . . Like the idea of God or of the tooth-brush."

The magazine's cover bore the curious portrait of Marcel Duchamp dressed as a woman, affixed to a perfume bottle of art deco design with an ornate crystal stopper. Thus was the quintessential lady's man Duchamp reborn as the chastely veiled Rose (or Rrose) Sélavy. "The one issue of *New York Dada* did not even bear the names of its authors," Man Ray later reminisced. . . . "What did it matter?" Indeed, what did it matter? For by then this isolated Dadaist was perhaps the most prolific of them all, with his constructions, collages, and airbrush paintings he called aerographs, not to forget the photographic tricks prefiguring him as the supreme art photographer. All of these works would later be called by Man Ray "objects of my affection." In a letter to Tzara, posted from New York on June 8, 1921, he explained:

> *Cher Tzara—dada cannot live in New York. All New York is dada, and will not tolerate a rival,—will not notice dada. It is true that no efforts to make it public have been made, beyond the placing of your and our dadas in the bookshops, but there is no one here to work for it, and no money to be taken in for it, or donated to it. So dada in New York must remain a secret. . . .*

Meanwhile Duchamp was about to disappear again. "We were out late one night after the chess club, during the Prohibition era, making the rounds of various cafés and carrying our own liquor," Man Ray remembered the moment. "Towards morning Duchamp stood in the middle of Fifth Avenue trying to hail a passing taxi, waving a bottle. None would stop." Man Ray took Duchamp back to his own flat in Greenwich Village, where they both fell asleep. When Duchamp finally woke up next day they went to lunch, at which time Duchamp told him for the first time that he was going back to Paris. Man Ray promised to make every possible effort to join him, and soon; he would try to raise the money with his camera (he was

occasionally asked to photograph the work of a painter or sculptor—a task that bored him).

Much later, Duchamp provided an explanation for his sudden relocations. He always traveled on a tourist visa, which limited his stays unless he asked for an extension (and he preferred to sail away rather than to involve himself in red tape). In June 1921 he was back in Paris.

Before his own departure for France, Man Ray thought it proper to inform Adon, the woman who had put him on the road he was now traveling. They were still legally married. "You will never do anything without me," he remembers her responding. "We'll see," was his reply.[3]

5 *Moving In*

MAN RAY'S BEST TRAIT WAS CURIOSITY, combined with an inter-est in people; his sense of humor was keen, and even his poor French was an asset for, unlike tourists and most short-term visiting writers and artists, he was not afraid to use it. Listeners did not appear to mind his improvised French, Brooklyn accent and all; it was rare enough to find an American willing to make the effort to communi-cate, let alone manage to be funny too.

His other asset—but he was only beginning to realize this—was his camera. *Of course* he was also a painter in the post-Cubist Dada mode, a creator of intriguing objects whose significance seemed just out of reach. But the things he was about to do with his camera no one else could then do, and some of the things no one would ever be able to do as artfully. It was always understood that photography was to be a source of income. Later he would insist that he had not even intended to try to sell his serious work—meaning paintings. "To be successful," he later told a television interviewer, and it sounded like something Marcel Duchamp would say, "art must remain unsaleable."

It began as simply as this. In New York, as early as 1915 when he had begun to make a photographic record of his own paintings, he dis-covered that not only could he handle a camera, but others liked what

he did with it. He had even tried his hand at portrait photographs, to earn a little money while he pursued his profitless (until then) painting career. Now, faced with a similar challenge in Paris, he was to find that the need for this particular talent of his was even greater.

Soon after his arrival, Man Ray was invited to lunch by Francis Picabia, whom he had barely known in New York. The language barrier remained. Worse, Picabia was in conflict with Man Ray's new Dada friends. Yet the visitor got along famously with this man of intense ego who, to compensate for his small stature, wore high-heeled shoes, and their meeting led to one of his first commissions. Picabia displayed a painting in his salon—actually an unpainted canvas on which fellow artists, musicians, and writers were invited to place their signatures and eventual comments around an incongruous eye. This was the collective work to be called *L'Oeil cacodylate* (*The Cacodylactic Eye*), the organ depicted being Picabia's, afflicted with shingles and treated by a drug laced with arsenic. In November, Picabia had dared to submit the canvas, autographs and eye, to the Salon d'Automne, where it was mocked as "urinal graffiti."

Francis Picabia
indulging in
his favorite activity
besides painting
(driving a sports car)

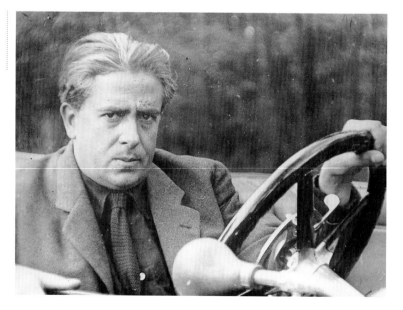

Invited to add his signature to the others surrounding the sick eye, Man Ray complied, in turn offering to photograph the canvas. That led to a commission to record all of Picabia's new paintings on film. And why not? Picabia was something of a playboy among artists, having inherited money both from a Cuban father and a French mother. He loved to be photographed at the wheel of one of his fast and expensive automobiles, and soon Man Ray would oblige him in that way too.

Meanwhile, the Picabia connection was going to lead him to occasional jobs for other, less affluent artists. First, a photographic record of their paintings. Then, portraits of the artists that would later be prized as works of art in themselves.

But as an indication of just how "unserious" his photography could be, his next promising assignment was a world away from art. His fairy godmother turned out to be Picabia's first wife, Gabrielle Buffet, herself an occasional fashion model. She sent Man Ray to talk to one of Paris's most admired clothing designers, Paul Poiret. So he made his way to Poiret's ostentatious fashion house on rue du Faubourg Saint-Honoré with his faithful old camera—the one he had picked up second-hand in New York when he began the photographic record of his own work. He warned Poiret that he was not sure what he could do for him. Just make your fashion pictures different, was Poiret's reply, and that utterance ought to have been accompanied by drums, for it changed fashion photography then and forever.

Man Ray was to get the run of the Poiret building. In the absence of a proper studio he had to make do with whatever lamps and bulbs and fuses he could find on the premises. For want of adequate lighting he was obliged to use long exposures, and that had him looking for models with light hair and light-colored dresses. Wandering through the Poiret establishment, he discovered the designer's impressive collection of contemporary art, and then and there decided to make use of a polished Brancusi sculpture as a prop alongside a model. Later, noticing through an open door that the floor in Poiret's

office was littered with brilliant-colored bolts of material, he had the model lie down on the pile. She lent herself readily to the pose, arms over her head, turned toward the lens with a coy expression.

It was all very new. No such things had been done before in a profession which until then tended to favor rigidly conventional representations. The "Man Ray" fashion photograph was invented that day. From then on, and through two Paris decades, his coverage of Paris fashions kept his name in print, making him a celebrity in a world far removed from the creative art circles of Paris and New York.

Francis Picabia, a man of fashion in his own way, knew people who knew people. One of the former was Jean Cocteau, darling of high society—although cordially despised by the Dada crowd, which considered him superficial and unserious. "Don't trust Cocteau!" Philippe Soupault remembered Apollinaire warning his young Dada friends: "He's a cheat and a chameleon." Eluard announced that the Surrealists would "shoot him down like a stinking animal. . . ."

Picabia, who like Cocteau enjoyed being outrageous, knew that the gregarious Cocteau could be helpful to Man Ray as he took his first baby steps in Paris. Cocteau had not only helped Picasso make his way among wealthier patrons of the arts, but he could also open doors to the people who counted in avant-garde music and theater.

Invited to Cocteau's apartment, Man Ray found the famous, still youngish, poetaster "freshly shaved and powdered, wearing a silk dressing gown . . . quite aristocratic and very engaging." While the visitor made his way around the salon, examining all the knickknacks one was expected to gaze at and admire, Cocteau surprised him by putting a Charleston on the phonograph and beating out an accompaniment with a pair of drumsticks. Man Ray made some photographic portraits of his host, and was invited to take further pictures of Cocteau's winsome young protégé Raymond Radiguet.[1]

His camera, he learned, would take him everywhere, gaining him entry to the best homes, introductions to the most influential people—

eventually to include vestigial nobility, the new- and the old-rich, and, of course, to the most interesting artists and writers and composers of his time. Apparently there was no one else like him, and his status as foreigner helped bridge class barriers. He was like the kid on the block with a guitar invited to everyone's party. The kid might end up in a corner of the living room strumming the instrument, oblivious to the social whirl about him, the merriment and the disputes.

It was to be something like that for the kid with a camera, at least in the beginning. In a way this was an advantage, in those times when literary and artist quarrels could quickly ignite into fights. "There were rivalries and dissensions among the avant-garde group but I was somehow never involved and remained on good terms with every-one—saw everyone and was never asked to take sides," Man Ray would remember. "My neutral position was invaluable to all; with my photography and drawing, I became an official recorder of events and personalities." He boasted to an interviewer: "Everybody needed me. It was like selling bread and meat." He lived a double life then—dress-ing for dinner in society, then reassuming a bohemian posture for life among the writers and painters.[2]

There could not have been a better time to embrace Montparnasse, and no better corner of the Quarter to live or to work in, to drink and romance in, than the little street off the carrefour Vavin, which was at once a cosmopolitan community and a village. Man Ray was going to enjoy all of that.

He was given a good-sized room at the Hôtel des Écoles; thanks to his key, which he was soon to reproduce in one of the experimental exposures he called rayographs, we know that he had Room 37. Thanks to the police department's good record-keeping, we know that this provided him with over 165 square feet of living, working, and loving space (including a small entry of some 14 square feet). He was to improvise a photographic studio here; with the lights switched off, the wash-up area served as a darkroom. Of course he had to wait until nightfall before beginning to use it and, even then, he would first draw

the curtains. Then he placed two trays on the table, lit a candle inside a small red lantern, ready to develop his plates one after the other.

Whatever they thought of Montparnasse, his new French friends—the pre- or proto-Surrealists—quickly found their way to the rue Delambre, and Room 37 became a meeting place. Then Tristan Tzara, who did not share their distaste for Bohemia, moved into the Hôtel des Écoles alongside his American friend.

As for Man Ray, he had no objection at all to living the life of his new neighborhood—which meant the life of its streets, its little bars, and grand cafés.

That is how he met Kiki.

He had only been in Montparnasse for a matter of months when he began to share a café table at La Rotonde with another Parisian self-exile, the Russian painter Marie Vassilieff, six years his senior and no less uninhibited and adventurous than he. Hers was a typical École de Paris career. After attending art classes given at a nearby studio by Henri Matisse—nearly all of whose students were foreign—Vassilieff opened her own school for young Russian artists, using her studio home in what was virtually a country lane in the shadow of the Montparnasse railway station. When Man Ray met her she was, in his eyes, still a struggling artist, making leather dolls caricaturing celebrities to supplement what the finer arts might bring in.

As Man and Marie chatted on one December day, he could not help noticing two young women seated across the room; he guessed they were both under twenty although trying to look older, with their heavy make-up and hair cut stylishly short with bangs. The prettier one also had curls falling on to her cheeks in a manner he associated with a rougher breed of women. But it was she who waved hello to his Russian table companion, who advised him that the girl was Kiki, "favorite model of the painters."

After taking the orders of Marie and Man, the waiter proceeded to the table where Kiki sat with her friend, but only to inform them that he would *not* serve them since they were not wearing hats. There was

an angry exchange of words, including some tough ones from Kiki (which Marie must have translated, for Man Ray later recalled them). A café was not a church, Kiki told the waiter, beside which all "the American bitches" who came in were hatless.

The manager took over. He tried to reason with Kiki. Since she was French and not American, her uncovered head might be misinterpreted (meaning that she might be taken for a prostitute). Kiki looked about her as if looking for something to throw, got up to declare that she was well known in the neighborhood, and that she would never return to this place. She sprang onto her chair, walked over the table, jumped down again—as gracefully as a gazelle, thought a captivated Man Ray. Marie invited the young women to their table. Man Ray got the waiter's attention and ordered for them with authority; an apology was forthcoming.

Kiki quickly forgot her anger, her resentment against the café manager and his rules, and began to regale her hosts with stories. For example, she had recently been posing in the nude for the Montmartre painter Maurice Utrillo. She described how he guzzled wine as he worked; he even asked her to have a drink but would not let her look at what he was doing. Finally she had a chance to see the canvas he had been painting as she sat for him. It was not a nude at all—but a landscape.

did not end here. Man Ray invited everybody to a nearby

ars, and they had a lot to eat and drink, main-

that Kiki and her friend seemed

diners.

readily

He would paint her, but from photographs, for he said that he could not work directly from a model as it would be too distracting; she was too beautiful. She was used to that, she said, all the painters she sat for flirted with her. But she refused to be photographed, for that was not the way an artist should work.

Anyway, she posed only for friends she knew well; she herself intended to become a painter.

He got help at that point from Marie Vassilieff, who vouched for his sincerity—and she seemed clearly on his side of the conspiracy.

"I've made the acquaintance of an American who takes pretty pictures," Kiki later reconstructed the memorable day, as if she had set it down in her diary at that very moment. "I'm going to pose for him. He has an accent that pleases me and a slightly mysterious air about him.

"He says to me: 'Kiki! don't look at me that way. You trouble me!'" (He used the wrong tense and that pleased her even more.)

She for one remembered the movie they had seen together, an early silent version of *La Dame aux camélias,* and she was aware that their Russian painter friend understood and blessed the relationship. "Now he's my lover," writes Kiki—jumping ahead.

It had happened so effortlessly. He had not been sure about how he would react in front of a naked beauty who was only meant to be sketched, or painted, or photographed; the situation had not arisen since his student days (and he had hardly been relaxed then). She had warned him that she had a physical defect she did not wish to show; he could not imagine what defect she could possibly have, "from the perfect oval of her face with its wide-set eyes to her long neck, high firm bosom, slim waist, small hips and shapely legs."

It turned out that what she called a defect was an absence of pubic hair. He took a few pictures, but soon gave up; the proximity of Kiki denuded was too much for him. At their second session he drew h___ into his arms.

She no lon___

evolved into a corpulent, generously endowed beauty. For with regular meals she was gaining weight and even her pubic hair began to sprout.

She inspired him; he improvised poses, introducing objects, arranging settings. As Man Ray invented Surrealism in photography, he did it hand in hand with his model. She became the Surrealist icon: Kiki with African mask, Kiki as an Ingres nude (her back a violin). He molded his model while she looked at him with love. But then she had also posed for many of the most popular painters of Montparnasse, among them the odd little Japanese-born Tsugharu Foujita, and none was heard to complain of her lack of compliancy.

"Summer and winter, Kiki never wears any underpants," Foujita later told the world. When she visited his studio for the first time, timidly (or so he thought), she removed her coat to disclose everything, and in that state marched over to the easel, ordered him not to move, and proceeded to draw his portrait.

She was a natural comedian, working with what she had. Man Ray told of how, at a raucous party given at Foujita's, she did an imitation

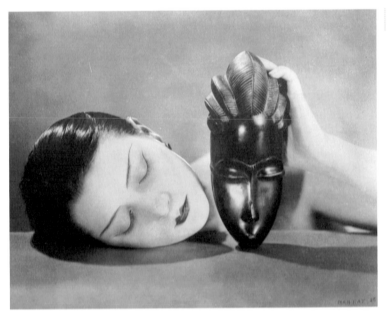

Kiki in *Blanche et Noir*, 1926

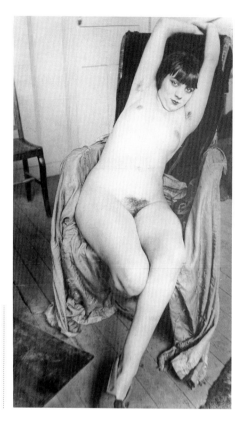

An early portrait of the versatile Kiki—Man Ray's favorite model—by Man Ray, Kiki's favorite photographer, in the days when they shared both a studio and a bed

of Napoleon, turning her hat around, lifting her dress up to her waist as she stuck one hand into her bosom. In the absence of underpants, her white thighs were eloquent representations of the emperor's white breeches. Everybody loved the skit.

Kiki, whose name was actually Alice Prin, was born (out of wedlock) in October 1901 in Châtillon-sur-Seine, a small town in Burgundy about 140 miles south and east of Paris. In 1913, when she was twelve, her grandmother sent her to Paris to be with her mother, and also to go to school. A year or so later she could read and count, and so was ready to go to work. At fourteen and a half she got a job in a bakery where she submitted to the baker's obscenities. The baker's wife called her a slut because she blackened her eyebrows with burnt matches, so she quit. Between jobs she posed nude for an old sculptor. "First con-

tact with art!" as she called that chapter of her memoirs.

By then she had met kindly Chaim Soutine, twenty-four years old and certainly as poor as she was, and they became lovers. She began modeling for real, posing for whoever would pay, living wherever a room was offered, getting herself fed on rue Campagne-Première at legendary Rosalie's—more of a soup kitchen than a restaurant, alongside other impecunious customers such as Modigliani (but he could pay for his meals with drawings).

Her housekeeping arrangement with a Polish painter, Maurice Mendizky, began in 1918. They lived poorly and she often did her bathing in the washroom of La Rotonde. She continued to model for other artists, among them handsome, generous Moise Kisling, who was not hard to like. (Later he would do one of the best undressed Kikis that has come down to us.)

She had just turned twenty when she met thirty-one-year-old Man Ray. At the beginning his spoken French was certainly even worse than an indulgent Kiki later remembered that it had been, and his New York manners and humor would have been as foreign to her as Foujita's Japanese culture. But they found a way.

He had to work as well as sleep in that hotel room on the rue Delambre and although he would often go out to photograph a subject, a growing number of people found their way to his improvised studio in Room 37. They worked it out so that Kiki spent her afternoons elsewhere; they would meet for drinks and dinner unless he had a date to see friends. She was concerned that he might be cheating on her during those absences, and he worried about what she might be doing—proof that they loved each other, he decided.[3]

Soon after he moved into the Hôtel des Écoles he had a visit from the most sober of his new friends, André Breton, Paul Eluard, and Louis Aragon. They wanted to take a closer look at his paintings since a fourth member of their informal group, Philippe Soupault, was getting ready to open an art gallery—and they wanted Man Ray to be the

first artist to show there. In fact, Soupault planned the enterprise as a bookshop, calling it Librairie Six for the insufficient reason that it faced a building bearing that number on the other side of the street (the real address was 5, avenue Lowendal, a prosperous section on the Left Bank near the École Militaire).

The choice of Man Ray, Soupault explained later, was motivated by a desire to revive the frontier spirit of the early days of Dada. The young poets and writers had gone off in different directions for their summer holidays, and somehow their team spirit had dissolved under the sun. Man Ray, who was extremely sure of himself, who knew where he was going and what he wanted, would bring them the strength they needed. Soupault, who had stayed in town for the summer, prepared the publicity material with Dada loyalist Tristan Tzara, collecting testimonials from each of the band, and the time that has elapsed between then and now has done nothing to tarnish the éclat of the signatures: Aragon, Hans Arp, Max Ernst, and Eluard, not to forget Tzara—and Soupault himself.

Curiously, Breton contributed nothing, nor did Picabia. In a sense this group enthusiasm for another painter could have appeared as an act of defiance to Picabia, although that was not going to prevent the older painter from making a conspicuous appearance at the opening, pulling up to the curb at the wheel of a racing car; he would shake Man Ray's hand but nobody else's.

The Man Ray show ("Exposition dada MAN RAY," so the invitation read) was scheduled for the month of December 1921, which should have been an ideal period for sales. The thirty-five works listed in the catalogue dated from 1913 to the present and included oils, collages, and airbrush ink-and-gouache paintings such as *Admiration of the Orchestrelle for the Cinematograph* (now in New York's Museum of Modern Art).

"Monsieur Ray," the Librairie Six catalogue introduced him, "was born—nobody knows where anymore. After having been successively a coal dealer, a millionaire many times over, and chairman of the

chewing gum trust, he decided to honor the invitation of the dadaists to show his latest canvases in Paris."

On the eve of the show the organizers sent out a press release. Taking note of newspaper reports to the effect that Dada had died a long time ago, it pointed out that the haste with which one had tried to bury it proved how irritating the new movement continued to be to those wishing to live comfortably as writers, painters, musicians. "From the sinecure that it had been until now, art thanks to Dada has become an inferno."

Dada had not died, the statement went on, it had simply changed tactics. Dada's first event of the winter season would be the Man Ray show, and it "will create a sensation."

The artist did not expect to create a sensation, but he did hope to sell. Prices of the paintings were kept low. But no buyers showed up. Yet, as Aragon's biographer Pierre Daix later remarked, for once the Dada group stressed genuine works of art and not monkey business.

One of the first visitors to the opening was a sprightly, white-bearded little man, older than anyone else in the room, an eccentric with his pince-nez, black bowler, black overcoat, and umbrella. The stranger attempted to engage conversation with the artist, but to no avail; Man Ray was too cold in the unheated bookshop-gallery, too exhausted from getting all his pictures hung, to make an effort to communicate in French. The visitor quickly understood, and used his English to invite Man Ray to a nearby café for a warming drink.

The kindly eccentric was Erik Satie, no stranger to the Dada spirit, although his expression was musical. He had begun his career as a cabaret pianist, producing his first eerie compositions before Man Ray was born. After inspiring the composers known as the Group of Six, who included Georges Auric, Arthur Honegger, Darius Milhaud, and Francis Poulenc, in their groundbreaking concerts on rue Huyghens (just behind Man Ray's rue Delambre, as it happened), Satie had earned his place in the modernists' hall of fame by writing the music for *Parade,* a ballet written by Jean Cocteau with Pablo

Picasso (who designed its Cubist decors and costumes), staged by Serge Diaghilev's Ballets Russes in 1917.

Nothing momentous came out of their café meeting over hot grogs, although the two men remained friends and Man Ray's portrait photograph of Satie in 1924 may have been the last; Satie died the following year. But on their way back to the gallery a hardware store sidewalk display caught Man Ray's eye. He picked up a flatiron, a box of tacks, and a pot of glue. Back at the gallery, he proceeded to affix the tacks to the iron's flat surface, creating another of his assemblages. Again, unlike Duchamp's ready-mades, this construct called out for a reaction—a rejection or a wincing movement. The useful gesture of pressing a shirt would be spoiled by the sharp points that tore into it. He gave the new work a title, *The Gift* and put it in the show. Later an art historian compared it to a collage titled *Guitar* which Picasso produced five years later, and through which the artist had hammered nails pointing to the viewer. But Man Ray's *Gift*, the historian agreed, had been the first "physically aggressive" Dada work.

Writing to Tzara in Cologne after Christmas, Man Ray informed him of the failure of his one-man show, and of the difficulty his friends were having trying to sell Ernst's work as well. "All our friends lack money as I do," he wrote in the best French he knew.[4]

6 *Man Ray, Photographer*

IT WAS PARADOXICAL, but the new year, 1922, a year that began with the insurgency against Dada, was also to see the enthronement of Dada's most resourceful artist. For the movement that sprung up from Dada's ashes was also ready to adopt Man Ray as one of its own. While Dada had been negation, host to a logic that denied the legitimacy of all productive activity including artistic creation, Surrealism would simply bypass it. As a creator, and a multitalented one, Man Ray had a part to play in the movement then in the course of being defined, and this without recanting the Dada creed or disowning old friends.

In fact, most of his friends moved out from under Dada before it collapsed.

Man Ray explained it later, much later, at a 1964 symposium that looked back on the Paris he had known.

> *The Dada movement was negative, it was destructive. You can only begin creating when you feel the ground first. You cannot build on ground that is already built up, so the idea of the Dadaists was to first level the ground. They had no future ideas. That came after—with the Surrealists who had a more constructive program—that is, after the Dadaists had swept the ground clear. But they were the same people, it was not a new group that came along, but exactly the same people, who then began to seek for a more positive, a more constructive attitude in new sources of inspiration, like the subconscious, the dream world, the automatic acts, you see.*

He was surely too kind, refusing to mention the personal conflicts and jealousies that split the avant-garde. Philippe Soupault, who proved to be one of the least submissive of the young men, remembered being among the first to feel unhappy with himself and his friends for indulging in Dada "clowneries" devoid of critical judgment. On his side, André Breton was to insist that even at the apex of the destructive period he had strove to counterbalance it with "a spirit of investigation" and "a moral concern" sorely lacking in Dada.

As was his way, Breton chose to institutionalize the differences between the destroyers and the builders. In what he later admitted was an attempt to distance himself from the closed universe of Dada, Breton planned nothing less than an international meeting of innovators in an attempt to make some sense of modernism— of movements such as Cubism, Futurism, and Dada—without setting up still another school. The event was to be called, impossibly, the Congress for the Determination of Directives and the Defense of the Modern Spirit.

What such a congress might have been we shall never know.[1]

Perhaps the Breton initiative was directed against Tristan Tzara, even though, of course, he had to be invited to participate. Tzara turned down the invitation, insisting that his refusal should not be construed as personal hostility to Breton or to other members of the committee. But Breton was not the man to take such things lightly (not then, not ever). He fired off a letter, duly signed by himself and five of his co-organizers, published on February 7, in *Comoedia*, a Paris daily newspaper that followed the modern movement closely. The letter contained some lines Breton was later to regret he scribbled so hastily:

> *At this time the undersigned, members of the organizing committee, wish to warn the public against the machinations of an individual known as the promoter of a "movement" originating in Zurich, that it is not necessary to identify otherwise, and that no longer corresponds to the slightest reality.*

No matter that Breton went on to promise that the meeting would be open to all. He had made himself vulnerable to reproaches not only from his adversaries but from his allies. Each side rallied its supporters, but clearly Tzara held the high ground thanks to the intemperate language of his opponent. Soon a counterattack was ready in the form of a declaration that concluded: "Putting aside all personal issues, we believe that it is time to call a halt to these quarrels among popes and to defend our freedom."

The defenders of Tzara invited all parties in the dispute to a meeting at the Closerie des Lilas. Forced to admit that he alone had drafted the attack on the man from Zurich, Breton nevertheless defended himself energetically. But he found little support in the group, and a resolution against both the congress and its organizers was easily voted by the fifty-odd artists and writers present.

Alongside his friend and neighbor Tzara, Man Ray was one of the signers, in the company of Paul Eluard and others usually found in the Breton camp. Looking for support, Breton found an unlikely ally in Picabia, who was also anxious to free himself from Dada, and had even fewer scruples than Breton about how to do it. Without identifying Tzara by name he underscored Tzara's Jewish origins—"this modernist of light complexion and greasy hair"—in a fierce editorial on the front page of *Comoedia* on April 16. Declaring himself on the side of the mystico-nationalist Maurice Barrès against "the parasites of La Rotonde," he assailed "the Jewish mind," which he said "had contributed to making Dada intolerable. Dada . . . that we were obliged to show to the door because it didn't know how to leave on its own."

Vigorously denying his own xenophobia while invoking his later anti-Fascist years, in retrospect Breton conceded that he had used an unhappy formula to identify Tzara without using his name. Unhappy formula or no, Dada was seeing its last days; the Surrealist era had begun.[2]

The momentous year had begun quietly enough for Man Ray. He was still painting (or so he thought) for his benefactor Ferdinand Howald,

a retired businessman from Colombus, Ohio. Howald had promised him regular payments as an advance for work in progress, although so far he was only getting *reports* of progress. "I am satisfied with the results of my exhibition [the Librairie Six show at which nothing was sold] which has placed me sort of apart from the huge mass of daubing that goes on here," he reported to Howald. And he was proud to say that thanks to himself, America was represented at the Grand Palais during the Salon des Indépendants. He had shown three of his works there at the beginning of 1922 (but he did not bother to add that none of them was new).

Yet money remained short. The occasional remittance from Howald and the modest help from his family did not suffice to keep him afloat. Luckily he could always turn to that source of immediate if still modest revenue—his camera. With it there would be no need to imagine a subject, to paint it and find a place to hang it so that it might be seen by potential buyers. No one questioned his right to demand payment for photographs made to order. It had worked with Picabia and Cocteau, and had worked in a totally different milieu at the fashion house of Paul Poiret.

Now it was going to work everywhere.

His first meetings with Pablo Picasso went well; each clearly recognized the other as a worker who knew his trade. But the Spanish painter, thirty-nine years old when Man Ray first entered his studio, was already recognized as a modern master. Had he stopped painting then, or had he died suddenly, he would undoubtedly have already earned his place among the artists of his century.

Man Ray had been sent to Picasso's studio on assignment. The intermediary was a versatile gentleman named Henri-Pierre Roché, man about town, amateur author, and friend of the arts but especially of artists. Like his companion Marcel Duchamp, he was a bridge between France and America. Roché had known Man Ray in New York, and now Duchamp had advised him that Man Ray was attempting to make a living with his camera. It was in this capacity

that Roché had enlisted Man Ray to make pictures of Picasso's recent work, to be submitted to a New York attorney, John Quinn, who was one of Picasso's most enthusiastic collectors.

After photographing Picasso's paintings, Man Ray used an extra plate he had brought along to photograph the artist himself. "It was nothing remarkable as a photograph," he would remember, "but showed the intense, intransigent look of the man, his black eyes sizing one up." It was the first of many Man Ray portraits capturing Picasso at work and at play, a souvenir of their friendship as well as a mark of mutual respect. A letter from Man Ray to Picasso of February 12, 1922, the first to bear a date, announces his visit for the next day on behalf of Roché. In May he signed another letter announcing a visit, with mock pretension, as "Man Ray, Photographe," the last word penned in elegant calligraphy. "He avoided definite appointments as much as possible," Man Ray remembered of Picasso. Man Ray seems to have dealt with that simply by announcing his visit and then waiting to see if Picasso would postpone or cancel it.

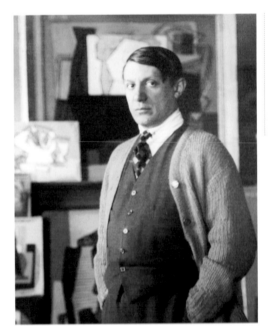

Man Ray's first formal portrait of Picasso, taken on the spur of the moment when making a photographic record of Picasso's paintings that would soon be in the possession of collectors

Gertrude Stein also became a frequent subject for Man Ray. There was the story—repeated by American-in-Paris Caresse Crosby—that when Picasso was told that his striking and severe painting of Gertrude Stein did not look like her he replied with perfect composure: "It will." Man Ray was soon to find out for himself that her ego was as wide and tall as Picasso's, although her own achievement until that time did not seem to justify it. Picasso and his work, Matisse and his, were at home at her grand drawing room at 27, rue de Fleurus, in a courtyard pavilion that was becoming a rendezvous of the artistic and literary privileged. "Little by little," Gertrude wrote in a memoir mischievously titled *The Autobiography of Alice B. Toklas*—Alice being her companion—"people began to come to the rue de Fleurus to see the Matisses and the Cézannes. Matisse brought people, everybody brought somebody, and they came at any time and it began to be a nuisance, and it was in this way that Saturday evenings began."

But if Picasso was to immortalize his benefactor Gertrude Stein in paint, Man Ray was soon her official portraitist on film. After Gertrude's death Alice B. Toklas published a memoir in her own right. What *she* remembered was that she and Gertrude had been introduced to Man Ray by visiting Americans in their Paris hotel suite. Man Ray needed work; would Gertrude pose for him? She readily agreed, as she would try anything once.

He gave her the address of his hotel on rue Delambre. "The room where he proposed to take the photograph was a little cubicle, a hall bedroom in a small hotel, but there he had all the cameras and wires and lights of all degrees. He took there the first of many photographs of Gertrude, a very nice one." She remembers him joking one day: "I am your official photographer."

In fact Man Ray managed to handle both his famous and infamous sitters quite well. They brought their egos and exercised them predictably, and he usually managed to control or to repress his.

What *he* remembered was calling at rue de Fleurus by prearrangement (no contradiction with Stein's recollection here). The contrast

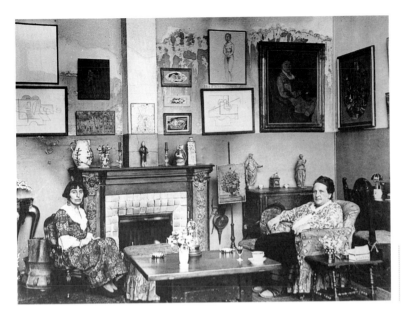

Alice B. Toklas (left)
and Gertrude Stein
in their legendary rue
de Fleurus drawing-
room gallery

between the modern art on the walls and the conventional drawing room furniture struck him. He thought it might be intentional, although he regretted that the Cézannes and Braques hanging over the fireplace had captured some of its soot. He fixed the scene on film: Alice and Gertrude seated at either side of the fireplace, a dozen paintings visible above and between them. For another exposure, he had Gertrude sit alongside her portrait by Picasso.

He found her stern as she posed, but he had no intention of introducing fantasy. "She might have welcomed the notoriety, as in her writing," he thought later, "and she might have thought more of me as a creative artist." He found her self-centered, but he could deal with that, proud to feel that his portraits of her were the first to appear in print, allowing her early readers to see what she looked like. Their early correspondence shows a friendly, business like relationship.

The explosion would come later.[3]

He attained the summit with remarkable speed. In this year 1922, when James Joyce was having his most influential work printed in

France (because it then seemed too dangerous for printers in Britain or publishers in the United States), Man Ray was making portraits of Joyce that would serve literary history. As the February 1922 publication day approached for *Ulysses* and Man Ray's availability as portraitist became known, he was asked to make the "official" portrait of shy, half-blind Joyce. The person who asked was a spunky young American, Sylvia Beach, who had resolved to publish the dangerous (and lengthy) novel under the aegis of her little English-language bookshop and lending library, which she had wonderfully christened Shakespeare & Company, and planted just across the narrow rue de l'Odéon from the shop of her companion Adrienne Monnier—that one catering to French readers.

An unenthusiastic Joyce showed up at the makeshift studio in Man Ray's hotel; clearly photographs were not his cup of tea. The neophyte photographer kept the writer distracted by talking about short pieces by Joyce which he had read in a literary magazine. (In fact these were episodes of *Ulysses*—passages which caused the magazine to be successfully prosecuted in the United States.)

But the studio lights clearly disturbed this man who was always between eye operations. At one point Joyce turned his head away, raising his hands to his eyes because he could no longer face the glare. Man Ray quickly snapped him in that position, and it became a classic portrait, although criticized by the unknowing as too affected a pose.

They would meet at other times—Joyce revealing himself to be more interested in drinking with Man Ray, or singing arias to him, than in talking to him seriously. But Man Ray's portraits of Joyce and his fellow English-language writers in Paris would gradually cover the walls of Shakespeare & Company. He and his future pupil in photography, Berenice Abbott, became the "official portraitists," to use Sylvia Beach's expression, of her Anglo-American crowd. And a decade later, when the time came for a formal portrait of Joyce's son Giorgio at his wedding, Man Ray was the one they called in.

Imagine. In this same miraculous year of 1922 the novice portraitist

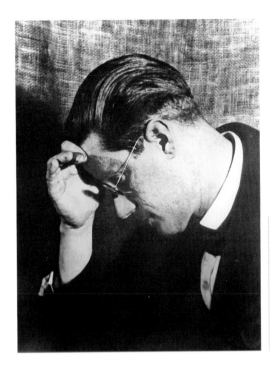

Portrait of James Joyce, photographed at an important moment in Man Ray's career and in Joyce's: the former was becoming a well-known portrait photographer; the latter was about to publish his most important work.

was called on to photograph that other great literary figure of his time (although, as in the case of Joyce, most of his contemporaries did not know it yet). Marcel Proust died on November 18. Ubiquitous Jean Cocteau, who had been one of the models for Proust's character Octave in *A la recherche du temps perdu,* and had served as a benevolent publicist for Proust as he was to do for Man Ray, advised Proust's brother Robert that he would do well to send for the photographer of the moment to immortalize this writer who had lived and worked in seclusion. Robert acquiesced, and next day, a Sunday morning, Man Ray was summoned downstairs by the hotelkeeper to take a phone call from Cocteau.

Man Ray found the dead Proust with a black stubble of beard of several days piercing the pale white of his face. It was understood that the photograph of his "majestic head and folded hands," to quote a biographer, was not meant for publication. The family would get a print, Cocteau a second, and Man Ray could keep one if he so desired. Later he discovered that the photograph had been published in a

One of Man Ray's earliest portraits of a famous man, Marcel Proust on his deathbed

"smart" magazine and, even worse, it was attributed to another photographer. When he protested, a correction was printed which (unpleasantly) announced that Man Ray "claimed" the photo to be his.[4]

Ernest Hemingway, who arrived in Paris just as Man Ray was getting settled in Montparnasse, was an assiduous user of Sylvia Beach's lending library. He confessed later that he could not only not afford to buy books at the time, but he could not even have paid the fee to join her rental library; Miss Beach waived it. Hemingway quickly noticed the photos on the walls "of famous writers both dead and living." He was in Paris to live cheaply and to write well, managing to do both in the company of his fellow Anglophones, including the Irishman Joyce (when he dared approach him). Yet soon enough Hemingway was chilling readers of the *Toronto Star Weekly,* for which he was European correspondent, with a ghastly account of Montparnasse, where "the scum of Greenwich Village...has been skimmed off and deposited in large ladlesful...."

Man Ray, who made it a point *not* to hang out with expatriates—he felt ill at ease with them, he would explain—nevertheless managed to capture the boyish-looking Hemingway on film. Robert McAlmon, an American would-be writer and amateur publisher, who seemed to be

everywhere and to know everybody in Montparnasse, set up a small publishing enterprise of his own called Contact Editions. When he was ready to bring out a volume of Hemingway's stories and poems, McAlmon accompanied Hemingway to Man Ray's for a portrait. Miraculously, the novice photographer hit it off with the novice author, and they spent an evening together at a boxing match. The result was a set of exclusive pictures of a knockout which he was able to place with an illustrated weekly for which he had begun to do occasional work.

Another time, Man Ray threw a party for a mix of French and American friends, Hemingway included. During the evening Hemingway made use of the studio's tiny toilet, but when he emerged he was covered with blood. The chain he had pulled was not the flush but the casement window, which came down with a splintering of glass. Man Ray wound a bandage around the forehead of his hapless guest, then shot a picture of Hemingway wounded.

Nor did Man Ray, though the son of Russian Jewish immigrants, seem to have any difficulty in approaching that dark poet Ezra Pound, quirky and racist, later raving mad. In addition to writing his own poetry and criticism, Pound was an effective promoter of the literary avant-garde, although reactionary in economic and political theory. (During World War II he broadcast Fascist propaganda from Italy to American troops.)

Pound, who was not a plastic artist at all, nevertheless had an impressive studio of his own a couple of blocks from the carrefour Vavin on rue Notre-Dame-des-Champs. He dropped in to see Man Ray one day, flopping into an armchair with his legs stretched out, his arms hanging loosely, which obviously helped set the mood. The result of that encounter was another set of portraits for the walls of Sylvia Beach's Shakespeare & Company and Pound's enduring admiration for the portraitist. At a later date he would urge his painter friend Joan Miró to get his portrait done by Man Ray, even drawing a map to pinpoint the photographer's studio on rue Campagne-Première for Miró's benefit.

Having a camera made Man Ray every creator's peer. While fresh from his portrait sittings, Joyce invited Man Ray to sit with him at Les Trianons, Joyce's favorite restaurant, *and* the most expensive in Montparnasse. Hemingway, on the other hand, despite his reputation, could admire Joyce only from afar. Once, the Hemingways waited outside the exclusive Michaud's restaurant for a table (they had money in their pockets thanks to a lucky day at the races) while Joyce dined inside with his family. When the couple finally got inside, they sat alone. [5]

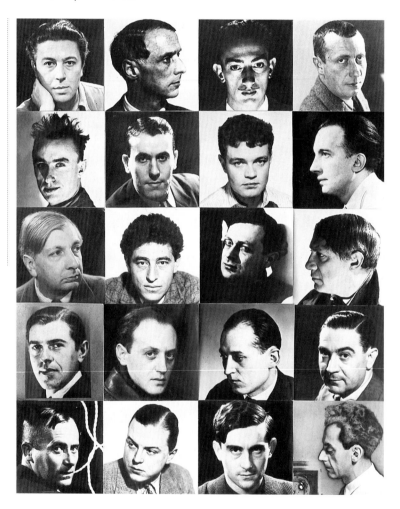

Montage of Photographs, 1934. Left to right, top row: André Breton, Max Ernst, Salvador Dalí, Jean Arp; second row: Yves Tanguy, René Char, René Crevel, Paul Eluard; third row: Giorgio De Chirico, Alberto Giacometti, Tristan Tzara, Pablo Picasso; fourth row: René Magritte, Victor Brauner, Benjamin Péret, Guy Rosey; bottom row: Joan Miró, E.L.T. Mesens, Georges Hugnet, Man Ray

7 Portrait Gallery

SURELY MUCH OF MAN RAY'S early success as a professional photographer was due to the novelty of his medium. To believe his later reminiscences, candidates for portraits signed "Man Ray" virtually formed a line outside his studio. From the beginning, those who called on the new portrait photographer included innovators in another medium such as Georges Braque and Juan Gris. He was always particularly pleased by the visits of Picasso, one of his first subjects. "At the time, I was the only photographer he allowed near him," he later told an interviewer.

Not to forget Henri Matisse, their prestigious senior, and who was no less eager to face Man Ray's lens. "That one always left the impression that he was a professor, and sometimes a merchant," reminisced Man Ray mischievously. Once, when Man Ray traveled to Matisse's home outside the city he forgot his lens (it had been wrapped separately). No matter: he did have a roll of tape in his kit, so he removed his eyeglasses and affixed them to the front of the camera, allowing one of the ground glasses to serve as a makeshift lens, while a black focusing cloth dropped over the glass became the shutter. The pictures turned out satisfactorily, and the absent-minded photographer learned that he could deal with unexpected situations.

Romanian-born, self-taught Constantin Brancusi was a special case. A real or false peasant, he insisted on doing everything himself. He did not take to the suggestion that he be photographed. Although he needed a camera record of his work, he was certain that only he could do that well. So Man Ray agreed to help him shop for equipment. In his private opinion, the photographs Brancusi subsequently made of his own sculpture turned out badly—out of focus or poorly exposed—but he had to admit that they added a curiously appealing dimension to the works themselves.

He had more success with Georges Braque, whose simplicity was a relief from the temperamental behavior of his colleagues. He posed as he was, in shirtsleeves. Moreover, he genuinely liked the American photographer's work, and when Man Ray refused payment Braque insisted that he choose a small still life in return.

Surprisingly, Man Ray also got along famously with turbulent Picabia. Picabia in turn seemed grateful that his American friend con-

Constantin Brancusi at work and play in his studio

tinued to see him despite his rupture with Dada. (It is quite likely Man Ray was unaware that Picabia had gone after the "Semite" Tristan Tzara quite viciously.) Now, in Man Ray's first spring in France, Picabia invited him along on a rapid visit to the Mediterranean coast, an offer Man Ray snapped up. He was disappointed by the cold, comfortless inn Picabia chose for their night on the road (unaware that there were few alternatives in those days). And then he was terrified by the narrow Riviera road high above the sea, delighted by his first cactus and palm trees, tempted by the roulette tables at Monte Carlo. Before the trip was over he resolved that he too would learn to drive, and perhaps possess a car of his own one day.[1]

There were the odd ducks, such as the woman who asked to be photographed naked to please her husband, another woman who required a similarly revealing photograph in order to *find* a husband, and a man who wished to show off his "virility." Summing up the strictly commercial side of his career, he reflected that while creative people were generally pleased with the results of their sittings, businessmen and socialites (including many of noble ancestry), preoccupied with their own vanity, were often disappointed.

The first of the titled sitters, and in many ways the most singular, was the Marquise Casati, former companion of the legendary poet Gabriele D'Annunzio. *La marchesa* wished to sit for her portrait in her own salon, where she could be photographed among her favorite objects; in fact it was a hotel suite on elegant Place Vendôme.

Tall, imposing, with what he described as enormous eyes, she received the smallish, still-novice photographer in a silk dressing gown. Although she was carefully made up, he noted that her red-dyed hair was in disorder—surely intentionally. He had brought his own lights but as soon as he switched them on everything blew out—another example, he thought, of the French system of installing the strict minimum of current. He dared not try his lights again, even when the porter replaced the fuses. He would use only regular lamps but the exposures would be longer and she would have to be as still as possible.

Once back in his hotel room, and after dark, he developed his negatives only to find that all of them were blurred. He waited for her to phone, and when she did he explained that the pictures were useless. She begged him to let her see some anyway. When he returned to her hotel she expressed delight at a close-up which, because she had moved during a long exposure, gave her three pairs of eyes. It portrayed her soul, she exclaimed—and ordered dozens of copies.[2]

These forays into what his literary and artistic friends might have considered hostile territory, this fraternization with the class enemy, never seemed to hurt his relations with them. In a sense, society insinuated its way into the Breton group, thanks to a highly polished top hat Man Ray designed for the cover of its monthly magazine *Littérature* in March 1922, the first issue of a new series of the group's magazine at the dawn of Surrealism. Thereafter, photographs by Man Ray, generally poorly reproduced, appeared regularly in the magazine—among the rare graphic contributions to nascent Surrealism.

One of these photographs, which opened the magazine's thirteenth issue in June 1924, virtually became the blazon of the new movement—or its fetish. It was a sensuous image of Kiki's naked back, touched up to suggest a violin. Its title, *Le Violon d'Ingres,* bore a double allusion: a reference to an Ingres nude, and to Ingres' violin playing. *Le Violon d'Ingres* also happened to be the familiar French term for "hobby."

Anything could become expression in Man Ray's unrestrained hands. Now a laboratory accident could blow up into an art form. It happened one night in his hotel room; he remembered that it was while he was making contact prints from plates for Paul Poiret. Unnoticed, a sheet of unexposed light-sensitive paper had accidentally slipped into the developing tray among those already exposed to negatives. As he waited for something to appear on it, he distractedly let some laboratory instruments, a funnel, a tube, and a thermometer, slide into the tray. When he switched on the light, unexpected shapes

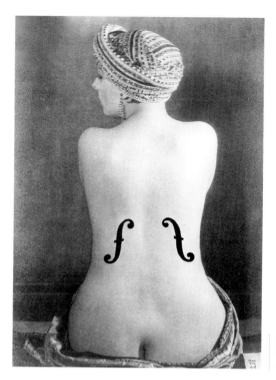

Kiki as Surrealist
icon, the *Violon
d'Ingres*, 1924

appeared on the photographic paper. The images of the objects in the
tray appeared distorted and refracted, white against a black back-
ground. He had done something similar as a youngster, he remem-
bered, when he placed fern leaves on proof paper and exposed the
frame to the sun, but now the developed print—thanks to the glass
objects that had been in contact with it—contained a three-dimen-
sional quality and tone graduation. In a word, they came alive.

He quickly repeated the process with whatever objects came to
hand, including the key to his room. He found that he did not have to
dip them into the liquid developer; it sufficed to place them on dry
paper before exposing them to the light. He certainly had as much fun
doing it now as he had when he was a kid with his fern leaves.

Next morning, as he pinned some of the night's work on the wall,
he knew what he would call them—rayographs. Tristan Tzara, who
was living in the same hotel, dropped in to suggest they have lunch

together; seeing the new creations, he called them pure Dada, better than anything of the kind that had been done until then (notably by Christian Schad, an early member of his band, whose exposures had lacked dimension). Tzara was back that evening, vying with Man Ray for the most original designs—matches on paper for Tzara, cones, triangles, and wire spirals for Man Ray—until the photographer called a halt to the whole thing, fearing that he was losing the exclusivity of his discovery.

In fact it would remain his, and Tzara became one of his most ardent publicists. But Paul Poiret was his first buyer, paying cash for two rayographs that Man Ray took along with a portfolio of fashion shots. An art and literary magazine, *Les Feuilles libres,* published a rayograph (which juxtaposed a spring and a cube) as its frontispiece. In the same issue, Jean Cocteau published an open letter to Man Ray. "In the past Daguerre and then Nadar liberated painting," he declared. "Thanks to them copyists could undertake more noble tasks.

"You have again freed painting. But in the opposite way. Your mysterious arrangements are superior to all the still lifes that seek to overcome the flat canvas and the prestigious mix of colors. . . ."

Writing to Ferdinand Howald, that collector still waiting for more of the Man Ray paintings he admired, Man Ray decided to be frank. "You may regret to hear it, but I have finally freed myself from the sticky medium of paint and am working directly with light itself." Marcel Duchamp, who was also getting progress reports from Man Ray, knew how to respond to the change in orientation of his friend's work: "I am delighted to know that you are having fun, and that above all you have given up painting."

Later, much later, Man Ray would regret that he had let himself float on this cloud; he would yearn for the sticky medium. But at last he had found something that would sell. And that might make him famous. The sophisticated American monthly *Vanity Fair,* which had begun to publish his portraits of artists and writers, Picasso and Joyce and Gertrude Stein among them, gave him a full page under the head-

line, "A New Method of Realizing the Artistic Possibilities of Photography." "Man Ray—the well-known American painter now living in Paris and closely allied with the modern school of French art," its report began, "has recently been experimenting along new lines with the artistic possibilities of photography." One of the rayographs reproduced was titled *Composition of Objects Selected with Both Eyes Closed.*

Success inspired him to become his own publisher. In April, in *Le Coeur à barbe,* a small magazine published by Tzara, Eluard, and fellow opponents of Breton's Congrès de Paris, it was announced that Man Ray was preparing to publish a limited edition of his new work under the title *Les Champs délicieux* (the publisher's address being his hotel room). There would be a preface by Tzara, who most certainly also wrote the advance promotion. "For the first time," it announced, "photography has been raised to the same level as original pictorial works."[3]

Henri-Pierre Roché, who in scouting art for collectors was as much an intelligent connoisseur as a dealer, made it a point to keep in touch with Man Ray. These were Roché's *Jules et Jim* years, when he kept a remarkable diary of his on and off life with the woman he shared with a German comrade, and which he would turn into art in a stunning novel, transposed into film decades later by François Truffaut. Roché's was also a diary of everyday happenings, such as his visit to the Hôtel des Écoles in early May 1922, where he made the acquaintance of Kiki, "Man Ray's tart, a Burgundian but no hick."

"Tart" was a little rough, but of course we were not present when the diarist sought the most appropriate term and then jotted it down, so we do not know if he wrote with tongue in cheek, whether he was being harsh or tender. What we know is that Man Ray's new life was an undreamed-of situation. Only a short time before, as he photographed the shapely models at the Poiret salon, he had been a lonely expatriate, looking on with envy as others flirted, although certain that "my time would come one of these days, when I, too, would have

a girl leaning on my arm." Now when he walked out with Kiki, already a legendary figure in his adopted quarter, he had the most conspicuous of love objects on his arm, a willing captive. Unschooled, lacking the social graces, she was inherently talented, and expressive in her language (even in her English when she began to pick it up). Her reserves of energy made her a clever draftswoman and caricaturist when she was ready for that, just as she had become a popular cabaret singer—because she wanted to be one.

Her letters to Man Ray, often written during visits to her birthplace, confirm the image of a passionate if self-taught young woman throwing herself at a very cool monsieur. She needs to be reassured that he loves her, she craves his caresses. "I am jealous that you stay in Paris [while she is in Châtillon-sur-Seine] because you're sure not to be bored, it's sad for me to think of you alone at night in your nest, how much I should like to be your nest, so that you lie in my arms." He was not made for love, for he was too calm: " . . . I've got to beg you for a caress." Then her sense of humor takes over. "I can't cheat on you because you aren't jealous, it's no fun." Although once Kiki confessed to him that at one time or another some of his "most intellectual friends had propositioned her."[4]

He often took her along when he met friends in cafés or at someone or another's home. She fit in quite well, he thought, and they all liked her humor; it was only that she quickly became bored when the conversation turned abstract, and she showed it. So they would slip away to the more comforting environment of Montparnasse.

The best summing-up of Man Ray's first Paris year comes from Man Ray himself, in a letter written at the end of May 1922 to his patron Howald. He told of the many new friends he had made—including Picasso and Braque. "My new role of 'photographer' has made it possible to go everywhere and be much talked of. I say 'photographer' because it places me out of the fierce competition amongst the painters here. I have something unique, as Jean Cocteau says, I 'have

delivered painting.'" He had been showing his new things only for a month and had already sold twelve of them, not counting the four that the editor of *Vanity Fair,* Frank Crowninshield, had seen during a visit and took away with him.

"Yes, my work looks like photography, just as my last 'airbrush' paintings did . . .," he explained, almost apologetically. Describing the method by which he made his rayographs, he added, hoping to touch the collector in Howald, "Each work is an original—it can be photographed, but so can a drawing—never with the same quality." He thought that he could show his rayographs in New York but he himself did not wish to go there, and even if he did he would quickly return to Paris. "New York is sweet, but cold, Paris is bitter, but warm. There is real life here, real feeling. I seem to breathe, and communicate with people more easily in spite of the lack of vocabulary."

He was, he said, still working in a cramped and expensive hotel room. But studios were "impossible," lacking water or electricity unless one could afford an expensive one; the housing crisis continued. "When I have my own home here, established, I shall feel free and think about coming to America. I should want to spend six months on each side of the ocean every year."

Finding a studio may have been difficult, but it was not impossible, especially for this artist whose new medium proved so rewarding. What he found, after only a year in Paris, could well have made many of his fellows jealous. It was a studio designed as a studio, in a palatial building put up just a decade earlier, its massive facade covered with glazed sandstone tiles, adorned with symmetrical windows and wrought iron doors. It deserved the designation of landmark which it eventually received.

On the other hand, the unit rented by Man Ray was a tiny one— compact, as he was compact. Once inside the lobby of 31 bis, rue Campagne-Première, a sharp left placed one at the entrance to a narrow two-hundred-square-foot ground-floor studio. Inside, a steep wooden staircase rose to a lilliputian (six and one half by thirteen

and one half feet) loggia. This upper floor actually extended over the lobby and had its own small circular window—the right place for a bed. There was a sink against the rear wall, the future photo laboratory, and a toilet.

He would never forget the housewarming, to which he invited all the Parnassians he knew, his Dada comrades, and the more important people he thought might come; guests brought their own bottles. Tzara mixed a number of alcohols together in a brew, which fueled the already warm atmosphere. Man Ray paid too much attention to a couple of young women whom he saw as future models—or clients. Without warning he received "a resounding whack" on the side of his head, and turned to see Kiki, eyes ablaze as she tossed insults at him as well as at the objects of his attention. He lunged, but she got up the stairs before he could seize her. An onlooker calmed him down. Later, when all the guests, "drunk and happy," had gone, he made up with Kiki and felt that they loved each other more than ever.[5]

Man Ray's pocket-sized studio on rue Campagne-Première, where everybody who counted in the arts and letters, and in high society, came to sit for a portrait

8 *The Return to Reason*

PERHAPS HAVING A PROPER STUDIO on rue Campagne-Première helped a career. The street itself was hardly the glory of the Quarter, and was too narrow for trees, although it served to connect the leafy boulevards du Montparnasse and Raspail.

There was that bland facade at Number 9, whose massive gate led to the courtyard lined with the "studio barracks" celebrated by Apollinaire, with its terrifying maze of unheated workplaces for young or unlucky artists. Close by stood a necessary eyesore, the wretched little restaurant named for its owner-cook Rosalia Tobia, who had migrated from Italy originally to model, and whose cheap and hearty portions had helped to keep Modigliani alive (and more recently Kiki).

As for the building at the other end of the street numbered 31 and 31 bis, one could approach its magnificent doors holding one's head high.

It was thus that the wealthy collector Jacques Doucet entered Man Ray's studio, escorted by André Breton, soon after Man Ray settled there in that summer of 1922. Then sixty-nine years old, Doucet was another of the great fashion designers, although by then he was almost better known as a patron of the arts. Ten years earlier he had liquidated a collection of eighteenth-century art in order to purchase

contemporary works, hiring young experts to advise him. One of his advisers was André Breton, and one early piece of advice from Breton was to co-opt Louis Aragon.

That day the white-bearded old gentleman set his eye on several works, eventually acquiring a small painting and some photographs. Soon Man Ray could tell his friends that thanks to Doucet he would be able to meet his quarterly rent.

Using proud new letterhead bearing his studio address, Man Ray wrote to Tristan Tzara, then on a summer holiday in the Alps, of a singular clash in his little studio between Henri Matisse, the old-modern master, and the brilliant, cheeky Breton. Matisse had been coming to rue Campagne-Première for a series of portrait photographs and happened to be there when Breton dropped in.

The encounter between ancient and modern rejoiced this American ever ready to add to his experience. As he related the event to Gertrude Stein, it was "delicious" to hear Matisse speak of the necessity of drawing hands that looked like hands—and not like cigar butts. Expecting a sympathetic iconoclast, Breton found himself facing a painting instructor. After sitting through the hour-long discussion, Man Ray decided that the two men were speaking entirely different languages (it was already an achievement that he understood them).

In the end Matisse confided that he had enjoyed the dialogue immensely. He had not talked that way about art in years.

There would be another singular encounter that summer. Max Jacob, born in 1876, was already a legend in the Paris of poets and artists, a colorful participant in the life of its Bohemia (which in his time signified Montmartre).

His fantastic use of language, even his daydreams and automatic writing, anticipated Surrealism (and no wonder he became one of the Surrealist deities). Born Jewish in Catholic Bretagne, he underwent a mystical conversion to Christianity at the age of thirty-three. Indeed, a year before his visit to Man Ray's new studio he had given up

Bohemia for the life of a recluse in a monastery on the Loire river eighty-five miles south of Paris.

In the best of the portraits made that day, Max Jacob appears as a dandy, sporting white shirt and bow tie setting off a dark vest and casual jacket. His expression is mischievous. He liked what he saw when the packet of prints reached him at Saint-Benoît. "It's a picture! what colors!" he exclaimed—of course the photographs were in black and white. "Or rather what exquisite values!" Painted portraits, he knew, were never accurate, but here he recognized himself. "Not too handsome! not too ugly! not made young again. Not too young! avec a solid big nose and a devilish woman's mouth." He promised to let everyone know how he felt about Man Ray's camera.[1]

Man Ray knew his way to their hearts. As money began to come in from photography, he could give away his paintings. Should someone

Elusive Max Jacob, bohemian and dandy

say that he loved a painting and wished he could afford to buy it, he would get it. He gave them all away, he would tell an interviewer late in life, and many of these works eventually found their way into museums—sold by the writers, and "more power to them," for they needed the money. "Maybe they helped make my reputation as a painter," he reflected.

The benefactors of this largesse included Aragon, Eluard, Breton, and Tzara. "They were so nice to me, they accepted me without hesitation, and that meant something!"

A group photograph taken just then attests to this. Man Ray was behind the camera, not then equipped to cock the shutter so as to be able to get into the picture himself. No matter. They simply took a blown-up portrait of Man Ray and held it in the place that he should have occupied (appropriately, it was the loyal Paul Eluard who held it straight).

Breton was absent from the group that day, but surely not absent by design, for there is ample evidence of his respect for Man Ray and his work. There is also evidence that the new group was incomplete without André Breton—"and it was even odd," Marcel Duchamp

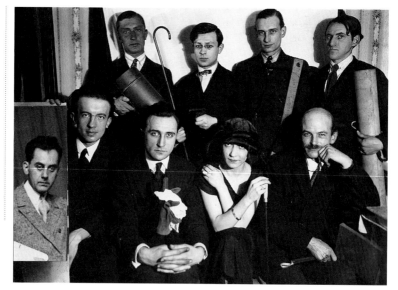

Group portrait of the Dada/Surrealist group, with Paul Eluard holding up a portrait of its photographer, Man Ray. Back row, from left: Paul Chadourne, Tristan Tzara, Philippe Soupault, Serge Charchoune. Front row: Paul Eluard (holding photograph), Jacques Rigaut, Mick Soupault, Georges Ribemont-Dessaignes

Tristan Tzara (left)
and René Crevel,
friends in Dada
and Surrealism

would recall, "to see how he immediately dominated people like Aragon and Eluard, who were only his lieutenants." Portrait photographs that did justice to this man with the head and behavior of a lion would not be made for another decade, when Man Ray was ready with solarization, a process that made gods of mortals.

It was Breton who introduced content into Surrealism, applying "scientific" principles to kindle automatic writing, then to induce sleep, or at least daydreams, in an attempt to elicit new forms of expression.

The first sessions took place in 1922 after everybody's return from summer holidays. The best sleepers were two young romantics, René Crevel and Robert Desnos. Breton invited Man Ray to sit in as an observer at the first session on September 25, and to return another time with his camera equipped with a flash lamp (and, if she agreed, with Kiki, who had fled the first seance because Crevel's sleep-induced tale of murder had frightened her). Explained Breton: "We'll choose the moment when the sleeping Desnos focuses his astonishingly troubled eyes on us. We are also thinking of recording his words with a phonograph. . . ."

Let it be said that Breton himself never managed to fall asleep during a seance and that neither Aragon nor Soupault desired to take part in one. Soupault was convinced that some of the sleepers were only simulating.

Robert Desnos, one of the group's true poets, dreamy-eyed even when wide awake, was indeed a perfect subject for Man Ray. "Large sea-blue shining eyes, always with dark rings around them, sensual mouth, vehement, always in the front rank in fights, and always in love," so he was remembered by Marcel Duhamel, who became an intimate of the group without being part of it. And in sleeping, eyes closed or open to reveal those impressive orbs, Desnos was also a natural poet. Man Ray's photographs that day became Surrealist documents.[2]

The new year, 1923, brought some good news. Marcel Duchamp, Man Ray's best friend in art, if artist he still was, and the one Frenchman he knew who would not let doctrine or career stand between them, was returning to France after having moved back to New York in January of 1922.

Robert Desnos, romantic poet and Surrealist loner

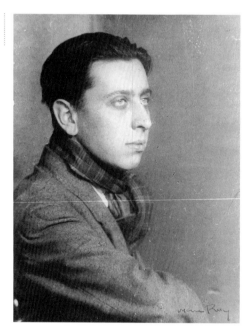

Man Ray (left) with
Marcel Duchamp

Characteristically, he chose to hole up in a badly heated studio behind the Montparnasse cemetery, close by and yet symbolically, almost grimly remote from the Bohemia lying on the other side of the graveyard. What interested him now was perfecting his chess, and apparently that was what he spent most of his time doing.

But it was certainly more than coincidence that his living quarters fronted a narrow lane that cut through the cemetery to boulevard Raspail, just opposite the opening of rue Campagne-Première. Visiting Man Ray now meant a five-minute stroll for this long-legged man. Soon Duchamp moved himself and his baggage even closer, into the Hotel Istria, alongside Man Ray's studio building. This modest hotel, which would get its first private baths and toilets only half a century later, was something of a refuge for distinguished transients. That same year, for example, Elsa Triolet, a young Russian separated from her French husband and a long-time resident of the Istria, booked a room there for her sister's lover, the Futurist Soviet poet Vladimir Mayakovski, during his Montparnasse stay.

By then, in order to receive his portrait sitters in comfort at 31 bis, Man Ray had also taken a room at the Istria for himself and Kiki. She could live part of her day there, and at night it became their bedroom. But if Man Ray spent only his nights at the hotel, Duchamp "lived there completely," as he later confessed to an interviewer, "because I wasn't doing anything."

Duchamp had ceased to paint—a decision he did not make, he argued, since "it came all by itself." He did not believe in art, neither in its value, nor in its persistence. "He owns nothing, collects nothing," Man Ray would say of his friend. After Duchamp gave up painting, he added, "one might say his principal activity is chess because his mind is alert and chess leaves no material traces of the most intense mental activity." An art dealer told Man Ray that if Duchamp would paint just one picture a year he could earn ten thousand dollars (an enormous sum at the time), so great was the legend that surrounded him. Duchamp just smiled at that; he had accomplished what he set out to do and did not wish to repeat himself.[3]

Man Ray now found himself in the middle of a brawl—the last great battle between Dada and Surrealism, involving fists and bloody noses. When it was over Dada retired from the field to lick its wounds; it would never again command the same attention.

And yet the Dada forces came to the battle armed with their moral advantage, acquired thanks to the ill-advised tactics employed by the Breton-Picabia side during preparations for the aborted Congrès de Paris a year earlier. Tzara decided to count his friends by organizing an evening devoted to contemporary works. He would include musical pieces by the best of the moderns—Igor Stravinsky, Darius Milhaud, Georges Auric, and Erik Satie, and short films by his Dada friends, including Man Ray. There would also be some provocative poetry readings, and then an absurd three-act play by Tzara himself, with actors attired in Cubist costumes designed by Sonia Delaunay.

As for a movie, Man Ray would try anything once. He had been

tinkering with film, using a small automatic camera that could record only a few seconds of motion at a time. The product of his tinkering had been a suite of unrelated scenes—which was quite fine, thought he, since this was what Dada was all about. Tzara had watched him work, convinced that if movies were a medium from which Dada had been absent, it was high time to invade the terrain. This day he walked into Man Ray's studio carrying the printed announcement of the Dada evening, which listed among attractions a movie by Man Ray.

Man Ray knew that Dada folk often made promises that were not meant to be kept. (Once they had promised, with no justification, the appearance of Charles Chaplin at a Dada event.) He, too, could ignore Tzara's promise. Tzara insisted. So he picked some earlier sequences from a shelf, warning Tzara that all this exposed film combined would not last over a minute. Tzara asked why he could not apply the rayograph process to movie film—simply placing his objects on light-sensitive paper without a camera. He promised to try. Soon he was pinning short strips of film onto the work table, sprinkling salt and pepper on one strip, pins and thumbtacks on another, and whatever came to hand on a third, exposing his combinations briefly to light. Now he had some three minutes of nonsense to show.

The 6th of July was a Friday night, which helped to guarantee a good audience—part of it prepared for anything, the other part subject to astonishment, indignation, and anger. The Breton clan, for example, quickly manifested its dissatisfaction at the inclusion of Cocteau in the program. Dissatisfaction became anger when a young provincial writer, Pierre de Massot, rose to deliver an unscheduled litany for the distinguished departed, "who died on the field of honor"; he included the very much alive Pablo Picasso as well as Marcel Duchamp and André Gide. Breton, for one, took that badly, dashing to the stage to put muscle into his protest. When Massot raised his hand Breton slammed down on it with his ever-ready cane and broke the poor man's right arm.

The police were there in a jiffy, seizing and expelling Breton and

his allies, who happened to be Robert Desnos and Benjamin Péret, apparently to noisy public approval.

Miraculously, the show went on. But during the intermission another Breton regular, Paul Eluard, rose to protest the expulsion of Breton, attacking Tzara personally when he came to the stage to present his play. At least one witness saw him slap both Tzara and the poet René Crevel, who was one of the actors (helpless in his rigidly Cubist cardboard outfit).

Then a sober Tristan Tzara climbed to the stage to announce the first screening of *The Return to Reason,* made by the renowned artist Man Ray in one of his lucid moments. In the darkened theater the unsuspecting public, which greeted the prospect of a movie with audible relief, was subjected to those flashes of nonsense footage prepared for them by a Man Ray pressed for time. First came something that looked like snowflakes, followed by a field of daisies, dancing pins, even "a lone thumbtack making desperate efforts to leave the screen." He heard some grumbling from the audience, some whistling—and just then the film broke.

After the film was glued back together spectators saw, and enjoyed, a brief shot of striated naked breasts and belly. But that was followed by an unexplained spiral, actually a paper strip hanging in his studio lab, followed by a revolving egg crate. There were protests—and the film broke again. Someone shouted a complaint, someone else defended Man Ray. In the dark he heard a resounding slap, scuffling, and shouting. The lights came up to reveal fights here and there in the theater, some of them spilling out to the sidewalk. Dada would never again try anything on the same scale.[4]

critic. A dozen or so Americans were seated at the Dôme on July 14, 1923, after waltzing in the streets with everybody else to celebrate Bastille Day. Then and there one of their number suggested that they cross the boulevard to the Rotonde to take a punch at the owner.

The fellow who made the suggestion was Laurence Vail, a handsome, impulsive playboy who was soon to marry a fellow American-in-Paris, the no less impulsive heiress Peggy Guggenheim. (At the time, Vail's public behavior inspired her to refer to her fiancé as "King of Bohemia.") Vail, Cowley, and the others were convinced that the owner-manager of La Rotonde was a totally evil man, a police informer who tattled on Russian revolutionaries conspiring over their coffees. Naturally the villainous proprietor was also despised for his brutish treatment of respectable young women, whom he dared to brand as harlots because they showed up hatless and smoking.

The dozen commandos who invaded the Rotonde that evening included at least one prominent member of the Surrealist band, Louis Aragon, attired in a dinner jacket, and young women both in evening dress and in tweed suits. As he approached the bar, Malcolm Cowley heard Aragon declaiming his contempt for informers, and wondering out loud how the sinister proprietor could expect decent folk to enter the establishment. Waiters drew up in a line to defend their *patron;* Vail pushed them aside to berate the owner in a French too rapid for Cowley's comprehension. Another prominent member of the Americans-in-Paris clan, Harold Loeb, the model for Robert Cohn in Hemingway's *The Sun Also Rises,* was also in the front line, but like most of the others seemed passive to Cowley, who now pushed forward, breaking the line of protective waiters to strike their boss with what he later admitted was only a glancing blow to the jaw. Cowley was stopped before he could do more damage, forced to retreat.

Later, well past midnight, Cowley ran into Tristan Tzara at the Dôme. Their conversation centered on whether Dada could be revived. One thing led to another and soon they found themselves crossing the boulevard to the Rotonde, where the sidewalk tables

were still packed. On seeing the proprietor Cowley shouted, "What a bastard! Ah, what a dirty little police informer!" He and Tzara then turned to go back to the Dôme. Halfway across the boulevard, Cowley was seized by two policemen who led him away—Tzara rushing off to retrieve Cowley's identification papers, knowing that they would be required at the police station.

It was a difficult moment for Cowley. One of the policemen taunted him: Cowley would have been treated more roughly by New York cops; they would have hit him on the ear—like that (and the French cop hit him on the ear). "They would crack you on the jaw—like this" (and he did that too). Before he could strike a third blow Cowley became aware that his assailant smelled of alcohol.

At the police station the arresting officer alleged that Cowley had kicked him, leaving a mark on his leg, which he displayed. In the end a group including Aragon and Vail showed up. The policeman accepted some cash in return for withdrawing his complaint, leaving only the owner's charges. After a night in jail Cowley got a new hearing. His witnesses, all well-dressed young ladies carefully chosen for the job, swore that he had not even entered the Rotonde the previous evening. The owner's only witnesses were his waiters. A friendly Parnassian, the journalist André Salmon, used his influence to get the trial postponed, and eventually it was abandoned. One guesses that Louis Aragon, through his Papa, exercised even more effective influence that evening, but Cowley could not have known that. By then Cowley had become something of a hero, a man worth knowing, and perhaps worth publishing too.[1]

We can document Man Ray's own July 14th of 1923, explaining why he and Kiki had not been witnesses to (or participants in) the battle of the Rotonde. The *deus ex machina* was Jules Pascin, one of the more colorful members of the École de Paris, a singular Parnassian then living and working on the boulevard de Clichy in northern Paris (another neighborhood where large studios came cheap).

Pascin was born to a prosperous dealer in grains. The family moved from Bulgaria to Hungary: he was raised in Bucharest and schooled in Vienna, changing his name to a more Latin-sounding one on reaching Paris in 1905. He found lodgings on rue Delambre and a spiritual home at the Café du Dôme. During World War I he avoided military service by emigrating to the United States, returning to Paris in 1920 as an American citizen. Pascin's dazzling canvases and his painterly book illustrations kept his name before the public; he avoided the sentimentality that permeated so much of the work of the Slavic strain of the École de Paris.

This Bulgarian-American-Parisian dressed and behaved as a boulevardier. He would later be described as "the dandy of three mounts, Venus, Montparnasse, and Montmartre," and Man Ray's camera captured that well, depicting (in the portraitist's own description) "his tight-fitting black suit on a spare figure topped jauntily with a bowler hat from which a lock of hair escaped, a cigarette butt in the corner of his mouth, and a spotless white silk scarf around his neck." For Man Ray this was the pose of the turn-of-century "tough guy."

Hemingway left a vivid recollection of the painter at the Dôme. "I went over and sat down at a table with Pascin and two models who were sisters," he wrote. "Pascin was a very good painter and he was drunk; steady, purposefully drunk and making good sense. The two models were young and pretty."

Man Ray was fascinated by the ease with which Pascin filled his studio with models, many of whom turned up for the successful artist's frequent parties. He seemed to believe Pascin's claim that his parents had been brothel keepers, and that he himself had been raised in a brothel. One night after a dinner at Pascin's, the male guests moved on to an establishment on rue de la Gaîté, alongside the Montparnasse cemetery. They began with drinks in the ground-floor bar, and by the time Man Ray went upstairs with one of the girls he was too drunk to do anything but vomit. Pascin confessed that he too had not been able to "do anything."

"Please come with Kiki," Pascin began his 14th of July party invita-tion. "You will see the fireworks in front of the Sacre-Coeur from my window and we will have a little party."[2]

They seemed inseparable, Kiki and her Man. That summer—it could have been shortly before or after Bastille Day—the couple joined a jolly crowd at a Normandy villa on the Channel coast that Peggy Guggenheim and her new husband, Laurence Vail, had rented for the summer. Other guests included Peggy's cousin Harold Loeb, Mina Loy (out of London and Greenwich Village), and Louis Aragon (then the lover of Vail's sister Clotilde). "A hideous old house, with a bath-room in the cellar," Peggy would remember; she also remembered the presence of "Man Ray and his remarkable hand-painted Kiki." "I am here for a few days after two years in Paris," Man Ray explained, almost as if apologizing for his escapade, in a postcard to Gertrude Stein (carefully not mentioning Kiki).

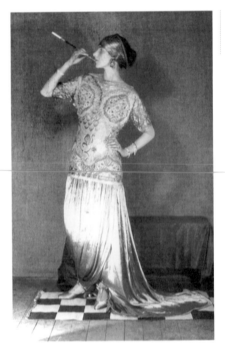

Peggy Guggenheim in a designer dress worn for one of her costume balls

Not all the reports of the couple were good; Kiki was too explosive (and Man Ray certainly too cool) for that. Sometime later, at one of the Sunday evenings the Vails held at their Faubourg Saint-Germain apartment that Peggy called Proustian, Kiki and Man Ray began quarreling. Kiki struck her Man in the face, calling him a dirty Jew. Peggy Vail's mother, Florette Seligman Guggenheim (widow of Peggy's father Benjamin, who went down with the *Titanic* in 1912), happened to be standing by. She was outraged, and quickly told Kiki what she thought of her.

It did seem, in that summer of 1923, as if there might be a total separation. Although Man Ray later insisted that Kiki had never been unfaithful, her best friend, Thérèse Treize as she called herself, later revealed the story of the American journalist whom Kiki found to be both tender and excellent as a lover; suddenly she packed a bag and sailed with him to America. In an attempt to explain Kiki's behavior, her friend recalled a dialogue between Man Ray and Kiki at dinner. "Man, I love you," Kiki declared, to which he replied: "Love, what's that, imbecile? We don't love, we screw." So she would screw another American for a while, first in Paris and then in New York.

Man Ray tells the story somewhat differently in his memoirs. An American couple looking for talent, enchanted by Kiki's personality as well as her singing, thought there might be something for her on the stage or in the movies in the United States. They promised to handle the details.

Whatever the true story of her American adventure, it did not work out. Thérèse had it that Kiki's journalist lover had to return to his home base in St. Louis, leaving Kiki alone in New York, although with enough to live on for a while. But Man Ray remembers her cabling for money for a steamship ticket back to France.

Home in Paris, she proved to be as volcanic as ever. A few days after her return, she showed up at a café where Man Ray sat with friends, waiting for her to join him for dinner. She began by accusing him of having had an affair during her absence, and slapped him. He led her

back to the hotel, where he replied to her persistent accusations by striking her. She threw a bottle of ink at him, broke a window with her fist and leaned out of it to shout, "Murder!" They were asked to find themselves another hotel.

There was no reason, of course, to assume that Man Ray had been more faithful in Paris than she had been in New York, although most of his female contacts that summer seemed to have been platonic, at best good company. One of the new companions was Berenice Abbott. Born in Springfield, Ohio, twenty-five years earlier, she had gone to New York in 1918 to further her goal of becoming a journalist, but soon got caught up in the cradle of talent that Greenwich Village then was. So she changed her goal, studied sculpture, encouraged by Marcel Duchamp (for whom she designed chessmen), and went dancing in the Village with him and Man Ray. She got to Paris—nearly everybody's next step after Greenwich Village—some months before Man Ray did, living poorly, earning a little money modeling for artists (her own sculpture would not have taken her very far).

Now, needing money, "dying of hunger" was the way Man Ray remembered her putting it, she joined him as a lab assistant and occasionally posed for him. Inevitably, and this became important for the history of modern photography, she began to learn something for herself about picture-taking. Once, before a visit to Amsterdam, Man Ray lent her a box camera to see what she could do with it. Later, Peggy Guggenheim remembered, Berenice borrowed some francs to buy her own camera. When she tried portraits she found that sitters would pay for them, and by the time she left Man Ray she too was a professional.

In that narrow street mobbed with talent, one particular artist seemed well hidden from his contemporaries. A fifth-floor walkup in a nondescript house that bore the number 17 bis, rue Campagne-Première was home and studio to an elderly unknown named Eugène Atget. He spent his days recording Parisian street scenes, the unspectacular ones: early-morning markets, pushcarts, humble neighbor-

hoods, perhaps unaware that as his life went on the Paris he had been recording was vanishing. Just steps away in his own studio, Man Ray had gotten to know the old man, occasionally purchasing prints from his collection of thousands of images exposed in the course of a lifetime (Atget would sell one for five francs, the equivalent of an American dollar—and sometimes for much less). Man Ray had tried to get Atget to use a more permanent fixative for his prints, even lent him a faster camera—all to no avail.

Berenice Abbott, who first saw Atget's work in Man Ray's studio, at once understood the importance of the bent old artisan in his patched and worn work clothing. She would buy some prints whenever she could spare the money, and made sure that he put away more prints until she could afford to buy them. She got as many people as she could to do the same. On Atget's death in 1927, and with the assistance of an adventurous New York gallery owner, Julien Levy, she managed to acquire much of the vast stock of prints and plates he had left. Eventually it became a museum's pride.[3]

In Paris, a sign of the times, the time the French called the Crazy Years, was the disappearance of a tired-looking but friendly café-restaurant called Le Caméléon, which occupied a low building at the western corner of rue Campagne-Première and boulevard du Montparnasse. Although the loss of the Caméléon would be mourned by traditionalists (and a new site would be found for it just a block away), it had been an ugly little place, needing a paint job for as long as anyone remembered, and its chairs and tables shook lightly. But the woman who ran it cooked cheap and hearty food, and only a couple of years earlier she had recruited a neighborhood poet to organize evening lectures and chamber music concerts, and comedy performances on Sundays.

That was not enough to keep the place afloat. The lease was taken over by Americans (one of them a self-taught painter, Hilaire Hiler), renovated hastily, and endowed with a counter bar, serviceable tables, and a dime-sized dance floor. Most of the work went into the facade,

decorated by Hiler with boldly naïve images of cowboys and Indians. They would call their place The Jockey (which was the profession of one of the partners).

It was an immediate success, both for the foreign colony and Parisians who enjoyed the company of these foreigners. "We've started off a new little nightclub that looks like it's going to be a bright-light spot," wrote Kiki in her memoirs as if she had just then left the place for a brief night's sleep. ". . . Hiler, the painter, is at the piano; and he's some player. . . . The walls are covered with the weirdest sort of posters you could imagine; and every night, we're just one big family there. Everybody drinks a lot, and everybody's happy. Scads of Americans, and what kids they are!"

Group photographs taken out front at the inaugural include a dapper Man Ray in the front row, for after priming the shutter to give himself time he had rushed to join the others. Among well-wishers captured on film were Ezra Pound ("in his false-bohemian getup," Man Ray remembered), William Bird (founder of his own Paris-American Three Mountains Press), Tristan Tzara, and even Jean Cocteau.

"Every customer can do his thing," Kiki recalled—and she would be living proof of that, although she warned that she could not sing when she was not drunk. In fact she quickly became (in her Man's fond recollection) one of the main attractions, thanks to "her naughty French songs, delivered in an inimitable deadpan manner." She followed the accepted procedure by passing the hat after her act, but then she divided the money among less favored performers.

"She was famous for her apache songs, her unusual makeup, and her acquaintance with practically everyone in Montparnasse," remembered Jimmie the barman. "She was particularly fond of American seamen. I do not suppose that there is a single sailor on the U.S.S.S. *Pittsburgh* who has not toasted Kiki. Once I saw her on the Dôme terrace with thirty sailors and not another girl!"

But that would have been a little later, after Man Ray.[4]

10 *Amusements*

LET NO ONE THINK that Man Ray sat with the idlers. In his Montparnasse group he was one of the busy bees, seizing any pretext to expand his circle—not only to potential sitters for portraits but to editors of illustrated magazines in New York and London that were opening their pages to Paris—to its fashions, of course, but also to its influential or amusing personalities.

Correspondence with Gertrude Stein allows us to see Man Ray at work. He had a manuscript of hers to show to editors, a manuscript that in fact was a brief prose poem dedicated to Man Ray, something he thought might be published together with his own photographs of her. Perhaps it was more Stein than Ray. "Sometime Man Ray sometime," it began. "Sometime Man Ray sometime. Sometime Man Ray sometime. Sometime sometime." To make a long story short, he never found an editor who wanted it, and neither did she.

Some people could not accept the notion that a photographer might demand the kind of money a painter would get. Such was the case of the poet William Carlos Williams when he turned up in January 1924 for his first visit to Paris. The connection between portraitist and sitter was made by the ubiquitous Robert McAlmon, everybody's American in Paris, who considered it his duty to see that

Williams meet everybody who counted. McAlmon threw a party for him at smart Les Trianons, reputed for its fine food; it was in Montparnasse, directly opposite the railway station in fact, but not of it (not in its prices, or style, or clientele). Williams was placed opposite James Joyce. Among the other guests Williams found a few old acquaintances—Marcel Duchamp, Mina Loy, and Man Ray. He met bookseller Sylvia Beach, Paris-American publisher William Bird, and Louis Aragon, the Frenchman most likely to turn up at an Anglo-American party.

Williams remembered that it was Man Ray who suggested that he sit for a portrait. So McAlmon took him around to rue Campagne-Première. Williams noticed a young woman who remained "curiously" at the rear of the small studio—someone the visitor would always regret not getting to know. (It was Berenice Abbott.) "She gave only one look, but it was a fine head, an impressive face, and the look was penetrating."

When Man Ray sat him down Williams's eyes were wide open; Man Ray asked him to close them a little. "I opened them, though, later when I got his bill," Williams wrote in his memoirs. He would compare the charge for the six prints to a week's stay with his wife at the Hôtel Lutetia; that good hotel had cost less than the photographer. Worse, he hated the portraits, feeling that they made him seem soft and sentimental, when all the people he was seeing in Paris were the hard sort. A bad experience all around.[1]

France was already famous for the readiness of wealth and rank to welcome Bohemia to its public manifestations. Now, in the 1920s, it was the turn of Montparnasse to be feted by high society, which made for some weird combinations. Much of this willed promiscuity was the doing of an uninhibited patron of the arts, Count Étienne de Beaumont. In 1924 he and his countess gave the most memorable of their costume balls, held in their town house conveniently located on rue Duroc, literally at the Montparnasse boundary line. The event

was a splendid opportunity for a photographer, particularly if he had an inside track. It was truly a command performance. The shortish photographer remembered how the "tall aristocrat" put a room at his disposal to set up his equipment so that he could photograph the costumed dancers as they arrived. Earlier the count had advised Man Ray to wear a dinner suit or tails so as to fit in with the guests, and requested that he not solicit clients that evening. Man Ray later regretted that he had followed the request literally, thereby letting a number of potential sitters get away.

One of the guests was Tristan Tzara, who might have been considered an odd choice, had it not been known that the Beaumonts had already sponsored one of Tzara's plays. Another was Nancy Cunard,

Playgirl, writer, and publisher Nancy Cunard with Tristan Tzara at a costume ball whose official photographer happened to be Man Ray

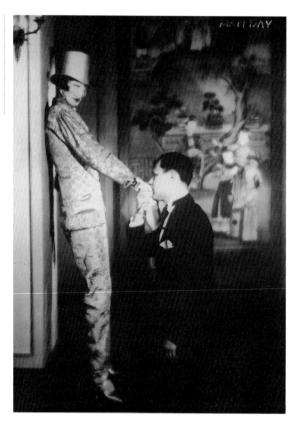

daughter of the heir to the British steamship dynasty and an American mother. Nancy had married at twenty but separated from her soldier husband soon afterward. Now she was free, and Paris, its art and its artists, became possible. Now a splendidly ripe twenty-eight, Nancy was the belle of every ball, displaying a slim figure that caused gasps. Seeing a picture at once, Man Ray put her together with Tristan Tzara. Masked, she stands tall, made even taller by her gilt top hat, as a kneeling Tzara in evening dress kisses her hand.

Before the evening was over, Man Ray stumbled upon another unforgettable image: Pablo Picasso as a toreador.

As time went on, his roster of upper-class clients lengthened. It helped that he was a frequent guest of the Viscount Charles de

Picasso (center) dressed as a toreador at a costume ball

Noailles and his viscountess, Marie Laure, who happened to be nostalgic for Dada.[2]

That these were command performances, however amusing, was evident. What was fun often still involved Marcel Duchamp.

To illustrate: *Entr'acte.* A brief (twenty-two minute) film with a cast brimming with talent—a young René Clair at the dawn of his career as a film director, Francis Picabia for the scenario, with music by Erik Satie. A film conceived (as its title indicates) to be shown during an intermission, separating two acts of a Dadaist ballet called *Relâche* (also by Picabia and Satie). The production was put together at the Hotel Istria on rue Campagne-Première (Picabia, Satie, and the others taking rooms there for the final weeks of filming).

The brief film consisted of walk-on parts. Perhaps the best remembered, because most often reproduced in still photographs, is a sequence starring Man Ray, neatly costumed and with his hair carefully combed, and Marcel Duchamp, whose own hair has been ruffled by the wind. They are playing chess on the edge of the roof of the Théâtre des Champs-Elysées.

Man Ray and his favorite chess partner, Marcel Duchamp, on a theater roof (from René Clair's *Entr'acte)*

And then, to celebrate the New Year, Picabia mounted a special event, which has come down to us in the form of a single Man Ray photograph. Marcel Duchamp appears stark naked (albeit with a vine leaf), playing Adam to an equally undraped young Eve played by a comely Swedish model, Bronia Perlmutter. Duchamp remembered that during the performance René Clair was perched in the rafters, keeping the spotlight on the couple. Then and there, Clair fell in love. René and Bronia married soon after that, and it was not a Hollywood marriage—for they stayed wed.[3]

Meanwhile Montparnasse was changing—at least for transients and the expatriate community. Thanks to its novelty and its good-naturedly rowdy atmosphere, the Jockey had skimmed off some of the clientele of traditional cafés like the Dôme, but it was not the only new distraction. Many of the Quarter's Anglo-Americans preferred more intimate drinking places off the main boulevards, places reminding them of bars and pubs they had left behind, and no matter that the streets were too narrow to allow for sitting outdoors. These denizens eschewed the sun, and who knew what adventure might begin in a dim interior?

One of the dim bars was the Dingo—Le Dingo (The Madman) as it was christened by the Frenchman who took over a seedy working-class bistro at 10, rue Delambre—across the street from Man Ray's first home in the Quarter—and converted it into an English-style bar in 1923. By the time gregarious Jimmie Charters took his place behind the bar a year later, it was one of the street's busiest. He had worked on the Right Bank until then, but after visiting the cafés and bars of Montparnasse, not excluding The Jockey, he knew that the Quarter was his Quarter.

Charters learned to distinguish between the kinds of people who went to the Dingo. Soon after noon he would see not only the sleepy ones, still suffering from their hangovers, but also a more earnest group talking seriously about art. Sylvia Beach of Shakespeare &

Company once told him, "We have always served the same clients, you with drinks, I with books."

By five in the afternoon the Dingo was bustling with interesting women, amorous couples (mixed and same-sex), and still the "over-serious young men expounding theories." A lull at dinner hour, and then another mob scene, but now came the fighting, the sobbing confidences—both by-products of alcohol. Charters guessed that some seventy percent of his customers were American, twenty percent were English, and the rest might have come from anywhere.

To hear Philippe Soupault tell it, for this Frenchman mixed easily with the foreign colony, not all of his American drinking companions had money to burn. "They were anxious. They didn't know how they would be able to make a living. And yet people thought they were rich because American. . . . They spent their time in the Montparnasse cafés, which were shelters for them, hoping to meet friends who could help out. They were right to do so, since the sons of billionaires often chose, as they left the Ritz hotel, to end their evenings in the Montparnasse cafés."

Undoubtedly Soupault knew what he was talking about. "We generally spent every night in cafés in Montparnasse," Peggy Guggenheim remembered of her Paris years with Laurence Vail. "If I were to add up the hours I have whiled away at the Café du Dôme, La Coupole, the Select, the Dingo and the Deux Magots [in the Saint-German quarter] and the [Right-Bank] Boeuf sur le Toit, I am sure it would amount to years."

There would be more of such places, often owned or inspired by the same Jimmie. One was the late-late-night Parnasse, just across from the Dingo; later there would be La Jungle, "a noisy madhouse," located right on boulevard du Montparnasse, its clientele less intellectual than The Jockey's. Or Falstaff, a welcoming wood-paneled pub on rue du Montparnasse.

Irritated by the general feeling back home that the Americans of Paris were dissolute idlers, Robert McAlmon and like-minded

companions sat themselves down one evening—appropriately in a Montparnasse café that might have been the scene of such debauchery—to compile a roster of artists and writers, permanent or long-time residents (most of them American), who were among the most talented creators of their time. Of course one of their best examples was Man Ray.[4]

The group least likely to be seen in cafés and bars, *especially* in a group, was the former Dada band, now on the way to reshaping its destiny. A singular opportunity, that would give them a meeting place far from the madding crowd, was about to open up. Credit a young member of a family of hoteliers, Marcel Duhamel, who with two inseparable comrades, the poet-to-be Jacques Prevert and the painter-to-be Yves Tanguy (and their respective companions), moved into a splendid ruin at number 54, rue du Château. It was a curiously elegant-sounding address for what was then a narrow street of disparate edifices behind the old Montparnasse station, and the derelict house they had chosen as their future residence did not appear more promising. Important, for André Breton and his friends, was that there was a café cum wood-and-coal merchant just across the street (for the times when a café meeting room was really needed).

The street floor of the old house had been occupied by a dealer in rabbit skins, while the floor above had been a humble dwelling. It seemed a wonderful adventure to youngsters with the energy to cope with it *(and* with sufficient funds, which would be Duhamel's concern). The ground-floor space was large enough to become a salon for its inhabitants and guests as well. Artist Tanguy took charge of the interior decoration (consisting largely of movie posters showing gangsters and their molls, and shop signs snatched during nightly prowls). In less than no time, which means by the time the comrades began to invite in new acquaintances—including members of the Breton band such as Benjamin Péret and Robert Desnos—they had invented a recreation center for excessively cerebral artists and

writers. A center that would be ready to receive the new Surrealists when the old guard Surrealists were ready with their fun and games.

Another moment of city traveling produced an unexpected result for Tanguy. Riding on a bus, Tanguy noticed a curious painting in the window of a gallery along the way and decided that painting—and that particular kind of painting—was what he wanted to do. He was then twenty-three years old. He returned to the gallery on foot (it was run by Paul Guillaume, best known for his collections of African sculpture and the works of Picasso) to discover that the work that had caught his eye was signed "Giorgio De Chirico."

Legend? Sometime later he would learn that André Breton had had the same experience—seeing a De Chirico at the Paul Guillaume gallery through a bus window. It did not make a painter of Breton, but it helped him decide that painting might have a place in his system.[5]

11 *The Surrealist Revolution*

AS A MOVEMENT, SURREALISM assumed concrete form only in October 1924, which suggests a surprisingly long period of gestation after the demise (or the neutralization) of the chaotic Dada group. That many of the same young people moved from one school to the other should not surprise. The young were a little older now.

As if to underscore their serious intent, the founders began by inaugurating what they called, somewhat solemnly, a Bureau de Recherches Surréalistes. It really was an office, occupying a ground-floor room in an eighteenth-century landmark town house made available to it by the indulgent father of one of its members. The address, 15, rue de Grenelle, placed it in the shadow of Saint-Germain-des-Prés church, therefore out of the jurisdiction of Montparnasse and its distractions.

Soon there would be an official group photograph—made by Man Ray, of course, although this time he was not in the picture at all. It included all the familiar faces (those of founders Breton, Aragon, Eluard, and Soupault), and some less familiar, such as Giorgio De Chirico, Robert Desnos, Raymond Queneau, and Roger Vitrac; the women were Simone Breton and Marie-Louise Soupault. The young Surrealists wore suits, white shirts, and ties; only the wall decorations,

which included a suspended plaster sculpture of a headless nude and suitably modern works by the likes of De Chirico and Robert Desnos, indicated that this was not a birthday party in the back office of a bank.

Strange as it may seem, the members of the new movement actually expected visitors to show up at rue de Grenelle prepared to describe experiences of the unconscious or subconscious, for the Bureau invited such confessions in announcements sent to the press. More usefully, the office gave the Surrealists a tangible presence, and potential recruits could find them. And to hear a Breton biographer tell it, it allowed society ladies to satisfy their curiosity in a totally proper environment—and perhaps also to test their powers of seduction.

What the new movement lacked most was content. As if aware of this failure, Surrealism's chief began to sketch out a preface for a collection of short poems in prose resulting from his experiments of automatic writing; the compilation was to be given a thoroughly Surrealistic title, *Poisson soluble.* Soon Breton realized that his preface could be both a guide to and a justification of the movement; it could be a manifesto. And it was—the first *Manifeste du Surréalisme.*

The Surrealists at their new (1924) headquarters, the Bureau de Recherches Surréalistes. Back row from left: François Baron, Raymond Queneau, André Breton, Jacques Boiffard, Giorgio De Chirico, Roger Vitrac, Paul Eluard, Philippe Soupault, Robert Desnos, Louis Aragon. Front row: Pierre Naville, Simone Breton, Max Morise, Marie-Louise Soupault.

The exercise also gave Breton an opportunity to shift the movement's founding date back to 1919, when he and Philippe Soupault decided to scribble down whatever came to mind—a collaborative effort at automatic writing they subsequently published as *Les Champs magnétiques*. The experiment was inspired by Freud, utilized by Breton himself on shell-shocked soldiers during the war. He would now draw out of himself what he had gotten from his soldier patients, "a monologue uttered at the fastest possible speed." He and Soupault agreed to give the name Surrealism to this "new type of pure expression," in homage to Apollinaire, who had used the word in 1918 without charging it with the same importance (he had called his *Mamelles de Tirésias* a "surrealist drama").

In the new Surrealism, the essential was to express thought by surrendering oneself to a "purely psychic automatism," and this in the "absence of the slighest control exercised by reason." Modestly, Breton disclaimed any pretense at talent on the part of the Surrealists; they only served a cause.[1]

Breton's *Manifeste,* and the poems that illustrated it, was available from the publisher by the middle of October 1924, but it obviously took time for common readers to learn of its existence and for the literary establishment to digest it. Before either of these things could happen, the new movement came to public attention in a more direct manner.

The occasion was the death, on October 13, of Anatole France, a moralist, a Dreyfusard who had stood by Émile Zola in his crusade against the government's cover-up, an affirmed anticlerical who looked with sympathy at nascent Socialist and Communist movements. Clearly France was the contrary of an establishment writer, or of an academic conservative (despite his co-option by the Académie Française and his Nobel prize).

"With [Anatole] France," wrote Breton in his contribution to a tract published by his group to counter the tributes the deceased author was getting from everyone else, "a portion of human abjectness has disappeared. Let us celebrate on the day they bury the

tricky, the traditionalism, the patriotism, the opportunism, the skepticism, the realism, and the lack of humane feelings." He refused to forgive Anatole France "for having draped his smiling inertia with the colors of the Revolution." In his own provocative text for the tract, which he titled "Have you ever slapped a dead person?" Louis Aragon declaimed, among other things, "I consider all admirers of Anatole France as debased."

The designer-collector Jacques Doucet, patron of both Breton and Aragon, for they continued to earn their living by keeping him ahead of his time on contemporary art and literature—summoned his young advisers to a meeting, lectured them on their ill-advised, truly odious sacrilege—and fired them.

Sometimes the new Surrealists could make enemies without actually having to provoke them. Francis Picabia, whom someone called the anti-Dada Dada, continued to snipe at these ardent young fellows who (like himself) assumed that only their road led to Rome. His weapon was the unperiodical periodical called *391*, which was (as it had always been) more of a record of Picabia's moods than an objective report on happenings in art and literature. That Picabia's arrows carried no sting is suggested by the evidence that his magazine managed to gather in such talents as Man Ray and Marcel Duchamp, even Robert Desnos, all of whom would remain *persona grata* to the Breton circle, and this without ruffling the sensitivities of members of that circle.

It was Picabia's task, a difficult one, to demonstrate at the same time that Surrealism was a fraud—and that he was its inventor.[2]

In the end the Breton brand of Surrealism would win, of course; history knows no other kind. One can credit Breton's intransigence for that, for it could transform a literary quarrel into a *casus belli*. Breton's powers of indignation, his thirst for revenge, were prodigious. Thus the writer Raymond Queneau confided to a fellow Surrealist, Maxime Alexandre, that when Breton separated from his first wife, Simone, he berated Queneau for deficient loyalty because Queneau did not also

leave his own wife—who happened to be Simone's sister.

What André Breton had going for him was his persistence, one is sorely tempted to say doggedness, founded on the conviction that he was in the right. An obvious example of this singleness of purpose is the history of the movement's magazines that began in 1924, with the launching of the review *La Révolution Surréaliste.* This was followed in their time by magazines bearing other titles, depending on the circumstances, but no less under his control or influence.

Flipping through old copies of *La Révolution Surréaliste,* the first issue of which was dated December 1, 1924, one may be surprised to discover that André Breton is not its publisher or chief editor, but only one of a score of contributors. The magazine's graphic works are signed by familiar names—Picasso, Max Ernst, Giorgio De Chirico, and André Masson, but also by members of the Breton band better known as writers and poets. Despite his recent contributions to Picabia's anti-Breton magazine, Man Ray was listed as the magazine's photographer.

The oddest illustration in the magazine was a montage—twenty-eight diminutive portraits of members of the Breton band, Man Ray among them, to which some of their icons had been added (one was Sigmund Freud). The small images surrounded a larger photograph of a plain-faced woman, her eyes fixed in a determined expression. There was no caption to identify the men or this woman. But a reader of the daily papers would know that she was the twenty-year-old anarchist Germaine Berton, who a year earlier had shot and killed the head of the Camelots du Roi, the shock troopers of the antirepublican, anti-Semitic Action Française movement. Her murder trial in Paris was quickly transformed into the trial of Action Française, whose militants had created the climate of "hate and violence" responsible both for the assassination of Socialist leader Jean Jaurès in 1914 and for Germaine Berton's vengeful act.

She was acquitted (the jury had been reminded that the right-wing assassin of Jean Jaurès had also been acquitted) and soon received a

basket of red roses from the Breton band, accompanied by a note: "To Germaine Berton, who did what we didn't know how to do." The page devoted to her in *La Révolution Surréaliste* included a line from Baudelaire: "Woman is the being who projects the largest shadow or the brightest light in our dreams."

Dreams were indeed their raison d'être. "There is no longer a need to show the limits of knowledge, intelligence no longer counts, only dreams lead men down the path to freedom," so the editors—Eluard among them—introduced the first issue. "Surrealism points the way to dreams to those whom the night doesn't favor."

All the same, Breton never quite trusted Eluard's commitment to the basic Surréalist premise that art arose from the unconscious. Eluard, he later told an interviewer with regret, believed that composing a poem was a voluntary, even a deliberate, act, a concept that Breton condemned as "ultra-reactionary and in formal contradiction with the Surrealist spirit."

With all due respect to Breton, one can say that a number of his friends, and a considerable proportion of those whom he set up as idols, would have taken Eluard's side had there been a doctrinal split at the time. Worse, if we heed the judgment of scholars, some of the idols, including Man Ray and Marcel Duchamp, never quite renounced their earlier commitment to Dada.[3]

12 *Friends and Acquaintances*

TO A VETERAN CAFÉ-GOER who had emptied many a bottle with
the likes of Apollinaire and Modigliani, and who had watched Picasso
grow up and out of the neighborhood, there could be little that was
new in the Montparnasse of 1925. So why did Ilya Ehrenburg return to
the Rotonde and the Dôme each day, where he would find the same
old friends (Fernand Léger, for example, and Ossip Zadkine, Jacques
Lipchitz)? Their talk centered on art, of course, but could not ignore
a Russian revolution that concerned more than one of them person-
ally. They spoke with wonder of the ascendance of their little friend
Picasso and of Charles Chaplin, the universal hero. He and his friends
were hardly old men, Ehrenburg reflected. The oldest of his circle,
Léger, had just turned forty-four. But they were already jaded.

Younger people now filled the surrounding tables and the cafés were
as crowded as ever, with visitors from Sweden, from Brazil, and from
everywhere in between. Art had penetrated the fashion houses and lux-
ury shops of Paris, for better or for worse; the dealers were engaged in an
insatiable quest for the next Modigliani. Tourists in their buses were dis-
covering a nighttime Montparnasse. "At the Cigale [a *cafe-dancing* on
rue Bréa], at the Jockey, they danced till the small hours, and the lovely
Kiki, with eyes like an owl, sang bawdy songs in a mournful voice."

In 1925 a publisher who knew popular taste could launch a book bearing the title *Montparnasse* and expect a good and rapid sale. "Montparnasse is the center of the world!" the authors gushed. "In the 1200 or so yards of boulevard that separate the Montparnasse railway station from the intersection of the avenue de l'Observatoire and boulevards Port-Royal and Saint-Michel, you meet people from every country in which the arts seek to express new forms of life." And not only Europeans, but "the genuine Lapp poet; the Indian chief with his high feathers and Far West outfit. . . ."

The Yankees were having a positive influence on the neighborhood, the authors admitted. Housing had become more comfortable, with better plumbing, and cheap restaurants could be found that were both clean and attractive. The intellectual and artistic presence protected Montparnasse from the lower standards prevalent in Montmartre. "There was a Left Bank spirit clearly in opposition to that of the Right Bank. To speak frankly, the existence of a powerful foreign colony in Montparnasse, the respect that it showed for the highest manifestations of French art and thought, contributed to fortify the antagonism."

Alas, the current favorable exchange rate had seen the American colony grow in quantity. Street vendors noisily hawked the Yankee press outside the Dôme; a Frenchman might wonder where he was. This was the year the boulevard gave birth to a third café, Le Select, the first to stay open all night, although, strange paradox, the owners enforced stricter than usual rules of behavior. Le Select quickly became a favorite of Hemingway and other American writers.

Hemingway now lived at 113, rue Notre-Dame-des-Champs, on the last stretch before the Closerie des Lilas, snugly within the frontiers of Montparnasse. Now he had Ezra Pound as a neighbor. Hemingway remembered that Pound's studio "was as poor as Gertrude Stein's studio was rich," but in truth it contained ample light and sufficient space for the Pound couple and their collected art.

That Hemingway was also a regular at the nearby Dingo bar is

suggested by the fact that his first encounter with F. Scott Fitzgerald, something of an event in the literary history of the Lost Generation, took place at the Dingo when Fitzgerald wandered in and guessed that it was Hemingway he saw sitting at the counter. The two writers would soon meet and drink again—this time at the Closerie des Lilas. These meetings would mean the beginning of a seesaw relationship, a series of cockfights between mean-and-lean Hemingway and an insecure Fitzgerald that became a footnote in the history of the Lost Generation.

In that same year another and a considerably brighter light began to emanate from the Quarter—actually from the little hotel on rue Campagne-Première. The impresario of the Picabia-Satie *Relâche*, on the advice of Fernand Léger, booked another spectacle into the Théâtre des Champs-Elysées, a black American theatrical troupe called La Revue Nègre. On the arrival of the company in Paris in January, the cast took over the rooms that the *Relâche* production had abandoned at the Hôtel Istria, and went from there to capture all of Paris.

The secret to their success was of course Josephine Baker, a very mature eighteen, also a fearless performer who "made her entry entirely nude except for a pink flamingo feather between her limbs," as an equally young *New Yorker* correspondent saw her on opening night. The news traveled out of the theater fast that evening.

Not all the Americans who came to Montparnasse that year were charismatic, or boisterous, or seemed newsworthy at the time, but that did not necessarily mean they were less significant. Shortly before his twenty-eighth birthday, a still unknown William Faulkner, a future Nobel Prize laureate for literature, crossed the Atlantic on a freighter with a hometown friend, William Spratling. They found a room in Montparnasse. The fledgling author, whose first novel, *Soldier's Pay*, would see publication only the following winter, was still a nobody, and a shy nobody at that.

Indeed. One of his biographers, in a book whose 1,846 pages filled two volumes, had room for some comments about Faulkner and his

friend. "They visited Shakespeare and Company, but never saw Sylvia Beach, the proprietor of the well-known bookstore. They did not see Ernest Hemingway, who frequented it, or another American celebrity of Paris, Gertrude Stein. Once they saw Ezra Pound, Spratling thought. . . ." At last, in a café near Place de l'Odéon, they were sure that they had come upon James Joyce. Long years later Faulkner reminisced: "I knew of Joyce, and I would go to some effort to go to the café that he inhabited to look at him. But that was then the only literary man that I remember seeing in Europe in those days."

It was a refreshing reminder that not everyone got a center table at the Dôme or La Rotonde, or even knew that they existed. And also that one might turn out to be a better writer than most of those who did.[1]

So Man Ray missed William Faulkner. But he seems to have met almost everybody else who passed through Paris, from the elegant lyric poet Edna St. Vincent Millay to the young cutup Malcolm Cowley, the best painters and sculptors of his time, and the great musicians of the future. American friends living in Britain regularly sent well-known personalities to his studio, among them Virginia Woolf, Aldous Huxley, Havelock Ellis, and T. S. Eliot.

That he often worked for the fee, or felt the need to be the portraitist of the rich and famous, was demonstrated only later, when in publishing a selection of his celebrity portraits at the beginning of the 1960s, he let it be known that not all of his clients had pleased him. "Interests me just as little as I interest him," he grunted, in summing up his experience with the Anglo-American poet then at the summit of his reputation, T. S. Eliot.

"When portraying the personalities in this collection," so Man Ray explained in the prefatory note, "the photographer was solely interested in his models' faces, without taking into account their station in life, their degree of fame, or the greater or smaller amount of liking they might inspire in him personally."

It was when he got to know some of his subjects better, he said,

that his feelings toward them "crystallized." To express his feelings about them he would have recourse to the little game that had been popular among Breton and his friends. Thus he gave a 20 when "fully attuned to" the personality of his sitter, and when he felt an "unqualified interest" in the portrait.

Some of his judgments will surprise. The astonishing double exposure of Marchesa Casati, showing three pairs of eyes, gets a low grade of 2: "A failure as a portrait," he comments, "taken under very bad conditions, but greatly liked by the sitter." But a plain portrait of Cocteau—whose only originality is in Cocteau's gesture (he holds up an empty frame through which he stares vapidly at the camera) rates a 12. "Sparkling dragonfly," notes Man Ray.

His dreamy portrait of a reclining Dora Maar, Picasso's most interesting mistress, receives a more than satisfactory 14, with the

Jean Cocteau, an early and amused benefactor of Man Ray during the photographer's first years in Paris

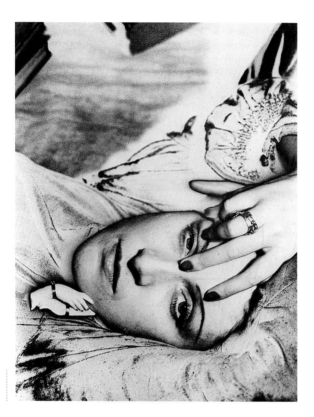

Picasso's friend
Dora Maar, an artist
in her own right

ambigious annotation: "When she met Picasso and he traded me one of his works for this portrait, she abandoned photography and took up painting."

A striking shot of wide-eyed Nancy Cunard, heavily braceleted, is given a 10 and the explanation that the purpose of the picture was to display her collection of African ivories. Soviet filmmaker Sergei Eisenstein, on an extended tour of the West as his reward for making good movies under severe censorship, curiously rated only a 6.

After the photographer's dismissal of T. S. Eliot quoted earlier, and certainly motivated in part by the poet's legendary stuffiness, picture and sitter received the low grade of 3. Another visitor from Britain, Aldous Huxley, got a somewhat kinder 10 out of 20. But a bare 6 for Joyce? "A course in English literature may be of some help in appreci-

ating him," was Man Ray's comment, as if he had been put off by their unsatisfactory conversations.

Man Ray's best ratings were obviously reserved for the inner circle. The highest given to any male, a 19, was reserved for Marcel Duchamp: "My oldest friend, since 1915. Devotes most of his time to chess and, always with benevolence, to the arts." In the next echelon of friendships, Tristan Tzara, Erik Satie, Max Ernst, and (less expectedly) André Breton each drew an 18, each with a reason. Tzara in part for a personal reason: "Founder of the Dada movement. Defender of my Rayographic creations." Max Ernst "built a bridge between poetry and painting." As for Breton, he "was the first to introduce Surrealism into the visual arts."

In this gallery of celebrity portraits, Picasso is represented with

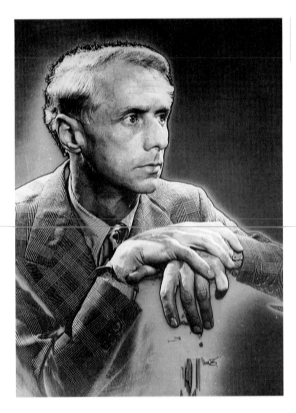

A formal portrait of Max Ernst, whom Man Ray called the "bird-man"

not one but three photographs, and yet received only a 17; Brancusi and Yves Tanguy each rated 16. One point less for Paul Eluard, another close friend ("I illustrated his poems with my photos, he illustrated my works with his poems.") Note that Nusch, Eluard's wife, also a favorite model of Picasso, was awarded a 15, like her husband. Her portrait by Man Ray reveals a beauty, but he felt it necessary to add: "No photo can reproduce the charm and sweetness of this woman."

The "15" category was not reserved exclusively for the Eluards; the Surrealist artist and model Meret Oppenheim received the same, with a bow to her fur-lined cup, saucer, and spoon. André Derain got a 14, Braque and Miró each a 12; both Matisse and Gertrude Stein were judged 10. Fernand Léger and Pascin had to make do with 6's—the former because "his work is so heavy it seems carved out of solid matter." As for Pascin, the only comment is a curious one: "For him, women are little girls and little girls are women."

Perhaps they were not celebrities, but the women in his life count here. "Kiki of Montparnasse" is represented as a shy nude, once "an intimate part of my life." She was worth a 15, and so was the elegant Lee Miller who followed closely on her heels, as shall be seen. Here he calls her an ex-photographer, and describes her as "one of my favorite pupils."[2]

As for Marcel Duchamp, the best friend, the chronologies of his life that have been published tell us precious little about what he was doing in 1925—apparently because there was little to tell. Both of his parents died early that year, only a week apart, and of course he was in Rouen for their funerals. Then came a chess tournament. If one believes the short version, the rest of his time was spent perfecting an infallible process for winning at roulette. In fact he continued to work on his own inventions—at that moment a Rotary Demisphere, a precision optical machine designed to intrigue (thanks to an electric motor driving a circular plaque, making the circles drawn on it seem to move forward and backward). The machine had been commis-

sioned by the art patron Jacques Doucet, obviously to keep Duchamp in funds. It was something he could build in company—the company often being Man Ray.

Duchamp was no less discreet about his private life, perhaps because he tried so hard to keep his true love secret; indeed, she was a victim of his paradoxical behavior. Mary Reynolds, an American war widow, was quite respectable, readily accessible, and yet the person Duchamp most wanted to keep in the shadows. One might know him as profligate, might catch a glimpse of one of his less avowable relationships, but to her chagrin, Mrs. Reynolds remained Mrs. Right yet relegated to oblivion. Later, for an interviewer, Duchamp summed it: "I had my hotel room, it was a true liaison lasting many, many years, very agreeable; but we weren't a couple in the sense of 'married.'" He may not have asked himself, or asked her, whether she liked it that way.

Perhaps she did not. That gadfly Robert McAlmon, who remembered hearing that Mary Reynolds was the world's most charming woman, added: "too charming, and that is dangerous when accompanied by a striking head set magnificently on a fine neck above as fine a pair of shoulders and as beautiful a back as Aphrodite." So she drank, drank with the high and the low, "and generally she paid the bills of them all." Sometimes her drinking partner would be Man Ray, who well knew that Mary worshiped Marcel—who was determined to live alone. But when she went out on the town it was with Man Ray and not with Marcel: "she to fill in the times when she could not be with Duchamp, I for social and more practical reasons—for contacts."

In one of his periodic flings with creation, Duchamp attacked the film art, but in his own way—with a seven-minute film that would never draw a paying audience. Under the circumstances its title, *Anemic Cinema*, seemed appropriate. Duchamp designed the content: a series of comic phrases, puns signed by Duchamp's alter ego Rrose Sélavy pasted on round disks that revolved on a phonograph, with alternate shots of spirals spinning to a syncopated rhythm—a variation on his "rotary demisphere" experiment, only more so.

This time he had some professional help. The camera crew con-
sisted of Man Ray and twenty-five-year-old Marc Allégret. Allégret
was at the debut of his own career as a cameraman and director; he
would become better known for another apprenticeship film made
on a journey through West Africa with André Gide, *Voyage au Congo*.
And of course *Anemic Cinema* was made right next door to
Duchamp's hotel hideout, in Man Ray's tiny studio.[3]

13 *A Place for Painters*

SURREALIST AMUSEMENTS WERE SERIOUS—but even when they were not, they often opened a door to serious consequences. The very first "survey" undertaken by the Surrealist's research office, announced in issue number one of *La Révolution Surréaliste,* explored attitudes toward suicide. "It seems that one kills oneself as if in a dream," the introduction began, before posing the question bluntly: "Is suicide a solution?" Questionnaires went out to an imposing list of personalities, including many unlikely to be sympathetic to their movement. "The question you ask is wretched," snapped poet Francis Jammes, Catholic and traditionalist, a generation older than most of the Surrealists, to whom he addressed a warning: ". . . If ever a poor child kills himself because of it, you'll be the murderer!" Jammes's response was printed on the first of eight pages of replies to the questionnaire (but he was called a clown).

In fact, as a scholar later observed, there were no more suicides among Surrealists than in any other group observed over a period of time. Indeed, only the impressionable, hypersensitive, explosive René Crevel replied affirmatively to the questionnaire, as if a forewarning of how he would cut short his existence. Yes, suicide *was* a solution, a means of selection, said this poet whose father before him had taken his own life.

In another of their provocations, the Breton band took on Paul Claudel, eminent Christian layman who was at once a prolific poet and playwright as well as France's ambassador to Japan. Claudel had attacked Dada and Surrealism as "pederastic." In an open letter dated the first of July 1925, the Surrealists went out after the "ambassador" in Ambassador Claudel: "We wish with all our might that revolutions, wars, and colonial insurrections succeed in annihilating this Western civilization whose vermin you have been defending in the Orient."

The letter was distributed at a banquet given at La Closerie des Lilas in honor of the Symbolist poet Saint-Pol Roux, and apparently the Surrealists participated out of genuine respect for the poet. Yet Breton later admitted that the anti-Claudel tract contributed to the tension between new and old guard at the banquet. In the eyes of the Surrealists, the real provocation was the presence among the guests of self-righteous patriots, anathema to the young provocateurs. One of the banquet's principal organizers was the venerable author Rachilde, who had recently declared that no decent Frenchman could marry a German. Now Max Ernst called out to her: "Madame, I'm a German, so please get out!"

Soon the agitation became aggression. Breton and his friends, climbing onto tables already garnished with a first course, harangued the startled guests. The scholarly Michel Leiris, a recent recruit to the band, cried "Down with France!" and "Long live Germany!" through an open window above the street, evoking hostility from a growing crowd below. The press coverage was equally negative. For their part, Breton and his most fervent followers were ready to carry their break with society one step further. That meant joining the Communist Party.

This last decision confirmed Man Ray in his determination to stand apart from Surrealist politics (it also alienated Picasso, at least for now, and Marcel Duchamp). Certainly for an American in Paris, meddling in France's internal affairs was out of bounds. But it was also true that politics of any kind bored Man Ray. "I considered my ideas and work as important as that of any of the world-shakers," he

was to recollect in tranquillity. Nevertheless he would meet with his
writer friends almost daily as they planned new activities and publi-
cations. "A good portion of these were politically slanted," he remem-
bered, "but, tactfully, I was not required to sign the pronunciamentos,
being a foreigner and liable to expulsion."[1]

Recalling those agitated years in a period of enforced idleness during
wartime exile, André Breton revealed that in 1925, sometime after
publication of his Surrealist manifesto, he and his friends were still
asking each other whether painting could qualify as Surrealist. Those
who pleaded for its acceptance pointed to De Chirico's dreamscapes,
"the acceptance of chance" in Duchamp's work, the quasi-automa-
tism of Paul Klee, and not to forget Man Ray's rayographs.

Actually Breton was well qualified to assess developments in the
art of his contemporaries, for he was buying and selling it. Although
they constantly censured each other for compromising with capitalis-
tic society, as when they worked in theater or wrote for newspapers,
Surrealists also had to eat. The irony (for Philippe Soupault) was that
the Savonorola of Surrealism, André Breton, was quick to criticize
those like Desnos who wrote for the dailies, or Crevel who wrote nov-
els, or Soupault who, by his own account, churned out newspaper sto-
ries day and night to earn his bread, while Breton himself—like
Eluard—putting his taste to work, dealt in art as merchandise.

Now, beginning in July 1925, Breton undertook a study of
Surrealism and painting, published in installments in *La Révolution
Surréaliste*. Here he argued that the best visual art, like literature,
derived from the mind rather than perceived nature. Today's reader,
not necessarily nourished at the breast of Surrealism, may well feel that
it called for considerable arrogance on the part of an André Breton to
concede a place to painters in the Surrealist heaven, as if poets had a
prior claim to dream life. To qualify for their place, painters would
have to refrain from imitating reality. He praised Picasso as an artist
who had practiced Surrealism before its doctrine was formulated.

Man Ray was a more paradoxical specimen, for he was admired not for painting but for photography. Yet this artist had done something new with what had been considered until then an instrument for recording reality, "on one hand, mapping out the precise limits of what photography can accomplish, on the other putting it to work for other purposes than those for which it appeared to have been created, notably to pursue his personal exploration of a region that painting seemed to have reserved for itself."

Surely Picasso, who was working brilliantly when André Breton was only a schoolboy, had no need of Breton's consecration. Nor could it have done much for Man Ray, whose public was already universal, while Breton's readers could still be measured in the hundreds (at best in thousands). But who shies away from praise? Picasso's most punctilious biographer, his longtime friend and collaborator Pierre Daix, reveals that although Picasso needed no endorsement from the young Surrealists, he was not displeased to be acknowledged as their mentor.

That autumn, in any case, Picasso was a conspicuous presence in the first-ever group show of Surrealist painting, at the small Galerie Pierre between Saint-Germain-des-Prés and the Seine. Indeed, the very fact of his participation in a collective exhibition was unprecedented, even if the works shown were borrowings from private collections. In addition to the Picassos, the show included works by Hans Arp, De Chirico, Max Ernst, Paul Klee, André Masson, Joan Miró, and Man Ray who, in a sense, had been the bridge between Picasso and his Surrealist juniors long before this momentous night.[2]

In a matter of months a dedicated showroom, the Galerie Surréaliste, was ready to startle Paris at Number 16 of tiny rue Jacques Callot, also in the shadow of Saint-Germain-des-Prés. Its enterprising young director, Roland Tual, had become an enthusiast of Surrealism without actually writing or painting, thanks to acute curiosity. That probably accounted for his choice of Man Ray to open his gallery with a one-man show in March 1926. In fact the show was dual: "Paintings by Man Ray and Objects from the Tropical Islands," and the scandal was in the objects.

Visitors invited to the opening were confronted by a gathering crowd, for Tual had placed one of the exotic "objects" in the street window: a smallish wood sculpture—from a smallish island off Sumatra—of a smallish plumed god with an aggressive penis. Naturally the proper citizens of the neighborhood, a neighborhood that was still largely lower middle class, took the whole thing badly, making it clear that they would soon begin smashing windows, and more, if the offending object were not removed.

As always, intrepid André Breton moved forward to confront the crowd (it is likely that the scandalous piece came from his personal collection). His comrades stood alongside him, waiting for the first paving stone to fly. Suddenly a simple chap dressed in working clothes strode forward to defend the gallery. Did the neighborhood fear for the virtue of its daughters? he demanded in a loud voice. The daughters would see a lot more if they had not already. And how had all these mothers gotten their daughters in the first place? He had soon reduced the onlookers to giggles, and eventually the mob evaporated.

But in taking leave of the Surrealists standing outside the gallery, a good Samaritan warned them: "Do you intend to keep this thing in the window? It might cause trouble with the police." They did hear from the police, and before the show was over they were obliged to remove the offending god.

Inside the gallery, Man Ray's show was in the nature of a retrospective, which was not a bad way to inaugurate the Surrealist era. He would confess that, apart from two or three works created since the launching of Surrealism, he had done nothing more than to hang leftovers from the Dada years, which he believed to be quite suited to Surrealist doctrine (clearly the Breton band concurred).

The new gallery rapidly became a second home to the movement. It sponsored a publishing program under the imprint Éditions Surréalistes, which included a selection of works from Man Ray's New York Dada years. Subsequent one-man shows honored other pioneers: Arp, Ernst, De Chirico, and even Tanguy, not to forget group shows

which juxtaposed their work with that of Masson, Miró, Picabia, and Picasso. Before the end of the year rue Jacques Callot had also become the new headquarters of the group's *La Révolution Surréaliste*.[3]

There was also now another center for Surrealism, if a most curious and informal one. It is tempting to call it a recreation center, until one remembers that Surrealist games were serious affairs. Marcel Duhamel, housekeeper at the rue du Château for his talented comrades Yves Tanguy and Jacques Prevert, remembered dining in their company at a bistro situated between the Rotonde and Select on boulevard du Montparnasse when a disturbance erupted at a neighboring table. Suddenly a young man sporting a cap rose from his chair brandishing a cane—clearly signaling the beginning of a fight. Prevert was about to express his annoyance at all this agitation when another diner at his table, an art critic named Florent Fels, informed the group that the disruptive young man was a Surrealist poet, and a promising one.

They would learn that he was Robert Desnos, Breton's favorite example of a man who could write in the semiconscious state favoring creation. Desnos had recently moved into a ramshackle house, one of several that lent the appearance of a village lane to an alley on narrow rue Blomet, in a nondescript neighborhood due east of the Montparnasse station; a painter and a sculptor, Georges Malkine and André de la Rivière, became his neighbors. (They were a second generation of Parnassians in the little village, for Joan Miró and André Masson had recently moved out.)

It was not very far from rue Blomet to rue du Château. The amiable Desnos soon became a habitué of the informal club created by Duhamel and his friends. Desnos eventually brought Benjamin Péret along, Péret brought Aragon—and all Surrealism followed. They found, far from the promiscuity of café life, a place for flirting and for the collective games of which they were so fond.

The most fascinating of the games was *cadavre exquis,* their

sophisticated version of a schoolyard game, in which each player in turn scribbles a line, or a partial drawing or painting, on a sheet of paper folded as many times as there are participants, without knowing what has been done by the previous player. The name of the game derived from the prototype phrase: "The exquisite—cadaver—will drink—the new—wine."

On his side, Desnos could offer his new friends another sort of recreation, for a dilapidated hotel near his little house on rue Blomet sheltered West Indian workers who gathered in a neighboring bar, dancing in the back room on Saturday nights. Not forgetting that he earned his living as a journalist, Desnos in one of his sober moments dashed off a tribute to the exotic ballroom for a daily newspaper— and Paris flocked to his "Bal Nègre."[4]

14 *Hands Off Love*

IT SEEMED AS IF EVERYTHING Man Ray touched now turned to gold. In his circle, he was one of the rare artists with an automobile, and it was always a powerful one. A good deal of his income came in dollars—whether from illustrated American magazines or from visitors to Paris—and dollars counted in those times.

Money occasionally fell from the sky. There were the Wheelers—he a retired broker, she in need of her portrait signed by Man Ray. Arthur and Rose Wheeler became true friends, and good hosts. One day at lunch, the year was 1926, Wheeler sought to convince Man Ray that with his talent he could be doing bigger things, such as making movies. He offered to finance a production and when Man Ray threw out a figure—$10, 000—Wheeler said it would cost at least five times that. Man Ray held to his figure, insisting that he was only going to make an experimental film and needed no more.

But even $10, 000 was a considerable sum, allowing Man Ray to do the kind of film he wanted to do and still put some money aside. And experimental it was, employing some of the techniques that he had used in *Return to Reason*—whirling disks, deforming mirrors and crystals—above all brief, seemingly unconnected scenes. Wheeler had invited him to do some of the work at his luxurious villa near

Biarritz, a villa bearing the Basque name *Emak Bakia*—loosely translated as "Leave me alone." That became the title of his film.

The finished work had some effective shots, notably the final sequence with Kiki. Inspired, he said, by her penchant for excessive use of makeup, the writer-director-cameraman painted eyes on her closed lids, then caught her as she gradually opened her real eyes. For the first screening, Man Ray arranged for live and recorded musical accompaniment. That and the film's brevity, under fifteen minutes, apparently made it supportable, and even enjoyable. The theater manager saw it as commercially feasible, and booked *Emak Bakia* for an indefinite run.

André Breton and his comrades were less pleased, although Man Ray felt that he had followed their theories to the letter. He guessed that their lack of enthusiasm had more to do with his failure to discuss his plans with the group in advance. But even without their endorsement he undoubtedly gained more than he lost in the adventure. In a note to Gertrude Stein on his return to Paris in September, he began: "Just back from a month's vacation"—a reference to his idyllic life with Kiki at the Wheelers. He had of course compressed vacation and a great deal of work into the same month, and in the same place.

Perhaps the most wondrous thing about his life in Montparnasse was this seemingly immutable honeymoon with Kiki—everybody's Kiki in the studios and cabarets, but really Man Ray's. Volatile, unpredictable Kiki, who was learning all the time; he had to stay on his toes just to keep up with her. He also realized that while they always seemed to squabble in public, in front of witnesses, when they were alone together she became as "gentle as a kitten."

Yet it was not to last forever. Without being stormy, the termination would be abrupt. But Kiki would forever mark her Man. The 1920s in Montparnasse were his formative years, and one does not forget those. His photographs of Kiki, things of beauty in themselves, were to become social documents, and contributions to the history of photography.[1]

For his part, Man Ray continued to keep his emotions under control. And he knew how to express his devotion by other means, means not requiring an outward show of tenderness.

Early in 1927, for example, he took Kiki along on his first trip to America since his arrival in Paris. More, he led her out to Brooklyn, to the home of his parents. She sat on his father's lap to be photographed, testing her impulsive English on all within earshot. The occasion for the trip was a New York screening of *Emak Bakia*, which had already been shown in London and Brussels. In New York it was anything but a hit, causing more puzzlement than admiration; the lack of connection between its parts was not appreciated.

The experience confirmed Man Ray's feeling that he continued to be a fish out of water in his native land. Whereas in Paris everything seemed possible. A similar conclusion was undoubtedly passing through the minds of other Americans, for Paris and particularly Montparnasse were ever more appealing. Once there, they found more distractions than ever; for the seriously intent, there were more opportunities than ever to show what they could do.

What helped to bridge the Atlantic Ocean, demolishing barriers and encouraging sociability, was the inauguration of La Coupole, a tour de force of a café-restaurant with the dimensions of a railway station, big and broadminded enough to receive both the top-hatted and those in paint-spotted work clothes.

Both La Rotonde and the Dôme were kind to clans; one knew immediately if one was welcome. La Coupole was open space, enhanced by a ceiling sixteen feet high. This and the vast spread of the main room, the biggest in Paris, allowing comfortable seating for several hundred, actually preserved privacy, so that each table contained its universe, and never mind which friend or enemy occupied the next one. Above all, the bar adjacent to the main room, set off by a partition, offered an alternative to the traditional café-restaurant.

Imagine, an "American bar" (never mind that America in the time of prohibition had no such bar, at least no visible one), accessible

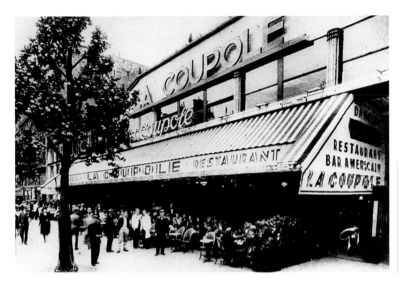

La Coupole in the heroic years. It shared the busiest block of Boulevard du Montparnasse with the smaller Café du Dôme, Le Select, and La Rotonde.

from the main room without the need to step out of doors. A bar roomy enough to contain all those who belonged there, yet not so vast as to lose the special quality of bar.

La Coupole was the masterwork of two entrepreneurs, René Lafon and his brother-in-law Ernest Fraux, whose families originated in the mountainous Auvergne, as did so many café and restaurant owners in Paris. To achieve their dream they leased a large parcel of land, formerly a wood and coal depot, right in the middle of boulevard du Montparnasse, within shouting distance of the Dôme, and within eyesight of La Rotonde and Le Select. Within a couple of years they had put a ballroom in the basement and a second restaurant and tearoom just above, these having all the advantages and disadvantages of an open roof.

The architect suggested a name for the new establishment appropriate to its neighbors, which of course were called (without justification) "dome" and "rotunda": so why not "cupola"?

One more touch was needed to guarantee the glory of La Coupole (today it is listed as a landmark). Lafon and Fraux hired local artists to decorate the main room. Each was to produce one or more appropri-

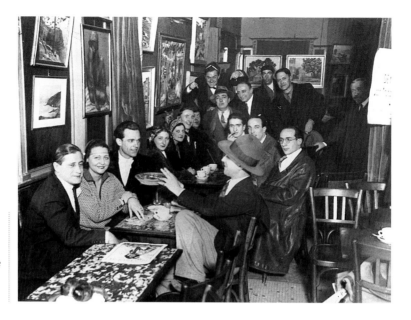

La Coupole, which opened in 1927, was the biggest café-restaurant in Paris, a place where one could choose to be gregarious or anonymous.

ately Parnassian oils on canvas, to be fitted on to the columns and supporting pilasters running around the walls.

The result was hardly avant-garde, but it managed to get into the spirit of the times (some young painters came from the studios of Matisse and Fernand Léger). Even artists who belonged to earlier decades understood that they were painting for café-goers. They did nudes, or diners and dancers with their clothes on; they offered tempting fruit, abundant vegetation—subjects lending themselves to warm colors. Among those whose work still seems right for its time and place were Marie Vassilieff (she who had brought Man Ray and Kiki together), and the Russian-born Swede Otto Gustav Carlsund.

With a single exception, the paintings were left unsigned, and over the decades many false attributions were published (the Carlsund was long credited to Léger, whose pupil he was). For the seventieth anniversary of La Coupole, an art historian was engaged to elucidate the mysteries; she was able to offer positive identification of all but half a dozen of the thirty-two extant originals. As they can be seen today, and despite the demolition of the original room and its recon-

struction on the same site at the end of the 1980s, La Coupole's oils are among the best surviving relics of between-the-wars Montparnasse.[2]

One of the young Americans who turned up in Paris in 1927 was on a dual mission—to find a purpose for his own life, and then to see what he could do about constructing a career as an art dealer. The son of a successful New York businessman, twenty-one-year-old Julien Levy had first toyed with the idea of making movies before falling in love with contemporary art. He met Marcel Duchamp the previous autumn at a one-man Brancusi show in New York, a show Duchamp had helped to organize, and was persuaded to go to Paris to indulge his passion.

Levy sailed to France as a fellow passenger of Duchamp in February 1927, and undoubtedly perfected his education on board. Duchamp invested his time wisely, for when he matured, young Levy would become one of the first and among the most influential promoters of Surrealist art in the United States.

In Montparnasse, the visitor proved to be an avid listener, moving from contact to contact, meeting writers and pretty women. After Duchamp, one of the most useful intermediaries was Robert McAlmon, a walking address book, as Levy described his bar talk. "Listen! You should live in the Quarter, the Istria, unnerstan',—Hotel Istria. Marcel [Duchamp] will tell you the same. . . . Man Ray's studio right next door. A nice little place. Get the room Brett and Mike used to have. You read *The Sun Also Rises?* Hemingway? . . . Lady Duff Twysden, and Pat Guthrie—Brett and Mike in the book—used to be around the Quarter all the time. . . ." Doing the town with McAlmon, the visitor concluded, was like taking a sightseeing bus—but to see people rather than monuments.

So Julien Levy got a room at the Hotel Istria—the love nest of Hemingway's characters Brett and Mike, also of the real Kiki and Man Ray, who put him in touch with Eugène Atget, one of whose works he had seen in *La Révolution Surréaliste.* "Pass by and knock on his door

any afternoon at all," Man Ray advised him. Atget was to die later that year; Levy would be instrumental in rescuing his vast archive of Paris street scenes from the garbage dump.

The young New Yorker got close to Man Ray in another way during his first Paris stay. Levy was hoping to make a movie, a visualization of T. S. Eliot's apocalyptic poem "The Waste Land"; somehow he saw Kiki in it. But, to believe Levy's own account, she refused to accept a part in the film unless handsome Levy made love to her. When he refused to be tempted, she dismissed him scornfully as "not a man, but a manikin." Actually the manikin was then deeply involved with twenty-year-old Joella, whom he would soon marry, after being tempted by Joella's mother Mina Loy, then a striking forty-four.

A deliberately arty Man Ray portrait of the multinational Mina Loy, wearing a darkroom thermometer as an earring, during her Paris years

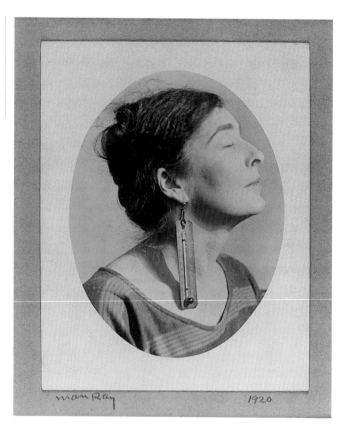

Was the loyal Kiki teasing Julien Levy about going to bed with him? If not, let this date—midsummer 1927—mark another sign of a rift.[3]

It was as if the arrival of La Coupole, with the promiscuity of its capacious café-restaurant, the intimacy of its *bar américain,* crystallized the fusion then taking place between the French and their foreign guests. For their part, the Anglo-Americans had long felt at home here, establishing small publishing and printing houses to do books and journals in English both for local consumption and export. After Sylvia Beach's Shakespeare & Company and Robert McAlmon's Contact Editions, both of which issued their first books in 1922, there had been Black Sun Press, Black Manikin Press, now Hours Press, and more were to come, some of them shutting down only when France shut down in 1939. The expatriate presses would publish expatriate writers, a few of whom survived to become credits to their cultures. Often the American and British amateurs translated their contemporary French counterparts, or wrote books and essays to explain Europe to America (such as Julien Levy's *Surrealism,* the first qualified work to announce what was happening over there).

One of the most influential Paris-based international ventures was *transition* (whose editors preferred a lowercase *t*). An English-language review of contemporary arts and letters, it had been conceived by Eugène Jolas, himself a specimen of the transatlantic mix. Born in the United States of parents hailing from Lorraine, he was raised in Lorraine when it was still a German territory, finishing his education in the United States. Back in France again he was hired by the Paris edition of the *Chicago Tribune* as a literary editor, introducing André Gide, André Breton, Paul Eluard, and Philippe Soupault to American readers. Then, with the assistance of fellow journalist and editor Elliot Paul, he drew up plans for what would be the most long-lasting of little magazines, which also had the particularity of being put together by Jolas and his Kentucky-born wife, Maria (née McDonald), in a house called La Boisserie in Colombey-les-Deux-Églises, a domain

later to enter history as the last domicile of Charles de Gaulle.

In their first issue, *transition*'s editors anchored their place in literary history by publishing the opening pages of James Joyce's cryptic masterpiece, "a Work in Progress" (which when finished received the title *Finnegans Wake)*. There were texts by members of the expatriate community such as Gertrude Stein and Kay Boyle, and also the reproduction of a painting by Max Ernst, with poems by Gide, Desnos, and Soupault translated by Jolas himself. In its first year alone *transition* published work by contributors from seventeen countries; later, as a quarterly, there were to be issues as lengthy as an average book.

Soon Man Ray was a regular contributor; how could he have been left out? In June of that first year the magazine reproduced a photograph of his *Snowball*—a very special Surrealist child's glass globe, Man Ray having added some touches of his own, such as a painted eye with lashes. Printed strips from his film *Emak Bakia* appeared in September.

Also in that first year, the new magazine was the first to publish a Surrealist manifesto in a translation from the French by Nancy Cunard before the original appeared. It was carried in *transition* in September 1927, while the original French version could be read in Breton's *La Révolution Surréaliste* only in October. It was also the first Surrealist manifesto to which Man Ray allowed his name to be attached.

It all began with a broken Hollywood marriage. Chaplin and his young wife, Lita, mother of his sons Charlie and, quite recently, Sydney, were going through a nasty divorce. The case made the front pages in the United States at the end of 1926, the press avidly reporting Lita's allegations of her husband's indecent acts and proposals, such as demands for oral sex and a suggestion that they invite a second woman to bed with them. In a separate complaint filed by Lita's uncle and attorney, Chaplin's behavior was summed up as "abnormal, unnatural, perverted, degenerate and indecent."

It was then that American tax authorities revealed that Chaplin owed over $1 million in unpaid taxes. He also had not paid child

support since his wife left him, so women's clubs began to raise money to feed his children. At least one American town banned the showing of his films.

He had defenders, too, and they made their voices heard. Then came Lita's formal complaint in January 1927, adding more details. Once he pulled a gun on her, threatening to kill her. The sexual acts he requested of her were alleged to be "too revolting, indecent and immoral to set forth in detail in this complaint." Of oral sex, he was said to have told her: "All married people do those kind of things." Eventually Chaplin satisfied the tax authorities. The divorce trial ended in August 1927 with a settlement said to be the largest ever awarded in the state of California (or perhaps any state). And Chaplin could go back to filmmaking—and to some of his best movies.

But for the Surrealists it was the sex charge that would not go away. Nor could they tolerate the attack on "Charlot"—admiration for whom united the Surrealists as perhaps nothing else did, as one of their number, Maxime Alexandre explained it. His was the first of thirty-one signatures—for as always they were listed in alphabetical order—on a manifesto titled (in both English and French versions) *Hands Off Love.* The signers made it clear that they accepted the truth of the charges against Charlot. But they attacked the attempt to set wives apart: why cannot the same law sanction breach of faith? Should personal habits be matter for legislation? For them it was laughable that Mrs. Chaplin took fellatio to be abnormal. Had free discussion of sexual habits been possible it would appear only right for a court to quash charges brought by a wife shown to have *"inhumanly"* refused herself to this "pure" practice. And if Chaplin had not had normal marital relations with her, where did the two babies come from?

Had Lita Chaplin sought to discredit Chaplin because of his opinions, and to discredit his work? "An unfavourable report, most particularly in that narrow zone of observation to which the American public confines its favourites . . . can ruin a man in the space of a day."

The Surrealists argued that Chaplin had sought to make the mar-

riage work. But he came up against "a wall of silliness and stupidity." They justify Chaplin's suggestion, at the time their marriage seemed to be breaking up, to invite a young girl to join them in sex: "This is the last attempt at transforming the domestic hatching-machine into a rational being capable of conjugal affection."

For these angry young men, their Charlot was justified in asking for more than Lita was willing to give. Recalling his film *The Imposter*, they explained: ". . . He has always been at the command of love, and this is what is very consistently demonstrated by his life and by all his films." The manifesto recalled the Charlot of desolate neighborhoods, the Charlot confronting the brutalies of the law, as in *The Emigrant*. Charlot's fate symbolizes the fate of genius. "Genius takes hold of a man and makes of him an intelligible symbol, and the prey of sombre beasts. Genius serves to point out to the world the moral truth that universal stupidity obscures."[4]

15 | *Montparnasse Memories*

"MAN RAY—WHO DOESN'T KNOW THE NAME?—is probably the
most extraordinary photographer and filmmaker of our day," so
began a tribute to Man Ray in a Havana magazine in 1928. It came
from a Cuban journalist—later a widely published novelist—who
followed events in France closely. "They have so much respect for him
in Parisian avant-garde circles that the most irreconcilable factions
find themselves in agreement when the time comes to praise him,"
Alejo Carpentier's laudation ran on, which does indicate that Man
Ray continued to maintain his position above the crowd.

After a visit to Man Ray's diminutive studio on rue Campagne-
Première, "the alchemist's laboratory," Carpentier undoubtedly
endeared himself to the photographer even further by expressing
admiration for the paintings covering the walls, describing them as
"truly magical objects."

Of all those who shared the Montparnasse of Man Ray and Kiki,
observing the couple and recording their impressions, perhaps the
most unexpected was Arno Breker. While he was fated to become
Adolf Hitler's favorite sculptor, in the late 1920s Breker was only
another foreign artist in Paris, an earnest craftsman who happened
to be a classicist among the moderns. After some early success
with monumental sculpture, Breker was immersing himself in the

Montparnasse of the École de Paris, consorting with the most advanced—Robert and Sonia Delaunay, Brancusi, Pascin, and Léger, while seeking to emulate the more traditional—Charles Despiau, Paul Belmondo, and Antoine Bourdelle. He would tell his biographers that he knew Joyce and Hemingway, as well as Man Ray, and that another American, young sculptor Alexander Calder, spent a year in his studio. He remembered Calder shaping wire figures, which he set in motion on a turntable, accompanied by German military music.

His memoirs depict a man who liked to move around the Quarter. To Breker, Kiki was "the most glorious" of the women of Montparnasse. "A true phenomenon of carnal beauty and plenitude," he wrote in sculptor's language, "her voice roughened by alcohol and tobacco covered everyone else's." Her body belonged to statuary, and he was surprised that no sculptor had employed her.

Breker did not miss the obligatory visit to Man Ray's studio. While the resulting photographs hardly merited a museum hanging, the sculptor would hold on to them throughout the Nazi era, saving them for his biographers. The German placed Man Ray among those most in view in the Quarter—"always seeking out rewarding experiences. . . . I was delighted to find, in his somber expression, the melancholic features of Baudelaire."[1]

Some memorialists of Man Ray's Montparnasse tended to see him only as half of a legendary couple, the other half being of course Kiki. To one Paris-American, the latter was the creation of the former. After seeing Kiki at the bar of the new Coupole, Kay Boyle reflected: "Man Ray had designed Kiki's face for her, and painted it on with his own hand. He would begin by shaving her eyebrows off, she told me, and then putting other eyebrows back, in any color he might have selected for her mask that day, sometimes as fine as a thread and sometimes as thick as your finger, and at any angle he chose. Her heavy eyelids might be done in copper one day and in royal blue another, or else in silver or jade, she said. Tonight they were opaline."

But this was not to render Kiki, however "heavy-featured and

voluptuous, her voice as hoarse as that of a vegetable hawker," unsympathetic to Kay Boyle. ". . . This much I know: when you knocked at Kiki's white stone flesh for entry, she . . . opened wide her heart and moved the furniture aside so that you could come in."

Or was Man Ray Kiki's creation? Her lap dog? For a brochure he was publishing about Montparnasse, a young journalist named Henri Broca sketched an overdeveloped Kiki with protruding chest and formidable derriere, fur-coated and veiled beneath an ample hat, looking behind her as if in afterthought at a small and resigned-looking Man Ray. "Not having found a Pekingese to her taste," read his caption, "Kiki adored the gentle Man Ray, who tries to make her life easy, and who is quite right to do so. Kiki is no longer what she had been, but she nevertheless represents a heroic era of Montparnasse. . . ."

Sometime later, on a copy of the caricature, Man Ray scratched out Broca's caption and wrote beneath it (in French): "A piece of crap— done by a jerk."

Perhaps the one who lived to regret the sketch most, with a Kiki who "is no longer what she had been," was the caricaturist. For soon afterwards Kiki, the alleged has-been, would leave Man Ray's arms for Broca's.

Perhaps there were signs of fatigue in the daily life of the legendary couple. Perhaps their fights lasted longer, reconciliations were briefer. In 1928, their last full year together, he gave her the starring role in what has been called his best Surrealist film, meaning his best film. This time there was a story line, as Surrealist stories go. The script was a poem by Robert Desnos, apparently written for his great love of the time, and the dreamer Desnos was always greatly in love. She was a popular singer and actress, the ravishing Yvonne George, who was the poet's "starfish"; that became the name of the poem, and of Man Ray's film *L'Etoile de Mer*. In the scenario, a man is attracted by a young woman selling newspapers on the street, and by the starfish in a glass bowl beside her. They go to a hotel room where she lies on a bed waiting for his approach, but he kisses her hand and leaves with the bowl containing the starfish.

Her life goes on with another lover. Then the original couple meet in an alley, but still another suitor appears to take her away. Man Ray had been moved by the poem when Desnos read it aloud, seeing its cinematic possibilities. Desnos was leaving for Cuba on an assignment and Man Ray promised the movie would be ready on his return (Desnos came back in time to play the man who finally leads Kiki away). To show his Kiki naked and to protect public morality at the same time, nimble Man Ray filmed his lady love at full length, he said that he detested partial concealment or other trick effects traditionally utilized in such circumstances, but first coated his lens with melted gelatin, to achieve a cut-glass distortion.

It was the versatile director-cameraman Man Ray who arranged for a first showing of the eleven-minute film at a small Latin Quarter cinema, Studio des Ursulines. It worked well as a short to accompany Marlene Dietrich in *The Blue Angel.* He wanted to invite the Breton crowd to the opening, but Desnos put a stop to that, for he was one of the first to break with the mainline Surrealists. (Seeing a photograph of Breton on Man Ray's desk, Desnos grabbed a letter opener and stabbed at the print, as Man Ray guessed he had seen native sorcerers do in the West Indies.)

But his film was a success. The Ursulines manager kept it on the program and other theaters booked it, and not only in France. Thirty years later, when it came time for Simone de Beauvoir to write her memoir of growing up as a proper young lady, we would learn that at the age of twenty, while working for a teaching degree at the Sorbonne, she had been one of the inquisitive Latin Quarter students who saw *L'Etoile de Mer* at the Ursulines; she mentions it because it had been a film to see in that time. She would never be known to any of the between-the-wars personae who put Montparnasse onto the cultural map, but in many ways she was as Parnassian as any of them.[2]

Although the house changed hands, its spirit survived. After many sociable years, Marcel Duhamel, who by then had moved from the

comfortable family hotel business to risky moviemaking, decided to put the Surrealist villa on rue du Château up for sale. Duhamel found buyers in two talented young men already familiar with the place—Georges Sadoul, twenty-four, and André Thirion, twenty-one, both of whom combined Surrealist engagement with acute social consciousness (they were Communists first and foremost).

But the new occupants carried on the tradition, keeping open house for the older Surrealists (who themselves were about to transform their essentially artistic concerns into political ones). In Breton's later benign souvenir of 54, rue du Château: "It was the kingdom of absolute nonconformity, total irreverence, and excellent humor."

It was here and now that the Surrealists undertook their formal research on sex. In an extraordinary series of meetings they would tell each other what they thought and what they did, apparently in all honesty. The seminar brought together all of the remaining faithful, with Breton as informal chairman (he was also the only one of the group present at all twelve sessions). Just half a dozen women took part in the Surrealist inquiry, and four of the six happened to be the wives of the male participants.

Man Ray lent himself readily to the antics of his old Surrealist crowd—even if they had not given him reciprocal support in his most recent experiments in film. Once, at a gathering in somebody's studio he had taken part in one of their games, a truth-or-consequences interrogation on intimate sexual matters (the heavy drinking that preceded it contributed to relaxing inhibitions). He was asked whether he was a homosexual and took the question seriously, feeling that it was based on the frequent visits of homosexuals to his studio. But he refused to reply, and for that he was sentenced to strip off all his clothing. Did they think, he wondered aloud, that by seeing him naked they could divine his sexual preferences?

But he had done what he was supposed to do, hopping onto a table to peel off all his clothes down to his shoes. Somewhat inebriated (he told this story himself), he'd performed a little dance, kicking

bottles and glasses off the table as he went along. An embarrassing moment—the worst of the evening for everybody, he later decided, but the Surrealists seemed to consider it of "psychological significance," or so Man Ray later concluded.

But this time they were not playing. The first session of their "sexual research" took place on a Thursday evening, January 27, 1928. "A man and a woman make love," Breton began. "To what extent does the man know whether the woman has had a climax?" He called on Yves Tanguy for a reply. "Why call on me first?" was the painter's first reaction, before conceding that it really was hard to know whether she had indeed—and that seemed to be the consensus. Can a woman know that a man has had his climax? The general feeling was that this would be equally difficult, especially if both parties achieved it at the same time.

Although soon the need for Breton as conductor of the orchestra evaporated, he was still often the most expressive witness. He confessed, for example, to a definite prejudice against homosexuality, which the Surrealists called pederasty, making an exception for the Marquis de Sade, but not for Max Jacob, Jean Cocteau—or the work of Marcel Proust. But when asked by Jacques Prevert what he thought of "sodomy between man and woman," Breton replied, "Only good things." Had he tried it? "Absolutely."

Another time, asked by Raymond Queneau what to think about "physical failures while making love," he said with elegance: "It can only happen with a woman one loves."

On the subject of the right position, Breton opposed the general view that a woman should be asked for her preference. They debated mutual masturbation, means of excitation (exhibitionism, for example), combinations such as a man with two women, and bordellos and other sex for hire. Prevert said that he had never paid for sex—but *he* had been paid for it.

Man Ray was invited to the second session on the following Tuesday evening. Louis Aragon was also present for the first time, and

expressed regret that he had not been able to attend the earlier meeting so as to give his own responses to the questions posed. Breton agreed that those who had been absent on Thursday should now be allowed to do that.

On the question of man and woman coming to climax simultaneously, Man Ray was the first of the newcomers to be given the floor. Pressed by Aragon to specify the frequency of simultaneous climaxes with his partners, Man Ray estimated: 75 percent of the time. Did he use artificial means to provoke such simultaneity? "Why artificial? Natural ones, calculated." Should he fail to "calculate," he admitted, he would come ahead of the woman.

On another matter that had been explored during the earlier session, whether a man could tell when a woman had achieved climax, or vice versa, Man Ray: "The woman necessarily knows the precise moment the man has come. But the man has to depend on realizing when the woman has begun to relax." And if the relaxation is simulated? Breton persisted. "So much the worse for the woman," replied Man Ray. "I go along with her game."

He did not like these nit-picking questions about who came first. If it were only a matter of physical satisfaction, nothing beat masturbation. "Making love to a woman is a game in which both must come to a climax at the same time." He was clearly the oldest member of the group present at that session; one wonders whether his juniors paid attention to his wisdom.

Their American friend was equally matter-of-fact on other burning issues. Concerning homosexuality, he saw no difference between that and heterosexuality, but he personally did not like to hear the details. Asked for his opinion, Aragon pleaded for time to think about it, and then seemed to echo Man Ray—just another sex habit, not justifying a moral condemnation. At the time, few of his peers would have guessed that this consummate ladies' man could also be a man's man, although Aragon had already confessed a tryst with Pierre Drieu La Rochelle to Maxime Alexandre.

Would you be disturbed by the presence of a third party? "A stranger would bother me, but not a friend," Man Ray replied simply. "A woman would never bother me." What sexual act seems most exciting to you? " . . . Fellation of the man by the woman, because it's what has happened to me least often."

Then it was time for him to ask a question. "Can Breton become involved with two women at the same time?" "I said it was impossible," was the reply. "And Man Ray?"

"Yes, but not more than two."

In Man Ray's case, he would soon demonstrate that he liked one at a time best. But for the moment, most of the tumult came from Aragon. "Elegant, dandy, romantic, good-looking, caustic, rapid and brilliant, Aragon intrigued men who feared his intelligence, the liveliness and the bite of his speech, and seduced women who were fascinated by the aura of mystery in which he moved." That from one of Aragon's new friends at rue du Château, André Thirion.

For they all knew Aragon, and his reputation. They may not have known Nancy Cunard, but they could stare at Man Ray's portrait of her that Aragon had put on the wall at rue du Château. They knew that she was the stunning heiress who dressed fit to kill, and also that she could not resist a new adventure. That summer Aragon had gone with her to Venice, where they spent their evenings listening to a black American jazz group in a nightclub on the lagoon, and Nancy soon moved out of Louis Aragon's arms and into those of jazz pianist Henry Crowder. Later Crowder, twelfth and last child of a poor Georgia farm family, would remember that during those heady Venetian weeks she also found time to flirt with a waiter at the club and a Venetian count.

Pending the renovation of a studio apartment he had found in the northern wing of Man Ray's building on rue Campagne-Première, Aragon moved in with his friends at rue du Château, to pour out his anguish in a memorable poem while staring at Nancy's photograph.

Earlier that summer Aragon had helped install a hand-printing

press with all its accessories, acquired by Nancy Cunard from one of the Paris-American amateur publishers. Soon she would be operating her own nonconformist publishing enterprise, which she decided to call The Hours Press. Until Venice, Aragon was to have been her literary adviser and chief helper.

But now Henry Crowder was her chief helper.

Nancy Cunard could change her man as easily as she changed a pair of gloves. Louis Aragon was now to prove that he could so the same, except that the initiative did not come from him.

Elsa Triolet, the young Russian woman who had been escorting her sister's lover Vladimir Mayakovski around Montparnasse, had set her sights on Aragon. Above all she admired his work, and she got a mutual friend, the Surrealist gallery owner Roland Tual, to introduce them; that happened at La Coupole on a night, November 6, 1928, to become part of their dual biography.

And now that she had him, she was not going to let him go. The scene switches to 54, rue du Château, on that same evening or soon after, during a party given for Mayakovski; André Thirion was the witness. Perceiving Aragon on the loggia floor, Elsa Triolet climbed the stairs to join him. She had not see the loggia before, she said, what did one do there? And then she spied a curtain, and a sort of deck chair behind it. She drew Aragon back there. "And there, what does one do? Make love?" Thirion watched as she kissed Aragon firmly on the mouth, and then turned away to protect the lovers from intruders.

This affair was to last. It would end—four decades later—only by Elsa's death before Louis's.[3]

16 *The Last of Kiki*

MAN RAY HAD NEVER lost touch with his former patron Katherine Dreier, she who had been the knowing subject of his enigmatic contraption *Catherine Barometer*, that gentle piece of mockery. On her side of the ocean, she had never abandoned her plan to establish a proper museum of modern art on American soil, continuing to collect (even Man Ray's works) with that in mind. A letter that he sent to her in October 1928 mixed her dream and his. "I'm glad the Société Anonyme is still fighting," he wrote, "to see the old letter-head gives one the feeling of security and encourages me in my resolution to devote a certain amount of time to painting again."

But would he? A young woman who walked into his life just then, not into his arms but into his studio, saw enormous quantities of photographic prints, cameras, lamps, and other equipment, but nary a painting. She supposed, rightly, that if he did paint he must be using a separate studio for that.

And yet he was photographing Jacqueline as a painter would, not necessarily for a specific assignment, say an advertising page or a poster, and not because she was a client sitting for her portrait, but simply for the beauty of it. Jacqueline Barsotti, the seventeen-year-old daughter of an Italian sculptor naturalized French, had been sitting at the Café du Dôme when someone introduced her to Man Ray. She

wished to model, and her good looks made it certain that she would succeed; within twenty-four hours, she would remember later, she knew everybody in Montparnasse. In time she would pose for Man Ray's photographs but also for painters as fashionable as Moïse Kisling and Tsugharu Foujita.

The Dôme was then the best place to meet people, the kind of people Jacqueline needed to meet; the Dôme on weekdays—weekends being for tourists. She never set foot in La Rotonde. Later she would remember that when La Coupole opened she and Man Ray were the most adventurous of their group, undertaking the sixty-second walk along the boulevard to see what it was like inside. They returned to the Dôme to tell the others, and henceforth their headquarters shifted to the bar of La Coupole's.

One of the things Jacqueline wished to have known, in retrospect, was that Man Ray would never let their relationship become awkward

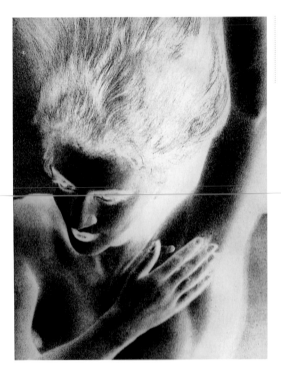

A solarization of Man Ray's model Jacqueline Barsotti, the good girl of Montparnasse

for her. He was over twice her age; she had her own life and dreams, and he respected them. She would pose nude for him, they might finish quite late. Or she would accompany him out on the town. In either case he would then drive her in his smart Voisin to her mother's house in suburban Rosny-sous-Bois, and that was that. Perhaps his smile occasionally betrayed a more than avuncular interest in her, but there would be nothing more.[1]

It was a time of transition for Man Ray, a time for personal and professional assessment. For one thing, he was aware that his life with Kiki was drawing to a close. And if he did not feel the difference that would make, others did. As she got to know him better, and to know the Quarter, his new model and friend Jacqueline decided that what gave Man Ray status was Kiki—being Kiki's man. In the more traditional artistic milieu, Man Ray's work as a painter was ignored, while his Dada pranks were not even understood by less complicated bohemians. What helped Man Ray belong in Montparnasse was the woman he lived with.

As for his professional life . . . henceforth he would proceed in a more businesslike manner, inviting potential clients to sit for his camera, and arranging for exhibitions of his work. He would simplify his existence, selling his professional movie camera for example, and even what he called his "swank car," the Voisin to which he had been a slave for half a dozen years.

While strolling in the neighborhood, he saw a for-rent sign on an attractive building at 8, rue Val-de-Grâce, steps away from one of the Left Bank's most imposing romanesque monuments, the Val de Grâce church, designed by François Mansart for the birth of Louis XIV. Furnishing the small flat put his imagination into play. He saw it as a love nest, but also as a secluded studio for his secret and enduring passion—painting. Here he could see his friends in less formal surroundings, enhanced by his own canvases and constructs. The only evidence of his photographic career would be a few rayographs, and

they had not even required a camera. rue Campagne-Première would remain his official address, and there he would receive clients of Man Ray, Photographer.

Kiki did not slam the door when she walked out. The end of the affair was more subtle than that. They fought, and sometimes the fights were ferocious affairs. And even after their separation, she could still erupt in anger when confronted by evidence that his love life had not ended with her. In truth, their paths grew apart naturally as Kiki became less dependent. If at times she had appeared to be Man Ray's exclusive model, she now sat for some of the best-known École de Paris painters, even for the resourceful Alexander Calder, who was fascinated by a nose that seemed "to jut out into space." His *Kiki de Montparnasse* (dated 1930) was a simple twisted strand of wire resembling an ink sketch. A year later, a more elaborate tin and wire construction was all nose, and appropriately labeled *Kiki's Nose*.

She pursued her singing career, spending the rest of the time at café tables, an unpaid model for all who sat near enough to sketch her.

As Man Ray recalled the next episode, it was during a longer than usual stay in Burgundy that Kiki made up her mind to write a memoir of her childhood. She mailed him the manuscript, he read it and liked what he read, and on her return urged her to continue with an account of her early years in Paris.

By now, Henri Broca, he who had drawn the caricature of a big, busty Kiki lording it over diminutive Man Ray, was publishing a monthly magazine, *Paris Montparnasse*. With a comfortably bourgeois upbringing in placid Bordeaux, but now penniless and ambitious, Broca was a tireless publicist when he was working and a dissolute drinker when he was not; somehow he seemed the right publisher for Kiki. It was during their collaboration on her manuscript that they became lovers.

The transfer was effected gently. She would even return to rue Campagne-Première occasionally to consult her former beloved

about her book in progress, or to pick up one of Man Ray's pictures of her. But from now on he would follow her career from a distance. That became easy, thanks to Broca's magazine. For if Kiki was one of Broca's best sources of information, she was also one of his best subjects.

Publication of Kiki's memoirs began in the April 15 issue of *Paris Montparnasse,* announced by Man Ray's portrait of a rather solemn Kiki on the cover, and a livelier Man Ray photograph of a scantily clad Kiki inside. Then came the book: an impressive *Kiki, Souvenirs,* paperbound and printed on ordinary stock, although containing illustrations she drew to accompany her story, as well as photographs Man Ray made of her during their life together. There were reproductions of twenty of her own paintings, and portraits of Kiki by artists including Kisling and Foujita. Montparnasse as she presents it is one large family. She sees it come to life in the early morning as young people rush off to their art classes; then the cafés fill up, and "the porridges of pretty American girls were served side by side with pre-lunch drinks." Seasoned models, her elders, take the sun at sidewalk tables. The evening is reserved for friends. She mentions, among others, André Derain, "who smiles at his own stories, Kisling with his cowboy shirts. . . . Then Man Ray gazing into the future—or dreaming of a new camera."

Sisley Huddleston, a British writer resident in France, found her memoirs more revealing about Kiki young than Kiki now. "They tell us, for example, practically nothing about Man Ray, the clever American photographer with whom she was associated; and yet what interesting intimate revelations of the man and his methods she might have made! She is very frank about sentimental experiences, yet she always stops short; if she is to say so much we would like to know more about the character of the men who attracted her."

There was a book launching party at the Falstaff on rue du Montparnasse, with champagne for all, and later on, a bookshop signing where, it was reported, buyers of her book got Kiki's autograph, and a kiss.[2]

Not every French author is lucky enough to be translated into English; Kiki was. The publisher who inserted himself into the legend of Montparnasse by so doing was the American Edward Titus, husband of Helena Rubinstein—she of the fabled beauty products empire, who financed his unprofitable literary enterprises from a distance. He had a life of his own as a specialist in old and rare books, living and working on rue Delambre, while Madame dwelled in luxury on an island in the Seine. In 1926 Titus founded a small publishing house he called At the Sign of the Black Manikin, also the name of his bookshop.

The story as told by Titus was that he had been trying to get Kiki to write her book for the past two years, before young Henri Broca actually dragged it out of her. Now Titus found the right translator in the American journalist Samuel Putnam, who had been doing Rabelais, which might have been considered appropriate training for interpreting Kiki.

Putnam then resided on rue Delambre, just above the Dingo bar and two doors down from Edward Titus. Which is to say, he knew the Quarter. To make his edition of Kiki irresistible, Titus had commissioned a preface from the best-known American writer in residence, Ernest Hemingway, who wrote it before the book itself was ready for him to look at. Not very thoughtfully, he declared in his short text: "It is a crime to translate it. If it shouldn't be any good in English, and reading it just now again and seeing how it goes, I know it is going to be a bad job for whoever translates it, please read it in the original."

Translator Samuel Putnam got back at Hemingway in his own prefatory note. "Every translation, of course, is an impossibility," he observed, "it is only when the impossible has been achieved that the translator has done a day's work. . . ."

Putnam knew Kiki—who did not? Later he would describe her as "far from the American conception of what a model should be," explaining, "Her figure, for one thing, especially as she grew older, was inclined to be dumpy; but she made up for it by a vitality and vivaciousness, a seemingly naïve yet not so naïve wit, and a genuine

talent—she turned out to be quite a good painter, herself—that won her an unquestioned place in the annals of the ateliers."

And she was a survivor, as her latest lover would not be. Broca's excesses led to eccentric behavior. Kiki told Man Ray that Broca had tried to kill her, and she had him hospitalized, but then goodhearted Kiki visited him during his confinement. He returned to his family home in Bordeaux for convalescence, and died there in 1935.

Life went on for Kiki. There were the nightclub performances, occasional private parties for which she was engaged to sing, some music-hall bookings—and she was not going to stay single very long. The lucky fellow was a civil servant and sometime musician who accompanied her on accordion and piano in one of the cabarets.[3]

17 | *Lovely Lee Miller*

HAD MAN RAY GONE in for flowery speech he might have described his Paris years as a waking dream. Almost from the beginning he was wedded to the quintessential Montparnasse in multifaceted Kiki, who was both a symbol and an oh-so-palpable example of the Quarter's work and play. ("There was something of the clown in her lovely face," observed Morley Callaghan, seeing her for the first time in that summer of 1929).

Now Kiki was to be replaced in the legend, and without the slightest effort on Man Ray's part, by a young American of talent, wit, and style, the stunning Lee Miller.

During a voyage across Europe, which began with a tour of Italian museums and churches, this young American had made up her mind that photography was what she intended to do. That put her on a train for Paris, for now she had to meet Man Ray. There was no answer at his door at rue Campagne-Première, but she was directed to a bar he favored and waited on its upper floor, talking to its owner until a head and then shoulders appeared in the circular stairwell. "This is Man Ray," the patron told her. "What's your name?" Man Ray demanded warily.

"My name is Lee Miller and I'm your new student."

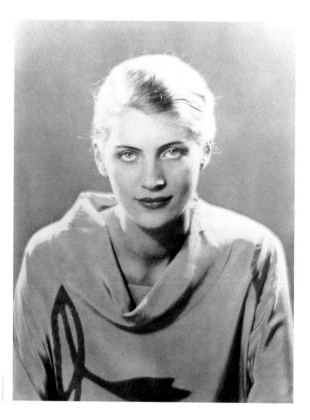

Lee Miller
looking lovely

"I don't have students," he replied. Furthermore, he was leaving Paris on a holiday.

"I know," she said, "I'm going with you." Which she proceeded to do. When they returned to Paris, she moved in with him.

Nothing about Lee Miller's life until then had been ordinary; why should it not continue that way? Elizabeth Miller, known as Lee, had been born twenty-two years earlier in Poughkeepsie, a smallish town on the Hudson River in upstate New York. Her father was a success-ful engineer whose hobby was photography, a hobby that seemed an obsession fixed on his daughter, whose adolescent and young-woman nudity he recorded on film before anyone else could. One of her biographers saw her first trip to Paris, at the age of eighteen, as an escape from parental control.

The event that was to change her life has all the trappings of legend: a near-accident in midtown Manhattan where a stranger saved her from being run down by an automobile. The stranger turned out to be the magazine tycoon Condé Nast, who at once saw her as a perfect model. She was not quite twenty when she appeared on the cover of *Vogue,* and henceforth was a favorite of the chief photographer of Condé Nast Publications, the celebrated Edward Steichen. But when Miller decided on photography as a career, meeting Man Ray, himself a much-admired contributor to the Condé Nast magazines, seemed the best way of entry. And, as her son and best memorialist would remember, she always had to act *now,* as soon as a notion came to her.

On his side, Man Ray never let himself become unsettled by the unexpected. His first months with Lee were idyllic. Perhaps they made a strange couple—the tall, fair, gregarious American beauty, with this slight, dark, and introspective workhorse—but they did function well together, and she knew she had much to learn. While learning, she lent her body to her professor's camera, as she had to her father's, although now her beauty was transformed by Surrealist props and poses. She would dress up for Man Ray, and dress down. One dares to say that Man Ray's portfolio of Lee Miller photographs is the most stunning in his corpus.

There would be problems. Professionally, she made her own way, armed with the techniques she was acquiring on rue Campagne-Première but applying her own eye and temperament. She also established her independence sexually, as he learned to his distress when their sexual cohabitation turned into dependence on his side. For Lee Miller there could be no jealousy. "She rarely allowed loyalty to a current lover to conflict with her sexual desires," her son would remember. Her son revealed a family secret: Lee's being raped at the age of seven, probably by the son of family friends with whom she was living during the illness of her mother. Back at home, her parents discovered that she had been infected by a venereal disease—and this before the age of penicillin, when the treatment was harsh indeed. A psychiatrist

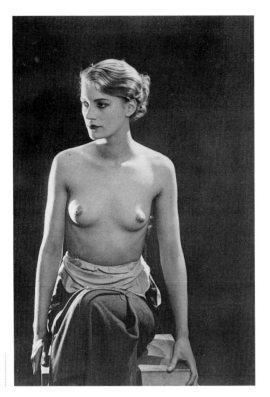

Among Lee Miller's evident qualities was a lack of inhibition.

consulted by her parents advised them to convince the child that sex and love were dissociated; it was hoped that by making light of the sexual act the pangs of guilt would be avoided.

Man Ray, the Man Ray one imagined cased in armor, later confessed to his vulnerability in the face of Lee Miller's behavior. One such occasion was a costume ball given by a sociable count and his countess in their Paris town house. Any costume would do, but it had to be white, and Man Ray had been invited to add some zest to that. His response was to place a movie projector on an upper floor, directed toward the dancers in the garden. Throwing old film footage onto moving couples all in white created an eerie effect, especially when actors and actresses from the old movies were recognizable on the dancers' costumes.

He had come to the ball dressed as a tennis player, Lee in a borrowed

designer evening gown. "I met lots of handsome young men who kept me dancing," she would later confess, "so I didn't do much work." While he was pleased to find her so popular, he became irritated when she was not available to assist him, but also, he realized, because of jealousy. He began to be clumsy with his equipment, went down to the buffet for a drink, and finally gave up the whole thing.

They seldom clashed on matters relating to studio business, and the generally overworked Man Ray often turned assignments over to Lee in order to free himself for painting. (The source for this is Lee Miller herself.) One of their rare differences, concerning the discovery of a technique to become known as solarization, became a footnote in the history of photography.

Years later, Man Ray discussed his use of this technique, a simple enough process but one that produced startling results. In solarization nothing changed in the way the photographer captured the image on film; it was all in the developing, which resulted in a line around the subject's face, as if a paintbrush had been used. In a solarized portrait, André Breton's leonine head is more imposing still, Lee Miller's profile more peremptory.

In an interview half a lifetime later, she claimed to have caused "the initial mess." "Something crawled across my foot in the darkroom and I let out a yell and turned on the light. I never did find out what it was, a mouse or what. Then I quickly realized that the film was totally exposed: there, in the development tanks, ready to be taken out, were a dozen practically fully developed negatives of a nude against a black background."

But if Lee Miller made the mess, her teacher knew what to do with it. He plunged the negatives into the hypo (the fixing agent sodium hyposulfite), not bothering to bawl her out (since she was already feeling sorry enough). When he examined the prints later he found that the sharp light had exposed the black background, so that it "came right up to the edge of the white, nude body." He decided to call the resultant line that separated background and image a "solarization."

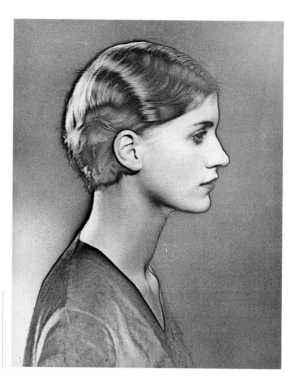

Lee Miller, a portrait using the solarization technique that she and Man Ray developed together

Lee Miller later gave her master the credit, observing that "it was all very well my making that one accidental discovery, but then Man had to set about how to control it and make it come out exactly the way he wanted to each time.... There were many people later on who copied [the solarization process], but they never seemed to handle it with the authority that Man did."

For his part, he dismissed the invention as no more than the studied application of a phenomenon known for some thirty years (the action of light on silver bromide). Alfred Stieglitz had exhibited the result of this technique long before the mouse ran over Lee Miller's foot.[1]

That Lee Miller took to working alongside Man is clear from her later recollections, and she never did say anything negative about her teacher. They enjoyed going out together and eating well. On the serious side, she was totally immersed in his circle, making friends—the

Eluards, Picasso, Max Ernst—who would remain her friends long after her separation from Man Ray. Of course she was still a model, and what a model; her naked image seemed to belong to everybody. Her son remembered that a glass manufacturer designed a champagne glass inspired by the shape of her breast. When *Time* magazine ran a photograph she had taken of Man Ray, it added the gratuitous comment that she was famous for having the most beautiful navel in Paris. Her father wrote an angry letter to the magazine, and the magazine printed it.

While those two strong women, Lee and Kiki, never fought it out, Kiki still found it hard to think of her ex-Man with someone else, never mind that she too was now with someone else. When she ran into Lee in the early days she would scowl, and Lee would scowl back. But after they were properly introduced, they got along fine ("because I admired her very much," Lee explained).

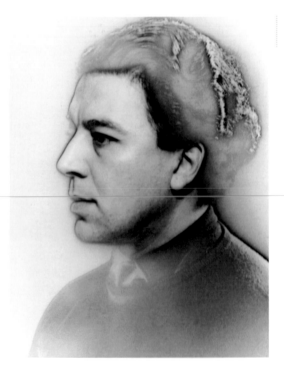

A solemn, solarized portrait of playful André Breton

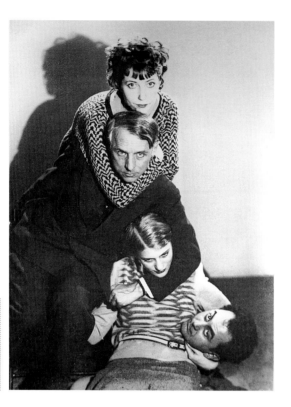

Clowning for posterity (from top): Marie-Berthe Aurenche (sometime fiancée of Max Ernst), Ernst, Lee Miller, and Man Ray

Contemporary accounts of the Montparnasse Lee Miller knew probably exaggerate the "Americanization" then taking place. In that summer of 1929, one of the liveliest observers of the Quarter was a young Canadian writer, Morley Callaghan. He and his wife began their walking tour at the carrefour Vavin, "the Raspail corner," where Le Dôme's sidewalk reminded him of a sports stadium, "the chairs and the tables set in rows extending as far as the next café, the Coupole. It had an even longer crowded terrace." They sat at the Coupole, waiting (in vain) for a famous expatriate writer to walk by. Then, as they came to know the writers and artists in residence, they would sit among the regulars gently mocking the buses filled with gaping tourists.

Before their summer was over, Callaghan would become one of many members of the foreign colony invited to put on boxing gloves

with Ernest Hemingway. Callaghan's was an exceptional experience, for Hemingway brought along a timekeeper in the person of a small, stocky Spanish painter, Joan Miró. "He wore a neat dark business suit," Callaghan recalled, "and the kind of shirt I hadn't seen for a long time; it had a stiffly starched front with stripes running crosswise." His head was covered with a hard black bowler hat. It did not help the boxing match that Miró spoke not a word of English. But he took the job of timekeeper seriously, calling out the three-minute rounds and one-minute rest intervals.

As that summer drew to a close, Callaghan decided most of the Americans he met would eventually go home. "The Americans around here can't be Frenchmen, no matter how well they speak the language," he told Hemingway. "If we are going to stay here it means really we have to become Frenchmen." Shrugging, Hemingway replied: "Who would want to stay?"

For even though it seemed to have reached its apex in 1929, Montparnasse as a home away from home for Americans was already beginning to decline. First the artists and writers moved away, alarmed by the tourist influx; then the tourist traffic began to wane. Bartender Jimmie Charters blamed this last phenomenon on America's depression, when families could no longer afford to send prodigal sons abroad, and the unearned income on which so many of them depended dropped sharply. Writing his introduction to the English version of Kiki's memoirs in 1929, a year before the translation actually came off the press, Hemingway pronounced the "era of Montparnasse" closed. It ended, he decided, when "Montparnasse became rich, prosperous, brightly lighted, dancing-ed, shredded-wheated, grape-nuts-ed or grapenutted . . . and they sold caviar at the Dome. . . ." He admitted that he was thinking of the public Montparnasse of cafés and restaurants, not the homes and studios where people worked. "In the old days the difference between the workers and those that didn't work was that the bums could be seen at the cafés in the forenoon. . . . The Era is over. It passed along with

the kidneys of the workers who drank too long with the bums."

The disappearance of "degenerate" expatriates of the École de Paris, in the wake of the Montparnasse exodus, was applauded by a French art critic, André Flament, who thought that one sometimes had to be grateful for financial disaster.[2]

The paradox is that Man Ray, so un-French in his speech and ways, remained unmoved by ebb and flow in the expatriate community. For all his indifference, and his reluctance to immerse himself in the concerns of his French friends, he was deeply involved with them. He continued to serve as unofficial photographer for the Surrealists, showing up wherever he was needed, and group portraits by his hand abound. Yet he hardly seemed to notice the seismic movements then occurring in the ranks of his Surrealist friends. As always, André Breton was at the epicenter. He went about his purging of the ranks as earnestly as the Communists did on their side, if for different reasons. The culminating act was the drawing up of a second Surrealist manifesto, published in the movement's house organ, *La Révolution surréaliste.* In this carefully reasoned but unreasonably lengthy text, Breton ushered many of his former comrades out of the Surrealist movement, sending them off with harsh words that were not easily forgiven. His victims included not only those who had sacrificed Surrealism for politics, but some whose only crime was to accept gainful employment while pursuing their art.

Readers who took the trouble to compare the magazine text of the second manifesto in 1929 with the book version some months later would have noticed a few changes in the direction of moderation. But in at least one case, the revision came out fiercer. In his original assessment of old comrade Desnos—"Desnos played a necessary, unforgettable role in Surrealism"—Breton accused him of according more importance to deliberate poetic composition than to Surrealist technique, and mocked him for earning a living writing for the vulgar press. By the time Breton was ready to give the manifesto more permanent form, he could produce fresh evidence of Desnos's treason:

Desnos was promoting a new cabaret in Montparnasse that dared to call itself Maldoror, which of course was a sacred name to Surrealists bred on Lautréamont. "There is, in a renouncement as rude as the association of the word *Maldoror* with an unspeakable bar, sufficient cause for me never again to judge Desnos's writing."

Curiously, as the Surrealists' historian Maurice Nadeau remarked, Breton was more indulgent to painters who sold their work, and he expressed no criticism of Man Ray whatsoever. He even welcomed back to the fold a former heretic, Tristan Tzara. Breton's jeremiad concluded with a plea for purity; he demanded a Surrealism free of the treason represented by the pretext that one had to earn a living.

Earlier purges had given short shrift to an old comrade, the caustic Philippe Soupault, and to the brilliant but uncontrollable Antonin Artaud. Now, a whole wagonload of former friends was driven to the scaffold.

And revolution would breed counterrevolution.[3]

18 *The Battles of the Thirties*

IN HIS SECOND MANIFESTO André Breton marshaled cruel language to attack erstwhile companions, some of whom would have been astonished to discover that what they saw as minor points of divergence, honest dissent, could bring out so much passion. A number of Breton's victims, though not all, met to plot a counterattack. They did not possess an official organ, but a pamphlet in the form of a broadside seemed appropriate. So did their title, *A Cadaver*, an ironic allusion to the Breton group's famous attack on Anatole France which had been distributed along the route of the deceased academician's funeral procession.

But if the original broadside was an attack on older reformers by young rebels, the second *Cadaver* was a rebuke to "Inspector Breton," or "Pope Breton," by former friends, older or younger than he, in vituperative language equivalent to his own. The roster of his enemies was now impressive, ranging from the veteran modernist Georges Ribemont-Dessaignes to more recent recruits such as Raymond Queneau and Jacques Prevert.

It remained for Robert Desnos, Breton's junior and a latecomer to Surrealism, to strike the hardest blow. He dismissed Breton as an imposter who lied to his friends, accused him of hypocrisy because he

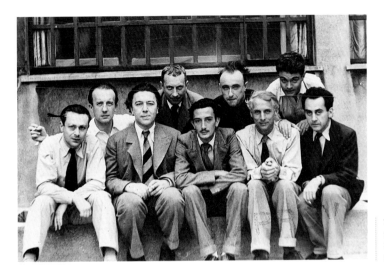

The Surrealists with their chieftain, André Breton (front row, second from left)

criticized others for making money with their art while he himself lived "on the fat of the land" by selling paintings, praising only those artists on whom he made money.

And Man Ray in all of this? Quite simply, he was not expected to take sides. Just as he had watched from a distance when the Surrealists brushed Tzara's Dada out of their hair, he could remain fast friends with Robert Desnos while pursuing cordial relations with a man Desnos despised. Later on, Man Ray would say that, despite his total confidence and respect for Breton, the Surrealist chieftain intimidated him. His closest companion in the group then and later was Paul Eluard, regardless of Eluard's attachment to the Communist Party. Eluard was "the most human," someone with whom everyone could get along.

In fact, Eluard was one of the first of the group to join the Communists, in as early as 1926. "Why are you getting mixed up in politics?" Man Ray remembered asking him. "They will betray you sooner or later." "They need me," Eluard replied. Man Ray did not think that Eluard, with his complicated expression, could communicate with the masses; he worried that his friend might be "the first one assassinated." Confronted with Eluard's stubborn determination,

Man Ray remembered telling him: "A poet doesn't need to justify his existence."

In his second manifesto Breton had revealed his own unsatisfactory relations with the French Communist Party. Quite simply, the Communists were not interested in the Surrealists, these "strange animals." The Party, he said, was already packed with doubtful characters, including police informers, and yet scorned a potential friend such as Breton.

And still Breton persevered. Beginning in July 1930 his *Révolution Surréaliste* reappeared under a title making its political allegiance unambiguous: *Le Surréalisme au service de la révolution.* The opening page reproduced a telegram from Moscow calling on the Surrealists to state their position should "imperialism declare war on Soviets." In their reply the Surrealists promised to act according to the directives of the French Communist Party. If it were felt that they could be of service, they were at Moscow's disposal "for precise mission making any use of us in our role as intellectuals."

Although Man Ray was not asked to take part in this very French debate, he was nevertheless in the movement, since that first issue of *Le Surréalisme au service de la révolution* featured his work. Yet typically, it was a Surrealist image of Lee Miller half hidden under a wire net, illustrating a literary text by Breton—thus nonpolitical.[1]

Man Ray never tried to look like a member of the proletariat. One of the best Champs-Elysées tailors made his suits in exchange for advertising posters. "Man was not exactly a dress dummy in his size or general shape," Lee Miller remembered fondly, "but he was always beautifully dressed by his tailor, marvelously." Alexander Calder would recall that Man Ray was "the only one of us who had money and never left I.O.U.s in the bistros." Man Ray himself confessed that when André Derain, seated alongside him at La Coupole, invited him to see his low-slung custom-built racing car parked at the curb, he was more interested in Derain's automobile than in his paintings.

Lee Miller's recollections of her teacher, at the beginning of the 1930s, compose the portrait of an industrious Man Ray. This odd couple was always busy taking pictures, trying out new techniques. One product of these efforts was a portfolio of stunning photographs of his pliant pupil and model; she was the "goat" of his experiments, she would later say—but not with bitterness.

Certainly it was such dedication that kept Man Ray's income up at a time when professionals in occupations not deemed essential were beginning to feel the pinch, as economies all over the industrial world were sucked in by recession. Indeed, his insistence on pay for work was now to clash with the anxieties of a woman dependent on the kind of income that was bound to decline in the context of crisis.

From Man Ray's earliest days as the photographer of Left Bank celebrities, relations with Gertrude Stein had been distant but cordial. Perhaps at the beginning her salon was a useful point of contact between Man Ray and potential portrait clients, and there is evidence that she found Man Ray helpful in expanding her own circle to include the stars of Dada and Surrealism. ("Thanks for your kind invitation for Friday," Man Ray wrote her at one point. "I shall come and try to bring Duchamp. Tzara is out of town.")

Then came the break. "Dear Gertrude Stein," his letter of February 12, 1930, began. "I am leaving in a few days and need all the money I can get together for the South." What he wanted, specifically, was 500 francs for a recent series of portraits. "My dear Man Ray," began her response

Kindly remember that you offered to take the last series of photographs the first time you saw my dog, kindly remember that I have always refused to sit for anyone who wishes to photograph me in order to give you the exclusive right, kindly remember that you have never been asked to give any return for your sale of my photos. My dear Man Ray we are all hard up but don't be silly about it.
Pleasant trip.
Always,
Gtde Stein

He did not reply; their relationship was over. Later he sought to explain how he felt just then. True, he was known to be an expensive photographer, most likely because he sent out bills whenever he thought the sitter could pay. It was not only the money, but he felt that photography kept him from more creative work and thus he expected retribution.

There would be some better known, some more significant clashes involving Gertrude Stein. Her break with Hemingway became a part of the Montparnasse legend, when she hinted in a book at his deficient manhood, and he in another book revealed what he saw as her abject behavior with respect to her companion Alice B. Toklas. "If Hemingway had some gripes about her, I have some, too," Man Ray told an interviewer late in life. While other artists had accepted him as a colleague, he explained, "to Gertrude Stein, I was a photographer who was going to help her with her publicity."

Another time, he attacked her famous phrase the "Lost Generation," which he thought that she had invented out of spite. "Why do they remember us if we're 'lost'?" he wondered.[2]

Lee Miller had now been with Man Ray for a year, working alongside him and often taking over his jobs, assignments he did not particularly want to handle or which did not pay enough. He had taught her how to take fashion pictures and he had taught her to set up portraits using his techniques. So she felt that she now had adequate experience to justify what she was going to say. "Isn't it silly for you to be photographing all these grand and famous people? Why don't you get on with your painting, and I'll do the photography." He was engaged in time-consuming labors in those years when there was nothing automatic about picture-developing, not to speak of picture-taking. They used glass plates that had to be unpacked carefully for loading into the chassis of the camera; after exposure the plates required equal caution, to be fixed on special frames before being plunged into the development tank. And in Man Ray's diminutive studio, this was an especially tedious routine,

for, as Lee Miller recalled, "the darkroom wasn't as big as a bath-room rug."

He did not take her up on her offer; later she admitted that it would have been difficult for him to return to painting half-time.[3]

André Breton believed it his duty to object to the opening of a cabaret on boulevard Edgar Quinet that dared to exploit the sacred-to-Surrealism name Maldoror, and had denounced Robert Desnos for his apparent endorsement of the place.

What Breton did not mention in the manifesto was the rapid mobilization of a Surrealist commando to attack the offending establishment. On the night of February 14, 1930, the Breton brigade marched on the cabaret, located between the Montparnasse railway station and the cemetery, bursting in during a formal banquet. The solemnity of the occasion served as a stimulus to Breton, who strode to the bar and rapped it fiercely with his cane as he proclaimed, "We are the guests of the Count de Lautréamont!" He then joined André Thirion in wrenching tablecloths from the tables, causing a shattering of bottles, glasses, and plates. Invaders, diners, and waiters came to blows. The Surrealist side took at least one casualty, as poet René Char received a knife thrust to the thigh.

That same month, Henri Broca, still Kiki's man and still editor of *Paris Montparnasse*, remarked that the Maldoror cabaret was drawing crowds, although it had been unsuccessful under a number of previous names (such as Le Vertige, Le Singe, and even La Sevillana). To illustrate how Montparnasse was being exploited, he described how the opening of still another cabaret and dance hall in the Quarter had been reported in a popular daily: "Montparnasse sent its queen," the newspaper gushed, "with some of her subjects" The queen was of course Kiki, and her subjects identified in the article were Broca himself, Pascin, and Kisling. In fact none of the persons mentioned in the story had been present, and Broca suspected that the source of the erroneous report was the cabaret itself.

Despite the frivolity, and the exploitation of frivolity, there is evidence that the Quarter continued to be pertinent to artists and writers. Other sections of the city seemed fenced in—Montmartre, for instance, limited by its climbs and declines. Like America's Far West, Montparnasse seemed to have no boundaries. One roamed it on foot, and in any direction. The boulevard itself could be seen as a strip of desert extending to the horizon, with a multitude of coves in which to hide.

And if the most fastidious of the Surrealists, their chief, still made it a point to keep his distance from Montparnasse, some of his comrades had not been able to resist. "Aragon and the other Surrealists were in evidence all over Montparnasse, in the cafés, bars, cinema," recalled Kiki's translator, Samuel Putnam. "If they occupied a table at the Dôme, it was invariably the noisiest of all and they were the center of attraction."

But Aragon too had his serious moments. During a visit to the Soviet Union with his companion Elsa Triolet and his rue du Château comrade Georges Sadoul, Aragon and Sadoul took part in a so-called international revolutionary writers congress. Before it was over they were official French delegates and had crossed over to the Stalinist side, formally renouncing the Breton brand of Surrealism. On his return to France, Aragon published a long poem, "Red Front," which in no-nonsense, nonpoetic language called for revolutionary violence. "Mow down the cops / Comrades," it declaimed, calling on workers to march on the wealthy quarters of Paris "where sleep / wealthy children and first class whores." In passing they would "sweep out" the palace of the French president, and "fire on Léon Blum," the French Socialist leader.

The publication containing his incendiary poem was confiscated by the police in November 1931, and Aragon was eventually indicted for inciting sedition and murder. Although Aragon had so publicly broken with his former comrades, Breton and his friends felt obliged to defend him (lyric poetry *must* employ violent language, they said in effect).

Writing in the December 1931 issue of Breton's *Le Surréalisme au service de la révolution,* Aragon called attention to another irony. No matter how extreme they became, the work of these would-be revolutionaries were collectors' items. "In 1930 and 1931, we have attained this paradoxical result: our doctrine is considered a luxury product *precisely* because of its revolutionary character. Bourgeois society accepts it only in smaller and smaller printings."

The truth, known to everyone who frequents galleries and auction rooms, is that Louis Aragon's discovery still holds. Surrealism pays, no matter how violent or subversive it was designed to be.[4]

19 | *Exchanges*

ANOTHER MEETING AT THE CAFÉ DU DÔME was to merit a place in cinema history. Luis Buñuel was then a young man promised to the film art, but he needed a push. Spanish born and bred, he also knew that the kind of film he intended to make would be understood only in Paris. His brief first try, *Un Chien Andalou,* written with another hopeful Spaniard, Salvador Dalí, was ready for showing, if only somebody cared. Then at the Dôme he was introduced to Man Ray, who in turn introduced him to Louis Aragon. Buñuel suggested that the movie he had just made could be considered Surrealist. Indeed. It opened with perhaps the most infamous Surrealist shot of all: a man slices into his lover's eye with a razor.[1]

Dalí had actually been around for some time before anyone noticed. Maxime Alexandre remembered that it was a fellow Catalonian, Joan Miró, who arrived at a Surrealist gathering in 1929 "in the company of a shy young man, unobtrusive, wearing the suit and starched collar of a store clerk, and he was the only one among us who also sported the store clerk's mustache." For some time Dalí would live in the shadow of his immediate seniors; his first éclat was of course *Un Chien Andalou.*

To believe some of his peers, everything the young Dalí achieved

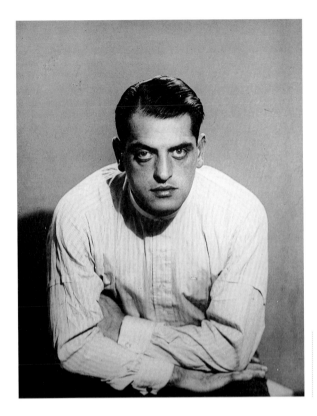

Filmmaker Luis
Buñuel, a late
addition to the
Spanish contingent
of the Surrealist
movement

during his climb was borrowed from those who preceded him. Yves Tanguy's Surrealism inspired his painting (with a touch of De Chirico, Ernst, and Miró). His chief assets were an unerring brushstroke and a controlled application of insolence.

He also knew how to draw attention. Alexandre also remembered the day Dalí was summoned to Breton's home to be scolded for a painting in which Lenin's portrait appeared on somebody's rear end. Dalí arrived with a thermometer in his mouth, his laces undone so that his shoes flew across the room as he rushed in, causing the other guests instinctively to bend to retrieve them. Turning to Breton, Dalí declared his affection in an exaggerated Spanish accent, quickly adding that he had dreamed the previous night that he had sodomized Breton. (To which Breton responded coolly: "I don't advise it.")

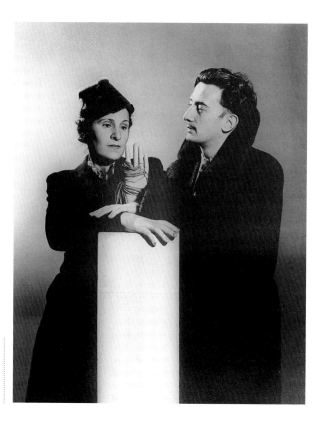

Salvador Dalí
and his wife, Gala
(formerly Madame
Paul Eluard),
in a suitably
Surrealist pose

But Dalí was part of the scene now. We have the photographer Brassaï's word that Picasso was an early admirer of his young country-man, which won him access to the best galleries. When Paul Eluard's voracious wife, Gala, transferred her allegiance to Dalí in 1930—Gala who was perhaps three to five years Eluard's senior (nobody knew her precise age), and at least half a dozen years older than Dalí—the ambitious couple began an ascension that would never stop. Breton later found what he felt was the perfect anagram for him—Avida Dollars. (When Gala went off with Dalí, some of the group called her the Cash Register.) By all accounts Gala (born Helena Dmitrovnia Diakonova) was a seductress, and Eluard, whose passion was mainly in his head, had encouraged her straying, enjoying the prospect of a threesome (at one time he shared her with Max Ernst). With Salvador

Dalí the sex was exclusive, but not a prerequisite for living together or even for marriage.

Perhaps Dalí's luck in his early Paris days was his association with Buñuel as cocreator of *L'Age d'Or*. Episodic, as most Surrealist films were, it proceeded by a series of shocks, and the result was sacrilegious enough to create scandal even among spectators who could not have made sense of the unconnected scenes. (A count who plays host to an orgy has the head of Christ.) In his memoirs Buñuel admitted that in his effort to avoid any resemblance to commercial cinema, he had jotted down a series of dissociated ideas which he called gags.

L'Age d'Or was first shown in a tiny cinema, Studio 28, beginning on November 28, 1930. Its debt to Surrealism was underscored by an accompanying art exhibition showing works of Ernst, Miró, Arp, Tanguy, and Dalí (Man Ray was represented both by paintings and photographs of members of the group). It took some days for news of the virtually private screenings to reach the outside world, but then the reaction was brutal. On December 3 young toughs affiliated with extremist groups, the League of Patriots and the Anti-Jewish League, erupted in the little theater, shouting, "We'll see if there are still some Christians in France," and "Death to the Jews!" They tossed smoke grenades and stink bombs, damaged the screen, and then proceeded to lacerate the paintings on display.

Left-wing militant André Thirion was ready for combat at the next showing, accompanied by a group of workers armed with blackjacks. But by then the danger was elsewhere, as the conservative press called for seizure of the film. That was accomplished on December 11. It would not be seen in Paris again for another fifty years.

The sequence of events, the provocation by right-wing extremists followed by the ban, was a sign of a growing Fascism, so declared a statement endorsed by Aragon, Breton, Crevel, Eluard, Péret, Man Ray, Sadoul, Tanguy, Tzara—and most other Surrealists, whether regulars or dissidents.[2]

Another odd duck on the Montparnasse stage, another foreigner who never lost his outrageous accent, was the never-quite definable Ilya Ehrenburg, sometimes a Bolshevik, sometimes a skeptic. As observed by the American journalist Samuel Putnam, Ehrenburg moved about the Quarter seemingly disconcerted by the antics of the café dwellers, shocked by the Surrealists—yet there he was among them at the boulevard cafés. When La Coupole replaced the Dôme as everybody's preferred clubhouse, the Russian was to be found at the Coupole bar, holding court at his own table (the last at the back), clearly content when he could introduce the young to the old, novices to celebrities, Frenchmen to Soviets. Among the latter were filmmaker Sergei Eisenstein, storyteller Isaac Babel, journalist and Communist activist Michel Koltzov, the first a lifelong martyr to Stalin's censors, the last two fated to be liquidated in Stalin's purge of cosmopolites. Among Russians permanently attached to Paris, and to La Coupole, there was Aragon's Elsa Triolet, in the description of Italian-in-Paris observer Nino Frank "fairylike, blond, fleeting expression, all in rapid moods and pouts, emitting a charm at once subdued and brilliant. . . ."

One would have to slip out of Ehrenburg's orbit to meet the Americans. In his café roamings, the observant Samuel Putnam would notice an obscure proofreader working for the Paris edition of a leading American daily newspaper. Henry Miller would stride into the Montparnasse cafés late at night after next morning's paper went to press, to expound philosophy, chiefly in four-letter words, to fellow Americans as drunk as he. Occasionally one of them would answer him with a banal put-down: "Why don't you write a book?" None of his listeners suspected that he really did write or intended to.

And although they were virtually neighbors, and shared the same cafés, Henry Miller and Man Ray never met. That was to happen only during World War II, and in far-off California. Miller later explained that in the Montparnasse years he had actually wanted to meet Man Ray but had been discouraged from doing so by "the English-speaking clique," who considered Man Ray "a phony."

Youki was another Montparnasse regular. Smallish and blond, with hazelnut eyes, she was born Lucie Badoul, rechristened by her first lover, the painter Tsugharu Foujita (who told her that *youki* meant "pink snow" in Japanese). Raised in Paris by a mother of Belgian origin, pert and pretty Youki appeared to have little difficulty adapting to the wilder ways of the Quarter. She would be compared to Kiki. She did have Kiki's compact body and lively curiosity, but with a somewhat better preparation for the world of artists and writers. She purchased books and journals and read them. She picked up Apollinaire's *La Femme assise,* published posthumously in 1920, and what she read in it about La Rotonde made her want to see for herself. And there she was, sitting at a table alone when she saw that odd little man with prominent brown bangs, horn-rimmed glasses and a small mustache, elegantly if curiously dressed—and she was at once captivated by Tsugharu Foujita.

They would spend their informal honeymoon in a Montparnasse hotel. By then she had attained the age of twenty-one and felt it was all right. Now she entered a world of painters and their mistresses. Her joyous love life with Foujita is suggested by sketches reproduced in her memoirs.

As she remembered it, Foujita happened on a copy of *La Révolution Surréaliste* and asked Youki to find more issues for him. She went to Man Ray for help, and he directed her to the Galerie Surréaliste on rue Jacques-Callot. But in the end Foujita was not impressed by the Surrealists; she would have to meet them alone. (The page of her memoirs containing this resolution reproduces a sketch—perhaps by Foujita himself—of a naked Youki, head lowered into her hands, held on a tight chain by Foujita.)

Her encounter with Robert Desnos was singular. He was sitting at an adjacent table at a small bar on rue Bréa. She observed that he was "slender, with combed hair from which a lock constantly fell over an eye." He was wearing a tuxedo. After they were introduced he began talking rapidly as he twisted the wrappings of their drinking straws

into the shape of a spider, letting a drop of liquid fall into the middle, which caused the spider legs to move. "How do you find him?" Breton asked when she mentioned meeting Desnos. "Quite unpleasant," she replied, and despite her protest he dashed off an angry letter.

Meeting Desnos again soon after that, she apologized for having told Breton about their meeting. "Don't worry about it," he replied. "Breton is angry with me but I'm not angry with him."

Henceforth she would spend much time with Desnos, letting him fall in love with her. He called her his Siren, and Foujita, who seemed not to mind, painted a Siren on her thigh. But it was only when the painter took up with another woman that Youki moved out to share the simple life of Robert Desnos.[3]

In this milieu of easy exchanges, no one could have been more jealous of Youki's freedom than Lee Miller. She was Man Ray's assistant, and increasingly his surrogate. Many of the friends she made through Man became her friends, and would remain hers as well as his after their separation. By then she had her own duplex studio cum apartment a short walk from rue Campagne-Première, at the corner of rue Schoelcher, facing Montparnasse cemetery. She had her own clients now, and modeled.

Her relations with Man Ray remained satisfactory on the professional plane, still no disruptive signs of ego on either side, but they were occasionally stormy in private life. Later she recalled an incident that bridged the two. He had done a head portrait of her stressing her long neck. Dissatisfied with what he had done, he discarded the plate. She retrieved it, and took considerable care to make a good print. He agreed that it worked after all, but then became angry because she claimed it as her work. In the end he ordered her out of the studio. When she returned later she found the print tacked to the wall, the image of her throat slashed by a real razor, while scarlet ink ran from the gash. Later still, he would sublimate the experience by using the doctored photograph, cut throat

and all, among the bric-a-brac in his painting *The Artist's House.*

Just as Lee Miller took full advantage of her independence as a photographer, she was constantly testing the limits of their amatory life. Her son Antony Penrose, heir to her papers, later wondered whether she had ever had a stable relationship with anyone besides her father. After one of her lapses, Man Ray felt his tolerance stretched to new limits, and told her so in an emotional letter she was to hold on to (for her son later quoted from it). "I have loved you terrifically, jealously," Man Ray wrote, "it has reduced every other passion in me, and to compensate, I have tried to justify this love by giving you every chance in my power to bring out everything interesting in you." And until now, until his discovery of her affair with a Russian émigre interior decorator, the arrangement had worked. "You know well," he concluded, "since the beginning I promoted every possible occasion that might be to your advantage or pleasure, even when there was a danger of losing you; at least any interference on my part always came afterward, and stopped before it could produce a break, so we could easily come together again, because every quarrel and making-up is a step toward a final break, and I did not want to lose you."

It was apparently through a Norwegian friend from art school days, Tanja Ramm, that Lee Miller met a wealthy Egyptian resident of Paris, Aziz Eloui Bey, and his wife, Nimet, although the first contact could just as well have been through Man Ray himself. For Nimet (as she was known simply) was a preferred subject for photographers thanks to her well-cared-for classic features and cool severity.

Something about the couple, or about Aziz, twenty years her senior, attracted Lee. Soon she was a houseguest at their villa in Saint Moritz (where another guest happened to be Charles Chaplin, who lent himself readily to her lens). There Lee got what she apparently came for, Aziz Eloui Bey himself.

As for Man Ray, he was simply desperate. Whatever pretense he had made of respecting her independence, he had never denied that he could be jealous. And now it looked like a permanent break. One

who saw him in this state was neutral Jacqueline Barsotti, too young to be a confidante perhaps, but it happened that she too was suffering the breaking up of a liaison. She ran into Man Ray, who looked haggard and purposeless, at the Dôme. He told her, in a voice that broke at times, about the rupture. He suggested that they take a walk. As he rose from the table she heard a metallic sound and to her question he confessed that he was carrying a gun. "Why?" she wanted to know. Because he was going to kill, he said, "her and him, and then myself."

Their route, not by accident, circled the Montparnasse cemetery. It was evident that he wanted to pass Lee's studio, to see if the lights were on. Jacqueline did not know where the studio was, and he did not tell her, but they did go around the cemetery twice. They then walked to his own studio on rue Campagne-Première, where despair ended with photographs. They agreed that there were many ways one

A self-portrait of simulated suicide, which Man Ray probably posed at the time that Lee Miller walked out on him.

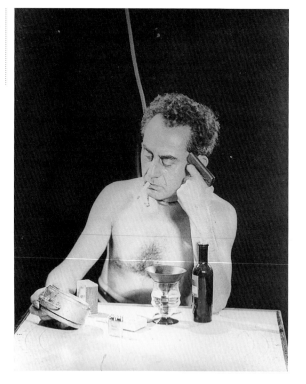

could kill oneself. First, the revolver, and she posed holding it to her head, smiling. He told her that one does not smile when one intends to kill oneself. She disagreed, "because you're doing what you want to do." But then she saw a heavy rope she had not noticed in the studio before, and this truly frightened her. She was also frightened when he posed with the gun held to his own head. After taking that picture she all but shouted, "All right, it's over, we've finished killing ourselves. Let's have a drink." Then or later Man Ray took another picture, for which he not only held a small revolver, but tied a rope around his neck, while a glass presumably containing poison stood on the table.

To believe the young art dealer Julien Levy, who was in and out of Paris buying paintings for his New York gallery, Man Ray's despair was common knowledge, "and it was reported dangerous for anyone to be seen these days with Lee." Levy took a chance all the same, met her at The Jockey, charmed her, and had "a most pleasant evening."

Her marriage to her Egyptian friend and her move to Egypt was not for now. It would take a long detour, via New York, where she settled in autumn 1932 not to wed but to set up a studio of her own and to arrange for a showing of her own work at the Julien Levy Gallery.

Man Ray's reaction to her work was all but indecipherable, addressed to the only one who might understand it. On a page torn from his notebook he scribbled: "Accounts never balance one never pays enough etc etc, love Man." He attached a photograph of Lee Miller's eye, slightly enlarged, on the back of which he wrote in red ink:

Postscript: Oct. 11, 1932
With an eye always in reserve
Material indestructible. . . .
Forever being put away
Taken for a ride. . . .
Put on the spot. . . .
The racket must go on—
I am always in reserve.
MR

But eventually the artist transformed his pain into art.

First, in *Object of Destruction*, the origin of which was one of Man Ray's constructs, a metronome to which the sketch of an anonymous eye had been clipped. Now, in the autumn of 1932, the photograph of Lee Miller's eye replaced the original. But the apparently conciliatory message that Man Ray had sent her was contradicted by the text accompanying the *Object of Destruction*:

> *Cut out the eye from a photograph of one who has been loved but is seen no more. Attach the eye to the pendulum of a metronome and regulate the weight to suit the tempo desired. Keep going to the limit of endurance. With a hammer well-aimed, try to destroy the whole at a single blow.*

It was to endure, this object to be destroyed, remade by the artist again and again, or copied with his permission. Only its title changed, sometimes becoming *An Indestructible Object*, or *A Perpetual Motif*; eventually it would be given the more charitable title—or was it a plea?—*Do Not Destroy*.[4]

Object of Destruction, in which the anonymous eye was eventually replaced by a photograph of Lee Miller's eye

20 *Retrospective*

FORGETTING TAKES TIME, and Man Ray would do it in his own way, by not forgetting. He would, he decided, paint Lee Miller's lips on a "superhuman scale." For that he hung an enormous (39 ½ by 98 ½ inches) canvas over his bed in the rue du Val-de-Grâce flat, and every morning before going to the rue Campagne-Première studio he would work on it in his pajamas for an hour or two, standing up in bed. Lee's full red lips floated over a familiar Montparnasse landmark, the Observatoire built for the Sun King. He walked past it daily going from home to studio, from studio home again, seeing its domes as upright breasts. He painted in the title at the bottom of the canvas: *A l'heure de l'Observatoire—les amoureux. At Observatory Time—the Lovers.*

He discovered that he was out of practice; those long years during which he found little time for painting had taken their toll. Even if photography required meticulous preparation, the act itself transpired rapidly, whereas in painting every stroke called for intensity and concern. He worked on the painting on and off over a period of two years, and even after its completion he kept it hanging over his bed. When at last he had a one-man show in Paris he made sure it hung there, and he was surprised at how much smaller

Man Ray used this nostalgic painting, *At Observatory Time—The Lovers*, which hung over his bed, as the setting for this fashion photograph

it looked in the gallery. At the first retrospective of Dada and Surrealism at New York's Museum of Modern Art in 1936, the painting was placed at the entrance and seemed to serve as the keynote. The day after the opening he returned to see that it had been removed, hung inside the gallery with everything else. It turned out that one of the museum officers had objected to its emplacement, considering the work obscene.

For the final issue of *Le Surréalisme au service de la révolution*, the finality certainly due in part to the raucous dissensions between factions, Man Ray provided what may have been the most shocking piece of work he had available when Breton came to him for a contribution. *Monument to D. A. F. Sade* he called it, and devoted a whole magazine page to a photograph of a woman's buttocks, framed by a line drawing of an inverted Latin cross.

Then a new publication came into being, thanks to the publisher Albert Skira, whose early achievements included limited editions illustrated by Picasso, Matisse, and Dalí (this last with a memorable accompaniment to the sacrosanct *Chants de Maldoror*). His sumptuous luxury magazine, christened *Minotaure,* was designed for a public of well-to-do art lovers prepared to embrace the spirit of the age. The concept was broad enough to include a veteran modernist like Picasso, but also the insurgents of Surrealism. Breton justified such collaboration with the class enemy by the fact that the Surrealists could no longer finance an organ of their own. Skira's magazine was intended to be eclectic, Breton later explained, but Surrealism improved its position with each new issue, until it simply took over.

It was also a splendid outlet for apolitical Man Ray. An early issue used as its frontispiece one of his projects for the cover of the first retrospective album devoted to his photography. A portrait of the artist—in the form of a sculpted bust—is surrounded by studio bric-a-brac: an upstretched hand carved in wood, a glass snow ball held by a marble hand, a photograph of a model crying glass tears.[1]

Man Ray was now, as early as the summer of 1933, deeply committed to this first overview of his photographic achievement, working on it "feverishly," so he would tell friends, while letting no opportunity pass to remove himself from the places, public or private, he had inhabited with his lost love. Perhaps it was purely for art's sake, but a new face and a new body were to appear in the album—that of the mysterious Natasha, and there is evidence that his interest in her awesome body went beyond the aesthetic. The relationship, however defined, lasted half a dozen years, until he felt comfortable with another full-time, live-in companion.

Meanwhile, for most of his comrades a summer hiatus, and preferably a southern one, was now de rigueur. It had not been so for Man Ray, but now he was given a chance to join his friends on vacation while carrying out a job, thereby lessening whatever guilt he might feel

about abandoning his studio. Marcel Duchamp had gone with Mary Reynolds to Cadaqués, a humble fishing village on Spain's jagged Costa Brava just south of the French border. It had been an early haunt of Picasso's, later a favorite of the Surrealists, and it was both cheap and quiet in those years before massive tourist migrations.

Salvador Dalí, a native of the region, was preparing an article for *Minotaure* on Art Nouveau architecture, exemplified in Barcelona by the weird genius Antonio Gaudí. While it is not clear whether the initial impetus came from Duchamp, or from Paul Eluard (who knew what the magazine needed, but also knew what Man Ray needed), the job of illustrating Dalí's report on Barcelona was Man Ray's to take. He would go to Cadaqués to stay with Marcel and Mary, then travel down to Barcelona to photograph its astonishing buildings, notably Gaudí's masterwork La Pedrera. "Man Ray will probably be in Cadaqués next week," Eluard wrote in one of his confessional letters to his lost but still beloved Gala. "You must make use of him, either by buying his photographic plates or by telling him that he can submit his bill to Skira."

Dalí's article, with photographs taken in Spain by Man Ray and in Paris by Brassaï, would be called "Of Terrifying and Edible Beauty, of Art Nouveau Architecture." To explain the title, Dalí recalled Breton's famously terrifying phrase: "Beauty will be convulsive or nothing." Alongside a photograph of one of Barcelona's gingerbread steeples, resembling nothing so much as a wedding cake, Dalí concluded: "The new Surrealist age of the 'cannibalism of objects' justifies this conclusion as well: 'Beauty will be edible or nothing.'"

Among other services rendered to his friend, Eluard had written a poem, "Man Ray," to introduce the collection of photographs of nudes in the retrospective album. It contains a line that sums up Eluard's attitude as much as it does Man Ray's: "You are too lovely to preach chastity." Meanwhile one can imagine that Eluard suffered the loss of Gala at least as acutely as Man Ray did Lee. Letters of Eluard begin: "My beautiful Gala, my dearly beloved, my only one . . ." or

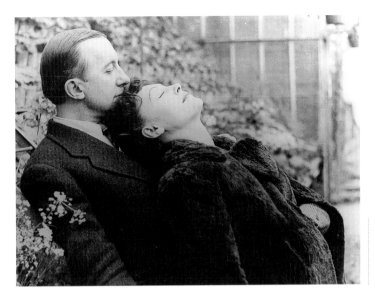

Paul Eluard and his wife, Nusch, protagonists of one of the great love affairs of Man Ray's Paris

"My Gala forever . . ." One of Eluard's biographers repeats the story that Eluard always carried a photograph of naked Gala in his wallet.[2]

Even without Gala there was, finally, a happy ending for Paul Eluard, spelled N-u-s-c-h. A dozen years his junior, she was born Maria Benz, of Alsatian stock, as sentimental as he was, and undemanding, especially unquestioning. Picasso was one of many who fell in love with her—at least with her face and her figure, which he painted often, although it was never proved that he too was involved in an Eluardian threesome. Man Ray could have filled a book with the photographs he took of her. Nusch married Eluard in 1934.

We also know that another piece of work that year, one that did not require travel, provided considerable distraction. Meret Oppenheim was another of the women of talent who lent their bodies to Man Ray. He would recall later that she was "one of the most uninhibited women I have ever met." She was a fellow artist, a professional who understood that this photographer knew what he wanted. At his command she spread her spectacular body over the studio carpet, or across the studio couch, or posed standing, again totally nude, with an overdressed, behatted, fake-bearded friend—the painter

Meret Oppenheim, Man Ray's colleague in Surrealism, model, and special friend, who lent herself generously to his experimental photography in *Erotique voilée*, 1933

Louis Marcoussis. One of these shots, in which she stands behind the wheel of the artist's engraving press, the palm of one hand and lower arm stained with printer's ink, became a Surrealist fetish.

She was born in Berlin in 1913, daughter of a Jewish doctor; her mother's Swiss passport would later protect her. She grew up bourgeois, studious, artistic, and literary, influenced by her parents' interest in psychoanalysis and the artists and by writers among the house guests. She herself drew strange, stark figures, products of psychoanalysis as much as of art school. At eighteen, she was invited by her father to study art formally. She arrived in Paris in May 1932 with a girlfriend who knew the city. They taxied from the train directly to the Café du Dôme, even before going to their hotel alongside the Montparnasse station.

With laudatory understatement, a biographer remarked that Meret's "haunting beauty" as well as intelligence and sophistication

served her in the conquest of already famous men. One of the first was Man Ray, immediately followed by Max Ernst. Within a year of her arrival she was invited by Hans Arp and Alberto Giacometti to participate with the Surrealists in a Salon des Surindépendants; already she had oils to show, and drawings, collages, and assemblages. Sometime later she would enter modern art legend with *Déjeuner en fourrure*, a fur-lined cup, saucer, and spoon (purchased on sight by New York's young Museum of Modern Art).

During the winter of 1933–34, Man Ray pursued his painstaking preparations for the retrospective album. From the start he had a benefactor, who eventually became his personal publisher, in a young art connoisseur and admirer, James Thrall Soby, born in Hartford, Connecticut. While a freshman in New England's Williams College Soby had purchased his first painting and, after another year in school, dropped out to go to Paris to begin more serious collecting. With his family fortune, one might say that he took no risk in buying what he liked; perhaps the greater risk was to publish his opinions as a neophyte art critic. As Man Ray put together the 105 photographs that would compose the album, an album to cover his career from 1920 to the present, he had the support of Soby, but it was Man Ray who chose his subjects, his engravers, and his prefacers. At last Man Ray himself seemed to realize that his photography was his art.

Picasso had promised to sketch Man Ray's portrait for the book. But when Man Ray showed up in wintry weather the master seemed not to be in his best form. The lack of heat in the studio may have had something to do with that, and Man Ray himself kept his overcoat on. Picasso sat on a low stool with a pad on his knees and a bottle of ink on the floor beside him. He seemed to be going about his work clumsily, blackening his fingers as he scratched away. If Man Ray was surprised, it was because he had seen Picasso work before and knew how swiftly and surely he could sketch.

At one point Picasso put down the pad and stood to roll a cigarette. Grumbling to himself, he rubbed the drawing with wet fingers,

Cover of the original edition of Man Ray's first book of photographs spanning the early Montparnasse years (published by James Thrall Soby in 1934)

getting ink on his mouth and hands. As he showed the blotchy portrait to Man Ray, he said he was not sure that he could use it, and would not mind if Man Ray decided to throw it away. Man Ray assured him that he would send it to the printer as is, if Picasso had no objection. He actually liked the idea that the artist had struggled with it—but perhaps after all he was only suffering from a head cold. In any event the sketch was a good likeness, even if a mess by academic standards. It was signed, and dated, on that chilly 3rd of January 1934, and became the album's frontispiece.

Man Ray used his own introduction, "The Age of Light," which he had published first in *Minotaure;* in it he called this first overview of his photography "autobiographical images." And indeed the book's opening section was a medley—studio scenes, arrays of objects, fruits and flowers, a locomotive—not exactly what one expected from him. Then Eluard's poem, introducing the nudes composed of headless backs and fronts we now know to be Kiki's and Lee Miller's, a celebrity performer, and a number of unidentified young women.

A preface by André Breton, titled "Les Visages de la Femme," clumsily rendered in English as "The Visages of the Woman," introduced faces, the familiar Kiki and Lee again, and Jacqueline, and even Gertrude Stein, but many more that remain anonymous in this tour de force of a book deliberately left uncaptioned. André Breton expressed awe at the photographer's ability "to surprise human beauty in movement at the very point where it reaches its full power."

Rrose Sélavy, not otherwise identified (and so most readers would remain unaware that this odd name hid an artist they did know, the playful Marcel Duchamp), introduced Man Ray's portraits of men— Man Ray himself, Duchamp, and their Surrealist comrades, Picasso, Braque, Derain, Matisse and Brancusi, Joyce and Eisenstein. As expected, Madame Sélavy's contribution was the most thoughtful. "There they stand and stare at the landscape which is themselves, the mountains of their noses, the defiles and folds of their shoulders, hands and skin, to which the years have already so accustomed them that they no longer know how they evolved....Women have told them what is attractive in them; they have forgotten; but now they put themselves together like a mosaic out of what pleased women in them....For they have a body only at night and most only in the arms of a woman. But with them goes always, ever present their face." While the other contributions were printed in French and English, Duchamp whimsically published his in German and English.

Appropriately, it was for Tristan Tzara to introduce the final section, a collection of rayographs. "These are projections surprised in transparence, by the light of tenderness, of things that dream and talk in their sleep."

As for that seductor Breton, he soon had an opportunity to demonstrate that Man Ray could draw out beauty in all its power. The occasion was his new marriage that August to twenty-three-year-old Jacqueline Lamba. He had already been exhibiting nude photographs of his fiancée on the walls of his flat, and had taken friends to a theater where she was dancing unclothed underwater. Now, after their

wedding lunch, the bride stripped again for a photograph by Man Ray, posing with Breton's witnesses Eluard and Giacometti in a remake of the Manet painting *Le Déjeuner sur l'herbe.*

The other Jacqueline, Mademoiselle Barsotti, was with Man Ray when the first package containing copies of his book of photographs was delivered to rue Campagne-Première. He decided then and there to autograph one for her. But what to say? "To the most beautiful girl I have ever photographed," he suggested.

"Not true and not flattering to the others," she objected. "To the only one I didn't sleep with?" "Too compromising for the others who may have done so." "To the most inspiring one?" "A compliment for me, but a perfect way of being rude to others."

So it would be, simply: "With all my love, Man Ray," and she was delighted.

Now, with his first retrospective behind him, Man Ray should have been ready to begin creating the rest of his life. If so, it would be in a strange mood, for neither he nor his mentor Marcel Duchamp believed in a future. Duchamp continued to divide his time unequally between chess and maintaining his reputation as one of the precursors of modern art, maintaining it, but not expanding it. In Paris, although he enjoyed the company of his friends, fellow artists especially, and Man Ray in particular, he was vulnerable to the general pessimism.

By 1934 the depression had laid France low and whipped up latent political animosities between the classic right and classic left. Proto-Fascist extremists were emboldened to launch an assault on the French parliament in session; it was routed, but France in the prewar decade would never be confident again.

It was in this context that Duchamp's deliberately slow-paced life was intruded upon by a questionnaire—of all things from the coauthors Morrill Cody and Jimmie Charters, preparing the bartender's story for publication. How, the authors wanted to know, would Duchamp sum up the glories of Montparnasse?

Glories there had been, Duchamp conceded. "Montparnasse was the first really international colony of artists we ever had. Because of its internationalism it was superior to Montmartre, Greenwich Village, or Chelsea. . . . But Montparnasse is dead, of course, and it may take twenty, fifty, or a hundred years to develop a new Montparnasse, and even then it is bound to take an entirely different form." He saw a similar regrouping in Hollywood, which he called "an industrialized, popularized Montparnasse."

But that was almost a positive statement. In addressing their question to Man Ray, Cody and Charters would get no similarly broad and benign view. What they got was a Man Ray who was obviously still suffering the loss of Lee Miller.

"I can see no reason for the continuance of the human race," Man Ray wrote as his response. "The sooner it dies, the better. Montparnasse has done much to help the cause."[3]

21 *Causes Célèbres*

THE AMERICANS OF PARIS were going to prove, if Hemingway and hot-blooded café-busters like Malcolm Cowley had not already done so, that they could wage a vendetta with as much gusto as any Surrealist or Communist, or, for that matter, as the French School, in its guerilla war against the École de Paris. The spark that touched off the Gertrude Stein affair was her autobiography, playfully written as *The Autobiography of Alice B. Toklas.*

For some—people of whom she had written—the book left a bitter aftertaste. Under the cover of joviality, the author had shot off some poisoned arrows. Among her targets was the publisher of *transition,* Eugène Jolas, and his wife, Maria. The Stein memoir let it appear that they were late arrivals at their own magazine, and that Jolas's coeditor for a time, Elliot Paul, had actually created it. "Alice Toklas" also let it be known that when *transition* ceased to publish contributions by Gertrude Stein, the magazine "died."

Her book appeared in the United States in September 1933 but the counterattack was slow to germinate. When it came it took a very French form—a pamphlet, distributed as a supplement to the February 1935 issue of *transition* (for the magazine had not "died" after all). In a preface, Eugène Jolas explained that it seemed wise to

correct Gertrude Stein's inaccuracies "before the book has had time to assume the character of historic authenticity." He did it by opening the magazine to those who saw themselves as victims of her errors. "These documents invalidate the claim of the Toklas-Stein memorial that Miss Stein was in any way concerned with the shaping of the epoch she attempts to describe," Jolas declared. "There is unanimity of opinion that she had no understanding of what really was happening around her. . . . Her participation in the genesis and development of such movements as Fauvism, Cubism, Dada, Surrealism, Transition, etc. was never ideologically intimate."

But if the opinion of Jolas himself mattered little to Gertrude and Alice, the names of other contributors to "Testimony Against Gertrude Stein," the unforgiving title of a cruel indictment, would hurt.

The first contribution came from Henri Matisse, already a long-established signature in modern art. He contested Gertrude Stein's explanation of the origins of Cubism, for she saw Picasso and not Braque as the precursor. On a more personal matter, she described Matisse's wife as "a very straight dark woman with a long face and a firm large loosely hung mouth like a horse." Matisse protested that his wife was "a very lovely woman." Matisse attributed Gertrude Stein's depreciative remarks about himself to an early feud (he had been angry with her over her failure to help Juan Gris during the 1914–1918 war, despite a promise to do so).

There was also a contribution by Tristan Tzara, whom Man Ray had introduced into Stein's circle. For him, Miss Stein was a self-confessed exploiter of those who entered her drawing room, for she herself described how she would attract visitors by her impressive art collection—people who might then become useful in placing an article of hers in a magazine.

In his own response to the Stein autobiography, Braque himself dismissed her widely heralded expertise. "Miss Stein understood nothing of what went on around her." Her insufficient knowledge of French had been a barrier. She had misunderstood Cubism, which she

saw only in terms of personalities, when in fact he and Picasso had sought to efface personality, and amateurs mistook Picasso's paintings for his. "Miss Stein obviously saw everything from the outside and never the real struggle we were engaged in," he summed it up. "For one who poses as an authority on the epoch it is safe to say that she never went beyond the stage of the tourist."

The little pamphlet, although published by a small-circulation avant-garde literary magazine in Paris, crossed the ocean quickly. It found Gertrude Stein on an American journey, in Chicago, and reporters were ready with questions. Matisse's attack on her provided a sensational element, and no one forgot that she had compared his wife to a horse. She tried to convince the press that the comparison had been intended as a compliment, for she was crazy about horses.[1]

Man Ray had not been drawn into the *transition* polemic. His own quarrel with Gertrude Stein would remain private. With one notable exception, he managed to keep out of the year's causes célèbres and his 1935 was an industrious one.

But if hard times could have drawn him away from the essentially nonlucrative universe of his Surrealist friends, and into the tempting embrace of pure commerce, he was paradoxically more engaged than ever now in the concerns of fellow artists and writers. They in turn, and chief censor André Breton first of all, refused to be perturbed by Man Ray's determinedly commercial side, his use of the same cameras and lenses and lights for art photography and work for hire. He even *advertised,* and in the very magazine that by default had become the chief outlet of the Surrealists, *Minotaure.* The June 1935 issue gave him a full page—perhaps in exchange for work he was doing for the magazine—to announce his new studio address on rue du Val-de-Grâce and to advise potential clients that he was available for portraits.

In the same month, Breton called on his American friend for help in mounting a lecture series on the present status of Surrealism. The first talk, in which Breton explained why he was a Surrealist, was

accompanied by a projection of photographs by Man Ray to illustrate the work of Lautréamont, Alfred Jarry, Picasso, and Duchamp, among others. Meanwhile another high-toned review, *Cahiers d'Art,* was offering its pages to members of the group. In a remarkable and remarkably brief essay, "Sur le réalisme photographique," published in *Cahiers d'Art,* Man Ray attempted to show how choice of subject had rescued his photographs from what otherwise would be the crass world of commerce. Likewise, what he described as his untamed photographic Surrealism had enabled his camera work to approach the veritable reality of painting.[2]

No one among the denizens of Montparnasse could have known just how good a Communist Ilya Ehrenburg was, but his credentials as an anti-Fascist were impeccable. The Communist International (or Comintern), the Soviet Union's instrument for furthering its influence abroad, had approved the formation of popular front organizations bringing together Communists and well-meaning souls not affiliated to the Party and not wishing to be. It was a policy Ehrenburg had long been advocating to Moscow.

Now it was time for Ehrenburg to abandon the comfort of his café observation post and to help bring about this much-desired unity of action. His labors would contribute to a new alignment of European intellectuals, but there would be schism where he hoped for union.

In the summer of 1934, after attending a Soviet Writers Congress with André Malraux, himself not a Communist but a willing ally of the Communists in combating Fascism, Ehrenburg wrote a letter to Stalin (who had always looked on him with favor) proposing that Communists join non-Communists in an anti-Fascist coalition. Stalin invited Ehrenburg to come to see him with a plan. But soon after that came the assassination of Sergei Kirov, the popular Communist Party leader of Leningrad, and although Stalin himself may have ordered the killing, he used it as an excuse to launch a ruthless purge of suspected dissenters.

In the ensuing tumult, Ehrenburg did not get to see Stalin, but henceforth he was considered to be on a mission to France, responsible for putting together an International Writers Congress for the Defense of Culture. The chosen site was an appropriate one, the Left Bank of Paris, and much of the planning took place in Ehrenburg's apartment behind the Gare Montparnasse.

To make a success of the meeting, the organizers would not only have to draw writers of the caliber of André Gide from France, but their counterparts from other cultures. Before it was over they had E. M. Forster and Aldous Huxley from Britain, Isaac Babel and Boris Pasternak from the USSR, Bertolt Brecht and Heinrich Mann from Germany, and Robert Musil from Austria. The American contingent was in a minor key, dominated by Communists or their fellow travelers, and in America that was indeed minor.

Shortly before the scheduled opening of the Congress on June 21, 1935, André Breton saw Ilya Ehrenburg leave La Rotonde to cross boulevard du Montparnasse to buy tobacco for his pipe at the shop alongside the Dôme. Breton followed him inside, announced who he was, and proceeded to slap Ehrenburg repeatedly across the face— Ehrenburg stood with his arms at his sides, demanding to know what it was all about.

It was about, and of course Ehrenburg knew it, the offensive language the Russian writer had employed about the Surrealists in a book published in Paris a year earlier. Ehrenburg had referred to the Surrealist group as a "stinking pheasant." Surrealists pretended to support the Revolution, he wrote, but most of all they avoided constructive labor. Yet they were not entirely idle, for they actively studied "pederasty and dreams." They busied themselves devouring a legacy—or a wife's dowry. "The Soviet Union disgusts them because over there people work."

Breton, who himself showed little tolerance of homosexuality, could not have appreciated Ehrenburg's attack on the masculinity of Surrealist males. (They turned away from women, Ehrenburg said,

preferring "onanism, pederasty, fetishism, exhibitionism, and even sodomy.")

The incident at the tobacco counter had one immediate consequence. Having offended a member of the Soviet delegation, for Ehrenburg had that status now, André Breton would be excluded from the Writers Congress.

The meeting was to be an event of international scope, willed by Stalin, who became personally involved in the selection of delegates. At one critical point, when the French organizers criticized the mediocrity of the Soviet delegation, Stalin personally called Pasternak to the phone, ordered him to buy Western clothes, and to get on a train that night for Paris. So certainly the Congress would not stand or fall on someone getting slapped on the boulevard du Montparnasse.

But what happened in the shadow of the Dôme that night symbolized a real debate taking place among congress participants. The repression of dissent inside the Soviet Union was becoming known, as veteran Bolsheviks were arrested, subject to confinement and torture, with executions not long in coming. Sympathizers with the revolution both inside and outside the Soviet Union who rejected Stalin's arbitrary rule were not properly represented at the Congress, and would find it hard to register their protests against the growing repression.

Just three days before the opening of the Congress, René Crevel was found dead by his own hand, having sought in vain to reconcile Surrealists and Communists, and to convince Ehrenburg to allow Breton to speak. True, he was a hypersensitive poet with a febrile temperament, suffered from bad lungs, and forever seemed at the limit of his endurance. His American confidante Caresse Crosby, who could not resist occasionally caressing the boyish René Crevel "for comfort," although realizing that he was sexually out of bounds to her, had found him particularly vulnerable that week. With tears in his eyes he had said to her, seemingly apropos of nothing in particular, "I can't stand it!"

But Ilya Ehrenburg thought he knew what had caused Crevel to take his own life. The "silly story" of the tobacco shop attack had proved to be the last straw for him. And it did seem to bring the Surrealist group to the center of the stage, when in fact they were to have been only a minor element in this congress.

The organizers did all they could to keep them minor. Both André Gide and André Malraux, who presided over the opening of the Congress, were inclined to silence concerning Stalinist abuses, the point being to preserve harmony among anti-Fascists. And it was only after midnight on the next-to-last day of the congress that the rostrum was turned over to Paul Eluard, who was to read Breton's speech. This was the compromise René Crevel had fought for, and perhaps died for.

By then the audience was thinning, and some lights were switched off. While Eluard read to a room divided between sympathizers and the discontent, all expressing themselves energetically, the chairman saw fit to interrupt him with a warning that since the hall had been booked only until 12:30 A.M., it was possible that the lights would soon go out. Given the noise, it was easy for the newspapers to report the speech the way they wished to, or not at all. Had it been audible, some members of the audience might have been surprised to hear Breton, through Eluard, denouncing not the Soviet but the French system. "We Surrealists don't love our country," he declared.

But if he seemed to condemn the French establishment while sparing the Soviets, that attitude was quickly subjected to reexamination. As soon as the Congress closed its doors, Breton sat down to draft another Surrealist document. To endorse it, he solicited the support of all those who could be considered loyal to the main current of Surrealism. That included Man Ray, who was now to sign his first important political statement, together with other non-French artists, including Dalí, Oscar Dominguez, Max Ernst, Dora Maar, René Magritte, and Meret Oppenheim, joining French Surrealist veterans Eluard, Péret, and Tanguy.

The pamphlet that came out of their discussions was conceived at once as justification of the movement's position on the Writers Congress and an account of its current attitude regarding the USSR. The Surrealists, noted the text, had joined the Congress as a group, sincerely expecting a genuine debate, convinced that a "defense of culture," the Congress's raison d'être, called for a transformation of society.

The meeting itself, the pamphlet continued, "took place under the sign of systematic suppression." There was no hope for genuine discussion of cultural issues—and no chance at all for dissenters from "this majority of new conformists." It was necessary, "at the risk of provoking the fury of its flatterers," to denounce the Soviet regime itself and its all-powerful chief, "under whom this regime becomes the negation of what it should have been and what it has been."[3]

22 Expanding Montparnasse

AS TIME ROLLED ON it became evident that, regardless of whether Surrealism was a solid or a liquid, the Surrealists were not meant for each other. Of course there was a solid, and his name was André Breton, but the ranks of his followers continued to liquefy. Yet Man Ray saw no cause for a rupture, and Breton respected Man Ray, never demanding the impossible of him. Of the two surviving members of the original triumvirate, Breton and Eluard, Man Ray was clearly more comfortable with the poet with a heart. They worked well together, and their respective talents seemed to mesh, as when Eluard published his book of poems called *Facile* in 1935, illustrated with Man Ray photographs.

In April 1936 Eluard finally did what so many others had done before him. He broke with Breton "definitively," as he confided to his beloved Gala. If he could no longer work with the acknowledged chief of the Surrealists it was because of the way Breton talked to people. "I had decided a long time ago not to accept the childishness and irrelevance and bad faith." Eluard wished to be free to criticize without seeing Breton turn to his flock of sheep for support.

Eluard had already worked out the consequences, e.g., to what extent he could continue to collaborate with a magazine like *Cahiers*

Man Ray at the wheel of the automobile that shuttled him between Paris and the Riviera

d'Art, which was in Breton's sphere of influence. He would fulfill his promise to send a number of paintings from his personal collection, works by Ernst, Miró, and Klee as well as Dalí, to the International Surrealist Exhibition, which was being put together in London by the British artist and collector Roland Penrose, but only because he was committed to Penrose and had even received an advance payment for shipping them. *"And that will be all."*

He knew, he said, that by breaking ties that went back eighteen years, his life was going to change, although he could not say in what ways. *"Between us,"* he told his confidante, "I feel a little as if I'm going out on an adventure."

And it was almost as if the break with Breton strengthened Eluard's link to Man Ray, with whom he could feel genuinely comfortable, and who was not always asking him to prove himself. They were together all the time now. At the beginning of the year, Man Ray had driven with Paul and Nusch part of the way down to Spain, where Eluard was going to take part in an art exhibition with Picasso who was showing his work there for the first time since his youth. In May the friends took time off to go to the famous automobile races in Le Mans just south of Paris. And after a stay in Saint-Raphael in July,

they had the first of what became an annual reunion in southern France in the hills above the Mediterranean coast, in a still humble village called Mougins. Picasso was there, and his brand-new love, Dora Maar, and so were Christian Zervos, founder and publisher of *Cahiers d'Art,* virtually a house organ for Picasso, with his wife, Yvonne.

Although some of the crowd had reached Mougins in a round-about way, Picasso following his own vacation route via Saint-Tropez and Cannes, in the hilltop village they lived simply at a pension grandly called Hotel Vast Horizon, taking meals on a terrace roofed with grapevines. They worked, photographed each other, and read or listened to one another's poetry.

If Man Ray seemed oddly alone in photographs taken of the group that summer, before his stay in southern France was over he had found a new mate. It happened on a somewhat exclusive beach at Antibes, where he had gone in search of subject matter for his movie camera (the camera and a new color film had been given to him by Kodak as a promotion). And there he all but fell into the arms of Adrienne Fidelin, henceforth Ady, a vivacious dancer from France's West Indian Guadeloupe colony, her light-brown skin classifying her then as a mulatto. "We were in love," he was soon able to say, and he

Adrienne Fidelin (Ady), Man Ray, Picasso, Dora Maar, and friends in Antibes at the eve of World War II

was relieved to find that his friends, and indeed everyone they met, readily adopted her.

Picasso took advantage of Man Ray's presence in Mougins to pick up some tricks from him, and began applying the rayograph process to his new obsession with Dora Maar, adding a Picassoesque improvisation by scratching her profile onto the photographic plate before exposing a patch cut from a Spanish mantilla. And it may have been at this first Mougins gathering that Man Ray and Paul Eluard put their heads together to work out what would become their most memorable collaboration, the book called *Les Mains libres,* in which appear Man Ray's most accomplished and evocative drawings accompanied by Eluard's poems. Heady stuff conceived in a heady atmosphere—it could turn a poor photographer's head.

That spring, Man Ray had delivered himself of his familiar complaint in a letter to his sister Elsie in New York. He simply hated photography, despite the constant pressure on him to do more of it. "I have painted all these years," he told her, "and if I brought over my things to New York I could fill a respectable gallery, but these one-track-minded Americans, the Modern Museum and others, even after having visited my place, and seen my work, have now put me down as a photographer." In his memoirs, written in the early 1960s, he would call drawing and painting a "relief" from photography. But in these last years of peace it seemed at times that he would choose one and give up the other if he could afford to.

Interestingly, the summer's charms, Picasso's honeymoon with Dora, Man's with Ady, not to forget the new book project with Eluard, seemed not to have been blighted by the ugly news coming out of Spain. There a Popular Front government of Republicans, Socialists, and Communists had come under the guns of a military revolt led by General Francisco Franco. To believe the biographer who knew him best, Picasso was almost the last of the group to show concern. And it was a poem by Eluard, titled "November 1936," published in the Communist Party's organ *L'Humanité,* that suggested to Picasso that

one could create and fight at the same time. "One gets used to everything / Save to these steel birds / Save to their hatred for the sun / Save to yielding to them."[1]

Montparnasse continued to grow in all directions in that summer of 1936. From Mougins, Man Ray drove along the Mediterranean coast to the port of Toulon to board a ship for Britain, honoring his promise to participate in the International Surrealist Exhibition, of which he was a member of the French organizing committee. His baggage was loaded down with copies of his retrospective album of photographs, which were to be sold from a booth at the London show. But his heart and mind were now engaged in a finer art—he had been drawing. And he was "hankering to paint again as I wish to," as he wrote to his patron and publisher James Thrall Soby. "Photography has become a social and automatic process with me, which is what I've worked for all these years, and it has also given me new insight and approach to more plastic work."

He was hoping to begin with a show of drawings "of an entirely new conception—a combination of realism and surrealism" (a description of what he was doing for Les Mains libres).

The London show had an unexpected effect: the reconciliation of Eluard and Breton. Both signed the protocol issued by French and British Surrealists (and their admirers), as did Man Ray, and they congratulated themselves on the success of the show. The statement gave the signers an opportunity for public censure of Louis Aragon, who had been responsible for a barrage of attacks on the Surrealists in the Communist press. In what was virtually an aside, Breton pointed out that even as a Surrealist Aragon had been an extremist, his extremism manifesting itself "by a quite artificial violence," which lured his comrades into carrying out provocative acts. In this he deserved the "scorn he inspires in all moral individuals."

But the big show for Man Ray, as of course it had to be for a native son, was the retrospective at New York's Museum of Modern Art with

the blanket title, "Fantastic Art, Dada, Surrealism," which ran from December 7, 1936, to January 17 of the following year. Here his painting and not what he dismissed as his routine (or "automatic") picture-taking was enthroned.[2]

Home in Montparnasse, one of Man Ray's priorities was to rearrange his life, taking into account his resolve to paint. He found that by working with advertising agencies and fashion magazines, and limiting his portrait business, he could earn more in less time, freeing himself for painting. Another time-saver would be to combine work and living spaces. The solution was a large studio that came with an apartment, and only minutes away from his favorite haunts, on narrow rue Denfert-Rochereau (a street since renamed Henri-Barbusse). In his new place all the necessary photographic equipment was present, and above all visible, to reassure clients. (He was amused to note that only fellow artists and other personal friends noticed that there were paintings around.) Importantly, he now had a home for his new life with Ady.

Yet there were still distractions. The 1937 Paris World's Fair was rigorously modernist, and even the Surrealists got their place in the sun. With Paris as the temporary center of the world, one could make the least expected encounters. At a Rochas costume ball, for instance, where the Surrealists were privileged guests, who did Man Ray run into but Lee Miller? She had lived out a life since their last meeting. In July 1934 she had, at last, married Aziz Eloui Bey, following him to Egypt after closing the New York studio she had been operating with her brother Erik. By all accounts Lee lived an idle life with Aziz, taking pictures only as a distraction. Brother Erik and his wife had joined her in Egypt, both to work at Aziz's company, the local agency for Carrier Air Conditioning.

And now Lee was in Paris. At the costume ball Man Ray introduced her to Roland Penrose, the Surrealist's man in London, handsome and talented. Apparently nothing about life with husband Aziz

back in Egypt prevented her from having a fling, even a serious fling that might last for years.

Before long, they were all—Lee and Roland, Man and Ady, Eluard and Nusch—at Penrose's lovely house in Hampstead, London's posh Bohemia, where he reputedly kept his country's best collection of Surrealist art. We know from Peggy Guggenheim that Penrose "had great success with women and was always having affairs." She also remarked that when he slept with a woman he tied up her wrists "with anything that was handy." With her, she said, he once used her belt, another time a pair of ivory bracelets from the Sudan. She found it uncomfortable to spend a night this way, "but if you spent it with Penrose it was the only way." Lee Miller, who had been photographed by Man Ray entangled in nets, seemed not to mind.

From there the group made its happy way across the Channel and down through France to Mougins, to join Picasso at the Hotel Vaste Horizon, where he painted Lee's portrait. For the record, Lee Miller had her next tryst with Penrose in 1938, joining up with him in Athens to travel through the Balkans photographing village life. The year after that he met her in Egypt, for some exploration of her husband's native ground. But by then it was time for an amicable separation from Aziz Eloui Bey, and she sailed to Britain in June 1939 to spend the rest of her life with Roland Penrose. Her divorce from Aziz became official only in 1947, after which she quickly married Penrose.

Her path would cross Man Ray's often, even in California after World War II, and they would stay friends. She admitted to an interviewer that she and Man still quarreled because, she confessed, she was a bully, and he was stubborn.[3]

23 | *Montparnasse Goes to War*

IT WAS INDEED AN ERA OF CELEBRATION. After the grand retrospectives of London and New York, it became the turn of Paris, which in January 1938 was the venue of the International Exhibition of Surrealism. Man Ray called it "the climax of Surrealist activity."

It was to be a true summit, bringing together some three hundred works from fourteen nations. A suitably prestigious home was found for it in the bourgeois Galerie des Beaux-Arts, whose director, Georges Wildenstein, was himself an art historian, although usually involved with less controversial art, and less troublesome artists. At its best or, from Wildenstein's point of view, its worst moments, the Surrealist show would resemble the department store invaded by the Marx Brothers.

The exhibition catalogue was a keepsake: a *Dictionnaire abrégé du Surréalisme,* compiled with wit but nevertheless a serious attempt to come to terms with creators and works difficult to circumscribe. Those already familiar with Surrealism could learn much about who was in favor just then, and who was not. Aragon was defined as a "Surrealist writer, from the origin of the movement to 1932, the year he violently denounced all his past activity." Desnos, a "Surrealist poet, from 1922 to 1929." Dalí was defined in an unattributed quote:

"Prince of Catalan intelligence, colossally rich." Gala, Dalí's Gala now, yet also and secretly Eluard's, was oddly characterized by Dalí himself: "Violent and sterilized woman."

The dictionary project saw the active collaboration of André Breton and Paul Eluard, at least for art's sake, since they compiled and signed it jointly, even as their political differences grew. Henceforth, and for as long as he lived, the warmhearted Eluard would side with the brutish Stalinists as the best defense against Fascism, while gruff Breton would be dismissed as a Trotskyist for opposing both Stalin and Hitler and their apologists in the name of freedom.

When it came to mounting the exhibition, Wildenstein had the good sense to leave the job to the Breton group. Breton in turn persuaded Marcel Duchamp to come out of internal exile to put it on stage. Breton explained his choice later to an interviewer: If Duchamp enjoyed a "unique prestige" among Surrealists it was "both because of his genius proved by all his interventions in art and anti-art and his exemplary self-liberation from all the servitudes and miseries that normally accompany artistic activities."

Perhaps it was for similar reasons that Marcel Duchamp turned to his oldest friend in modernism, Man Ray, for technical assistance. They had to begin by making a hollow shell of the elegantly appointed Wildenstein gallery, notably by removing red carpets and period furniture. The skylight in the main room was blocked out by coal sacks which were filled with lighter and less flammable material than coal. Sixteen nude mannequins of the kind used in show windows were lined up in a corridor, each to be decorated by one of the exhibiting artists. While most participants strove for ingenious combinations of materials, Man Ray's mannequin was left unclothed, but with glass tears on her face and glass soap bubbles in her hair. Duchamp did not decorate his model at all, simply throwing his coat and hat on it as if it were a cloak rack—typical, thought Man Ray, of his friend's wish not to attract attention.

The invitation for the 10 P.M. opening on January 17 called for

evening dress, although many of the effects planned for the event were designed to trouble the composure of the gallery's customary clientele. A hidden phonograph emitted hysterical laughter recorded in an insane asylum, which, explained Man Ray, would cut off any visitor's intention of laughing or joking about the art on display.

Responsible for the lighting, Man Ray had a ramp built all around the gallery, with hidden bulbs illuminating the walls as on a theater stage. But on opening night these lights were switched off. As visitors entered they were handed flashlights: as it turned out, they were more interested in looking at each other than at the exhibited works. The lack of light upset the artists, although Man Ray was able to assure them that for the rest of the show, when serious buyers would be coming to the gallery, their works would be lit to everybody's satisfaction.[1]

The lights shut down, flashlights and then full illumination again, the hysterical laughter seemingly coming from nowhere—accoutrements of the climactic Surrealist exhibition of 1938—could perfectly well symbolize the year. Europe was poised for war, yet nothing seemed as important as holding on to peace, at the price of appeasement of dictators.

Uncertainty about what the near future would bring, hesitation about how to behave in the here and now, had begun to influence Man Ray's behavior, even though his personal financial situation, thanks to the bounty of the fashion pages, had until recently run counter to business curves on both sides of the Atlantic. The possibility of making more money with less work thanks to high magazine commissions freed him for painting, and he took full advantage of this freedom.

But now, from the beginning of 1938, there were signs that even for this lucky American abroad something was changing. Through his sister Elsie, he had regularly sent small sums of money to his parents in Brooklyn; he could no longer do that. After the Czechoslovak crisis

and the Munich compromise the situation got worse. "Things are quiet comparatively," he told his sister, "I am painting a lot, almost no photos." In mid-December: "I am staying on here until there is real discomfort—so far it's all in the air—except for the poor wretches in Germany and Italy." In January 1939: "I shall continue as long as possible, but for the past year I've been dropping photography and going seriously back to painting."

Yet the prosperity of the recent past had left traces. During summers on the Mediterranean he had come to see the beauty of having a place of one's own, and why not combine the instinct for domesticity with his artistic needs? The product of that reflection was a studio apartment in Antibes, still a friendly little town snuggled between the more elegant Riviera resorts. He had found what he called "a sort of penthouse flat" at 44, boulevard Albert Ier. It had a terrace overlooking the town's chief landmark, a seaside castle with Romanesque towers, which in the immediate postwar years would become still another studio for Picasso, and then his museum.

At first sight Man Ray loved the place, and with Ady it became a love nest. The seasons made no difference. He was there in late September 1938 when the French and British prime ministers were in Munich negotiating with Hitler and Mussolini about the concessions they were about to make to preserve peace in Europe, as was said, "in our time."

In the end, however, it was all too bucolic, too good to be true, too far from Montparnasse. Early in 1939 he settled for a country setting just outside Paris. He had already found a small house at Saint-Germain-en-Laye, only twelve or so miles west of Paris by automobile. Henceforth *that* would be the country place.

When he told Picasso about giving up Antibes, this man who never had enough houses and studios, just as he never had enough mistresses, offered to take over the lease. So Man Ray was soon busy packing up again. Picasso, who was watching, stopped him from taking down a composition Man Ray had put together with folded papers,

corks, and bits of string, for he wanted to have it. Man Ray reflected that nothing he ever did was wasted, and was soon making a copy of the abandoned work, this time in oils.

Since he was staying a while longer in Antibes, he moved into a nearby hotel. When he paid Picasso a farewell visit he could see that his Spanish friend was already at work on a large canvas using paints and brushes he had picked up at a local shop. *But were these permanent paints?* his Paris dealer who had come down to see him asked him anxiously. Picasso told him that such questions concerned collectors and investors, but not himself.[2]

In the buildup to war, these two expatriates, the Spaniard Picasso and the American Man Ray, seemed oddly unconcerned by the tensions and apprehensions. Although seemingly unperturbed, Picasso had made a public profession of anti-Fascism with his painting *Guernica*, and Man Ray's connections with Surrealism, not to speak of his East European Jewish ancestry, might have given him reason for concern.

Each of these expatriates continued to go about his affairs as if nothing could happen to France, or to himself. Man Ray was planning a one-man exhibition for Paris in March 1939, Picasso was to have his "apotheosis," in photographer Brassaï's words, at New York's Museum of Modern Art in November of that same year. Man Ray remained anchored in Montparnasse and nearby Saint-Germain-en-Laye, Picasso in the penthouse in Antibes. Indeed, Picasso spent the weeks leading up to the outbreak of war on the large canvas Man Ray had watched him begin, an outsized painting of night fishing by lantern off Antibes, now in New York's Museum of Modern Art. A biographer saw it as a work in the spirit of his *Guernica*, and whose fish and shellfish symbolized "violence and cruelty"—his way to sublimate his moral and political dilemmas.

At the beginning of 1939, Barcelona fell to Franco's troops, and at the end of February the French government recognized the legitimacy of the nationalist regime. But if the French cabinet now expected

the worst, it would have been difficult to find a corresponding urgency in the actions of the high command.

The surprise came in late summer. Although French and British military experts had been in Moscow to work out an agreement with their Soviet counterparts, on August 23 Stalin and Hitler approved their own pact—opening the door to the invasion and partition of Poland.

And yet it was possible, through these summer months, to pursue life as usual, even business as usual. Writing for *The New Yorker* magazine, Paris correspondent Janet Flanner reported that the city "has suddenly been having a fit of prosperity, gaiety, and hospitality. . . . There have been magnificent costume balls and parties. . . . The expensive hotels have been full of American and English tourists."

As if they had waited for summer festivities to end, the Nazis launched their offensive against Poland on September 1. France called for a *mobilisation générale* the same day. Honoring their treaty, France and Great Britain declared war on Germany two days later.[3]

Although in their Dada years following World War I the Surrealist vanguard had pledged that they would never again bear arms for their country, for most of them there was no question of evading combat against Fascism. Breton, Eluard, and Benjamin Péret were among those who answered present.

Henceforth, for Paris, it would be a warless war. It became known as the phony war. On September 6, the day the French entered the Saar, Man Ray was in Saint-Germain-en-Laye, writing to assure his sister that he was safe and well. In a letter he sent to Picasso the same day, he added the detail that he was there with Ady, and that he planned a brief trip to Antibes to finish cleaning out his things.

As for Picasso, when mobilization was decreed on September 1 he was at the Antibes flat, finishing *Pêche de nuit à Antibes*. He rushed back to Paris to see what was happening—above all to assure the safety of his paintings. According to his confidant Brassaï, when

Picasso thought about how widely dispersed his work was, and how much of it there was, he gave up trying to deal with it and left for Royan, on the Atlantic coast. There Marie-Thérèse Walter, seduced by him when she was seventeen, and still the most secret of all his women, was waiting with their daughter. To complicate matters, Picasso brought Dora Maar along.

The European-American writer Anaïs Nin, winding up her French life before returning to a safer United States, sought to help a German Jewish refugee who needed a train ticket to Switzerland. Lacking cash herself, she sold her camera to Man Ray. That Man Ray was not himself thinking of leaving but was ready to add another piece of equipment to his present trove, suggests that he saw himself as a permanent fixture.

This was more or less true, for he did think he could sit it out, the way he saw so many native Parisians do. Yet there were blackouts now, and one walked dark streets marked with small blue lights at street corners. Everybody seemed to be carrying a gas mask and he was stopped and asked why he did not have his. When he explained that as a foreigner he was not entitled to one, he was told that he should buy it himself.

To go to Antibes to clean out his apartment he needed a special pass, which an influential friend was able to get for him. He drove off at top speed, stopped occasionally by soldiers checking identities. It was only when he skidded and went off the road that he realized he had been driving too fast. When he finally reached Antibes, which showed even fewer signs of war than Paris did, he arranged to have the contents of his penthouse shipped to Saint-Germain-en-Laye.

As the situation worsened in Paris there was a rationing not only of food but also of gasoline for his automobile; even with ration tickets, there were lines at food shops. In the absence of photographic assignments he did more painting. Then in February and March 1940, the traditional period for unveiling spring and summer clothing at the fashion houses, the designers decided to mount impressive shows

to let the world know that France continued to exist. American buyers arrived, and in their wake some fashion magazine editors. True, one of the photographs he did for *Harper's Bazaar* showed a Schiaparelli evening dress in a print inspired by a Scottish regimental flag—a nod to an ally.

For a short time, with the pile-up of assignments and the frantic deadlines, Man Ray's Paris seemed its old self.

Not for everybody, of course.

Breton, then forty-six, had been sent to Poitiers as a doctor in a school for pilots; the armistice found him in the Vichy zone. Eluard, who had also served in World War I and who was not quite forty-four years of age, was called up as a lieutenant; the surrender would thrust him into the underground.

The third member of the original triumvirate, Louis Aragon, long since lost to the group and now a rising star in the Communist constellation, had been genuinely taken in by the Stalin-Hitler pact. His first reaction was to justify it in an editorial as an "instrument of peace against the aggressive Reich," unaware that the pact contained a secret protocol enabling Hitler's Germany and the USSR to share the spoils after the invasion of Poland. The French banned the Communist Party and its press, but by then Aragon had been called up for military duty. He served under fire in a medical detachment; later he would stay in France, helping to organize the Communist resistance to the occupation.

Meret Oppenheim had moved to Switzerland, her second home, in July 1939, and was not seen in Paris again for a decade.[4]

24 *Everybody Out of Montparnasse*

IN HINDSIGHT, WE KNOW what anti-Fascist artists and writers had
to do, indeed what artists of any modern school who might be classi-
fied by the Nazis as "degenerate," refugees from Germany and Nazi-
occupied territories, Jews French or foreign had to do. They had to
move out before the invaders arrived. During the months that sepa-
rated the declaration of war in September 1939 from the German
spring offensive, Peggy Guggenheim was in Paris buying a work of art
a day, for she intended to create her own museum. She had had a
gallery in London and lost money with it, so decided that she might
as well lose more and do something worthwhile. She acquired an
important work by Léger on the day Hitler attacked Norway. The next
day she went to see Man Ray and bought a painting he had done in
1916, together with several rayographs. She acquired Brancusi's *Bird in
Space* only days before the Germans marched in.

It was on May 10 that the German plan was ready to be put into
effect, with an invasion of the Netherlands and Belgium, drawing the
best French troops north to meet them. Then on the night of May 12,
German Panzer troops crossed the Meuse River along a stretch of
wooded borderland that was considered impenetrable, and was
therefore poorly defended.

Matisse remembered meeting Picasso just then. Matisse was going to his tailor's; how could he do that, Picasso asked him, with the French army in full rout, the Germans perhaps only a day away from Paris? "What about our generals? What are they up to?" Matisse asked him. "Our generals," quipped Picasso, "are the School of Fine Arts." (Nothing in Paris seemed more old-fashioned to modern painters.) Running into André Derain one morning, Man Ray discussed the German offensive with him. Derain was convinced that Paris would be spared. It would be like the first war, when the Germans were repulsed as they approached from the east. And so neither Derain nor Man Ray had anything to worry about, since their country homes were *west* of the city.

Like Man Ray, citizen of a neutral country, Ilya Ehrenburg did not have to run. As those who could evacuate the capital began to load up their automobiles, as the north-south boulevards of Paris became jammed with refugees, Ehrenburg found the carrefour Vavin to be a privileged observation post.

Just a year earlier the intersection of the north-south boulevard Raspail and the east-west boulevard du Montparnasse had received Auguste Rodin's controversial statue of a resolute Honoré de Balzac who appeared to be in motion. The sight gripped Ehrenburg now as he sat outdoors at the Rotonde observing the flow of refugees. "A mad Balzac seems to want to step off his pedestal," he noted in his diary. "Suddenly it seemed to me that Balzac was also leaving, with everybody else."[1]

With all newspapers shut down, their staffs evacuated to what were believed to be safer regions, the city lived by rumor. From his autobiography we know that Man Ray thought that civilians had been ordered to leave Paris within twenty-four hours. In fact the contrary was true—the authorities wished to keep roads free for troop movements. Undoubtedly he too was affected by the spectacle of the uninterrupted column of refugees crossing the city, an exodus he thought had "a biblical character."

He prepared his own exodus cautiously. When he toured his studio in order to decide what to take with him, he felt helpless, with the stacks of paintings, drawings, photographic material, and books accumulated over the years. Finally he packed only essential clothing and managed to persuade Ady to do the same. They took some food and a bottle of champagne. He went down to his bank to draw money, though they would not let him have it all, and purchased a fresh set of tires.

From Paris they headed first to Saint-Germain-en-Laye to close the little house, stopping for lunch at one of the popular restaurants opposite the old castle, where they shared a bottle of good wine.

Leaving Saint-Germain-en-Laye, they turned south. Although Man Ray chose secondary roads, driving became difficult, and once they had to abandon the car for the adjacent woods when German planes flew overhead. They reached the Atlantic coast at Sables-d'Olonne, a traditional family resort, where they found an attic room with a small casement in the ceiling offering them a patch of sky.

Man Ray's plan was to proceed along the Atlantic coast to Bordeaux, the best place to book ocean passage home, then to continue south to Arcachon, where Marcel Duchamp and Mary Reynolds had taken refuge. He wired Duchamp, and soon had a letter warning him not to try to go back to Paris. The Germans had marched into the French capital, without much difficulty, on June 14. From the French government's redoubt in Bordeaux, France's wartime premier Paul Reynaud ceded his place to venerable Marshal Philippe Pétain, who formally requested armistice terms from the Germans.

That was on June 17. The next day, the day a lonely but defiant Charles de Gaulle made his own radio speech from London, Man Ray wrote to Picasso, who was settled in Royan, farther south on the coast. "We (Adrienne and I) [are] shipwrecked here, and shall probably leave this week for Bordeaux." They would stop en route to say hello.

It was on the morning of their eleventh day in Sables d'Olonne that the Germans arrived. Man Ray and Ady stood by as staff cars

turned into the central square. After breaking into the bank and town hall, the invaders posted soldiers on roofs, guns pointing at the silent crowd. Next day, when Man Ray presented himself at German headquarters in the town hall to ask for permission to continue his drive south, he was told to return to Paris. En route home, attempts to buy gasoline proved fruitless. In Le Mans, he talked with German army interpreters who thought it reasonable to help this neutral American get back to Paris. One of the Germans led him to a field with captured British tanks still filled with high-grade fuel; all he had to do was to extract it, and with some help he did.

While it is difficult to be precise about the date Man Ray reached Montparnasse after his round trip to the Atlantic coast, we do know when Adolf Hitler got there on June 23—and almost ruined the neighborhood. It was a Sunday, just nine days after the first Nazi troops had paraded through the city. Hitler drove in with his preferred guide, Arno Breker, the sculptor of supermen. Of course Breker knew the city well from his Montparnasse years. He had had his portrait done by Man Ray more than once. Landing at Le Bourget, Hitler and his retinue began their tour with Right Bank sites such as the ornate Opéra. Then it was over to the Left Bank for Napoleon's tomb, and the monuments to great men in the Pantheon.

Hitler was ready for more. What about Montparnasse, even Breker's old studio there? They stopped in front of La Closerie des Lilas, getting out of their vehicles to admire François Rude's statue of Marshal Ney, and the equally impressive Carpeaux fountain at the bottom of the Luxembourg Garden.

At that point they were only minutes away from Man Ray's studio apartment on rue Denfert-Rochereau. It is easy to imagine Man Ray walking by, carrying a loaf of bread or perhaps croissants for breakfast with Ady. Breker would have recognized him and introduced him to Hitler.

It did not happen. In the end, Hitler did not even get to see Breker's studio, as there simply was not time.[2]

What to do now? Picasso, in Royan, knew what he would do; he would stay in France and work, and so would his senior colleague, Matisse. Man Ray was of a different mind; he was now ready to leave. But there was no help to be got at the American Embassy, which despite its neutral status was all but quarantined. So he watched as Paris became overrun with Nazis. An outward show of benevolence, combined with growing repression, made for an atmosphere in which it was impossible for him to work. Besides, no one came to the studio anymore and his personal friends had vanished.

As time passed, and the German occupation settled in, the American Embassy became more receptive to visitors. This time Man Ray learned that he could ask the Germans for permission to travel through Spain to Lisbon, where a ship could take them to New York. When he applied for a pass for himself and Ady (his "wife"), the German officer in charge, noting that his papers showed him to be a permanent resident of Paris, asked why he wished to leave. The officer, who obviously knew Man Ray by reputation, was sure that the Germans could give him plenty of work—and would pay him as well as the French did, if not better. "But not as much as the Americans will pay me," he cracked. "That's why I'm going back." He got the pass.

At the last minute Ady decided not to leave; her family needed her. Man Ray wrote out checks so that she could draw on his bank account to the extent they would let her, and packed essentials, not forgetting a representative sampling of his work.

And then for a final tour of Montparnasse. By now it was late July, and suitably summery. The outdoor café terraces were filled with German soldiers, a few French women, but hardly any French men. He ran into Giacometti, who had left Paris on foot during the exodus, returning as nearly everybody did. Now he swore that he would soon return to his native Switzerland. Kiki called to them as they passed a café where she sat with a woman friend—surrounded by tables filled with German soldiers. Man Ray and Giacometti joined them. At one point Kiki turned her attention to a nearby table where a French girl

sat with a German, and loudly, although in slang, let the girl know what she thought of her association with a "kraut."

Man Ray was the only civilian on the train south. The final stop was Hendaye, on the French side of the Spanish border, where he spent the night in a hotel. In the dining room he ran into another Paris-American, the composer Virgil Thomson. They took a bus ride to Biarritz, where the American consul, a friendly soul Man Ray had met on visits to the Arthur Wheelers, gave them a letter for the German authorities to facilitate their border crossing. After that their journey was relatively easy. In Lisbon, at a packed first-class hotel, they found others waiting for passage to America, among them Dalí and Gala. There was a capacity crowd on the American ship that picked them up; they and some sixty other single men slept on the library floor.

While he realized that the arrival in New York harbor would be thrilling to most passengers, Man Ray felt an intense depression coming over him. After twenty good years in France, he was returning to the country which had not understood him. He resolved to hibernate until Paris was open to him again.

Surrounded by reporters and photographers who came aboard as they docked, Salvador Dalí asked Man Ray to serve as his interpreter. He himself had not been noticed, since his name was properly listed under R—while everybody knew him as Man Ray. But he decided not to help Dalí with the press, which, in any case, would be captivated by his accent. Man Ray was simply not in the mood to attract attention just then.[3]

For most of Man Ray's old crowd, getting away would not be that simple. They had to cope not only with a pitiless occupation, but also with a new French state led by backward-looking Marshal Pétain, who was more likely to criticize the excesses of Paris than of Berlin. And even if the Germans had other concerns as the war became global, the French collaborators of Paris and Vichy knew how to identify

and to track age-old enemies, enemies who, of course, included the artists and writers of Man Ray's Paris. Many were foreign residents opposed to the regimes of their countries of origin, and then there were the Jews, French or foreign, who were targets both of the Germans and Vichy.

There were few places to hide. One of the few was Marseille, which, as a seaport, signified departure, legal or surreptitious. Refugees there soon had the support of a singular institution, the Emergency Rescue Committee, run almost single-handedly by a thirty-two-year-old American, Varian Fry, a writer and scholar sponsored by the privately endowed Foreign Policy Association in New York.

Fry arrived in Marseille in August 1940, just as Man Ray was disembarking in New York. His mission was to locate, protect, and then evacuate refugees most likely to be taken into custody because of anti-Nazi activities or simply because they were Jews. He also carried a list of personalities from all over Europe, intellectuals, political leaders, artists, and writers, whether French or foreign, who were vulnerable to capture.

Aided by men and women of good will, some of whom transformed themselves into clandestine messengers or forgers of identity documents, Fry created a Centre Américain de Secours ostensibly sponsored by local dignitaries, and which more often than not used extraordinary methods to hide the endangered and then to evacuate them by land or sea, usually via Spain, to the United States or other safe havens. Although his work was endorsed by Eleanor Roosevelt, he faced stiff opposition from U.S. consular officials whose work required obedience to local laws, and whose status in occupied France called for neutrality. Fry and his people were not neutral.

Before his work was finished—or rather before it was interrupted by an embarrassed U.S. State Department—Varian Fry had facilitated the evacuation of a distinguished roster of artists—among them painter Marc Chagall and sculptor Jacques Lipchitz, German writers such as Franz Werfel, Lion Feuchtwanger, Heinrich Mann,

the international journalist Arthur Koestler, and social philosopher Hannah Arendt.

In order to provide living quarters for some of his candidates for evacuation, and also to have a secluded office far from the city center, Fry rented a large and largely uncared-for villa half an hour's drive from Marseille. Among his temporary guests were André Breton, his wife, Jacqueline, and their five-year-old daughter. Breton being himself, he had soon converted Villa Air-Bel into a Surrealist café with the occasional participation of poet Benjamin Péret, Spanish painter Oscar Dominguez, Cuban Wilfredo Lam, and Romanian Victor Brauner. Others who in one way or another benefited from Fry's support were Max Ernst, Hans Bellmer, and André Masson. Marcel Duchamp, who would later make his way to New York without the committee's help, occasionally spiced up the villa's Sundays. They would play games, such as *cadavre exquis,* or simply sketch or write.

Peggy Guggenheim was asked to finance the travel to the United States of the Breton family and Max Ernst, among others. Once in New York, she offered to subsidize Breton for a full year to give him time to get his bearings.

Ernst had only recently been released from a French detention camp as a suspect German. Under the armistice agreement of June 1940, he could be turned over to the Nazis at any time at their request. Peggy Guggenheim would not only bring him to America, but she would eventually marry that handsome man. Meanwhile she stood by helplessly as her charge and future husband was taken into custody as an enemy alien and detained on Ellis Island until his harmlessness could be established.[4]

25 | *Epilogue*

MAN RAY RETURNED TO NEW YORK in time to celebrate his fiftieth birthday—if celebration it could be called. For now that he had the leisure to ruminate on his life, he was disheartened by his conclusions. He had achieved a measure of fame, yet not for what he dreamed of doing. Later he summed up the moment for an interviewer: "I looked around New York, got my old depressions back again. I decided my life was finished. I'd left twenty years of work [in Paris]. I decided I'd go to Hawaii or Tahiti and disappear, like Gauguin. . . . On my way, I drove out to California with a friend. First time I'd driven across the continent. I got to Hollywood. There were palm trees, sunlight, the Pacific Ocean, lots of space. No skyscrapers. Made me feel taller. So I said, 'Why go further? I'll stay here a while.' And instead of staying two weeks, as I'd planned, I stayed eleven years."

He would paint there, give lessons in painting and photography both, and get an occasional show. He found just the right studio cum apartment at 1245 Vine Street. He also acquired a powerful automobile, a Graham Page. "How can you, a refugee from war-torn France, afford living here and sporting such a luxurious car?" his gallery friend Julien Levy asked him. Man Ray explained that for years he had been paid by magazines in dollars, depositing their checks in an American bank.

The day after his arrival, through a friend, he met Juliet Browner, twenty-eight years old and a New Yorker like himself. They married only in 1946, when Max Ernst was himself about to marry the young artist Dorothea Tanning, and the opportunity for an amusing double wedding presented itself.

But while Man Ray entered new relationships with enthusiasm, traveling up to his Big Sur cliffside home to spend time with his new friend Henry Miller, something kept him from remaining in close touch with members of the Paris crowd now in New York exile. He feared, so he would later say, that to see them with their "hopeful spirit of anticipation" might exacerbate his depression.

And he deplored the importing of their tiresome quarrels, "the sad sight of the surrealists in New York pinning decorations on the faithful, or rather the visible ones, and outlawing the absent or dead." Breton saw to it that he remained the chief spokesman for his movement, although, and without even trying, Marcel Duchamp, who had reached New York via Marseille and Casablanca only in June 1942, was everybody's favorite standard bearer.

And now at last Peggy Guggenheim had her museum, which she called Art of This Century. For the formal opening in October 1942 she wore one Tanguy earring and one by Calder, to show impartiality, she explained, between Surrealist and abstract art. Later she added a commercial side to the gallery, so that she could sell Max Ernst and other contemporaries.[1]

One began to hear of the underground in France. Paul Eluard, who had joined the clandestine Communist Party, passionate about that as about everything, had written poetry for resistance publications under pseudonyms. His best-known underground poem, "Liberty," began: "On my school pad / On my desk and trees / On sand on snow / I write your name—." The name revealed at the end of the last stanza was to have been Nusch. But as he wrote on, he realized that it had to be *liberty*, and from 1942 to the Liberation and beyond, it was France's favorite resistance poem.

Robert Desnos joined the underground in a capacity unknown to even his companion Youki. His attitude was made clear in the poem he wrote for an underground anthology, *L'Honneur des poètes,* under a pseudonym: "This heart that hated war now beats for war and battlefields!" Arrested by the gestapo in February 1944, Desnos was sent to the Buchenwald camp, dying of typhus in a detention camp hospital bed just a month after the German defeat.

If there was a puzzling case, it was that of Pablo Picasso, who lived and worked unperturbed during the occupation, receiving the homage of German officers, and even selling paintings. While he had no ostensible contact with the anti-Hitler resistance, he was saved from further questions at the liberation by his decision to join the French Communist Party.

Francis Picabia was a sorrier case. His war was spent on the French Riviera, riding around ostentatiously in a German automobile. He painted, sometimes exhibited. In conversations he expressed defeatism, unable to comprehend, so an otherwise friendly biographer observed, that what may have sounded progressive during World War I was now judged to be "cowardly collaboration with the enemy." At the liberation of France it was rumored that he would be prosecuted as a Nazi collaborator, but in the end he was allowed to go his own way.

There were many Picabias in Paris, artists, writers, and entertainers who had flirted with the enemy, as when the likes of Aristide Maillol, Maurice de Vlaminck, André Derain, Kees van Dongen, and even Jean Cocteau attended the opening of an impressive exhibition of Arno Breker's work at the Orangerie in May 1942. Maillol went so far as to call Breker a "new Michelangelo." For his part, although he spent most of his time in France with known Nazi collaborators, Breker later claimed that at Cocteau's request he saved Picasso from arrest and internment by the gestapo.

By chance Man Ray was in New York when Germany surrendered in May 1945. That called for celebration. He and Duchamp caught up

with Breton and they went looking for a suitable place, but everything they tried was filled to capacity. In the end they found a table at Luchow's, a traditional German restaurant on Fourteenth Street. It too was crowded, but with subdued Germans who stood solemnly when the pianist played traditional German music. Man Ray and his comrades remained seated, and eating—except that Breton complained about the food, as he did about any food that was not French.

With the unconditional defeat of the dictators, and Europe accessible again, there would be much catching up to do. One of the easiest of the old gang to follow had been Lee Miller. She had been a uniformed correspondent, following the war across Europe's battlefields before settling in Britain.

Of course Man Ray thought about returning to Paris, encouraged by the news that everything he had left behind was intact and his for the asking. But now that he knew that all was safe, the urgency disappeared. In August 1947, a full three years after the liberation of Paris, he made an exploratory journey to France, accompanied by Juliet; it was her first trip abroad.

They headed straight for Montparnasse, staying at a hotel within eyesight of the rue Campagne-Première and the carrefour Vavin. After being shown the attic where Ady and her French husband had stored everything he had left behind, he did some sorting and packing—things for shipping to the United States, an indication that he was not quite ready to settle in Paris. The first of his old friends he called on was Paul Eluard, despondent after the sudden death of Nusch, at thirty-nine. She had collapsed quietly on a sidewalk the previous November while he was traveling. Although they did not talk about politics, Eluard made it clear that he would continue to labor for the Communist cause. "Only a simple nature could have been so misled," thought Man Ray.[2]

Not everyone has had the opportunity to begin a life and career a second time. In his sixty-first year, and with no war to rout him out, Man

Ray could stay in Paris as long as he wished. And, this time, doing what he really wanted to do—paint. Later he confessed that he left Hollywood because a new landlord had raised his rent. For a moment he thought of simply settling in New York, where there was a new appreciation of work that had been rejected earlier. Still, he knew that his reputation as a photographer would overshadow his best efforts to be known as a painter there.

So it was to be Paris. On returning there in March 1951, he discovered a spacious if comfortless sculptor's shed on rue Férou, halfway between Montparnasse and the quarter that was now preferred by intellectuals, Saint-Germain-des-Prés. Henceforth he could be a full-time painter, sculptor, maker of objects, although it was inevitable that he would be pursued and applauded as the photographer he had been. But if photography had fed him, and could feed him again, he was inflexible; regardless, he would paint. He painted, and people came to look at his work—but not to buy.

He would learn that the photography he despised had now been raised to an art form, and there were galleries all over Europe, and publishers, ready to do business with Man Ray. To the extent he could call attention to his constructions—his "objects of my affection," and his paintings and drawings, he did so. He resumed contact with the old gang. A photograph, this one not signed "Man Ray," shows him seated in the front row at a gathering of the Surrealist group in March 1953, alongside Breton, Ernst, Giacometti, and Péret, with members of a second generation, Julien Gracq and Wilfredo Lam, in the group standing behind them. Marcel Duchamp had become an American citizen, lived in the United States most of the time and married there, but during his visits to Europe he and Man Ray would meet, and play chess.

Once, when Man Ray crossed the Luxembourg Garden that separated rue Férou from Montparnasse, he entered a café-restaurant for a quick lunch. Hearing a familiar voice on the bar side of the partition, he walked around to find Kiki. "She uttered a scream and threw herself into my arms, almost bowling me over," he remembered.

"She was very heavy, but her face was still the clean oval of former days without any sagging flesh—and as usual, made up as for the stage." They had a glass of wine together.

He could not have guessed that she had not long to live. And her death came here in Montparnasse (she had never left it). One day in March of 1953 she simply collapsed on the street near her apartment on rue Brea, on the little triangular place from which one could see the Café du Dôme down one street and La Coupole down the other.

Another familiar face appeared at his studio door one day—that of Jacqueline Goddard, the model who wouldn't. She found a new Man Ray: whereas in the past, when he had had to fight for his ideas, he seemed always to be running, he was now clearly in charge.

He found Brancusi in the studio he knew well, but the sculptor was now an elderly man, working little. On Brancusi's death in 1957, Man Ray attended the burial service at Montparnasse cemetery. Representatives of Romania's Communist regime were present, and were booed. The whole scene was depressing, and Man Ray decided never to attend another funeral.

To see Picasso he had to travel south, for Picasso was not coming up to Paris anymore. They had had a festive dinner, he and Juliet, at the painter's newly acquired villa outside Cannes, but never managed another tête-à-tête after that.

Then that tireless warhorse André Breton, together with ever-obliging Marcel Duchamp, mounted another major show. To avoid the curse of nostalgia, and to attract recruits from a younger generation, it came with a theme—EROS (Exposition InteRnatiOnale du Surréalisme)—which titillated Paris for ten weeks beginning in December 1959. Surrealism was not dead, although from time to time an aging Surrealist died.

Thus in autumn 1968, soon after Duchamp's eightieth birthday, the Man Rays dined with Duchamp and his American wife, Teeny, and Duchamp's biographer Robert Lebel and wife Nina. During the night an embolism snuffed out Duchamp's life. "He had a faint smile

on his lips," Man Ray recalled in a commemorative brochure. "His heart had obeyed him and simply ceased. (As his work had in earlier days)." It was tragic indeed, Man Ray concluded, "as the end of a chess game. I shall not say more."

There is evidence that Man Ray's own final years were bitter. A young helper, Lucien Treillard, who had first called at the rue Férou on behalf of an art editor he worked for, stood by as his hero grew older, his health in constant decline, his mood increasingly somber. His reputation was secure—at least as a photographer. If the first years after his return to Paris were barren, the prices paid for his earlier work were rising. Later they would set world records in the United States and Europe, and counterfeit Man Ray prints abounded. Yet he still was not taken seriously as a painter, not to the extent he had desired so ardently.

At the age of eighty he was interviewed for the *New York Times* by writer Sanche de Gramont, who described a "slight man" with a lined, elfin face and round eyes like lenses. Now he walked with a cane and obviously had to conserve his strength. So people came to him. And it did seem to Lucien Treillard that everybody who counted in the art world rang his doorbell. But if European museums mounted retrospectives, his own country continued to ignore him. An Italian collector and admirer, the dealer Arturo Schwarz, remembered how a major show put together in New York for Man Ray's eighty-fifth birthday was turned down by one of America's most reputed art museums. Man Ray became really interesting to such institutions only after his death.

That occurred the following year, on the 18th of November 1976. Two days later he was laid to rest in the Montparnasse cemetery, a comfortable five-minute stroll from the rue Campagne-Première, where it had all begun. Among friends already lying nearby were Brancusi, Tzara, and Desnos.[3]

With Gratitude

To come to terms with Man Ray's Montparnasse I had the benefit of some decades of living in or near it: the greatest handicap was the near total absence of living witnesses to the between-the-war years. What saved me was the good will of men and women who have made the period and its personae something of a specialty, and the existence of institutions on both sides of the Atlantic whose chief purpose is to preserve the heritage.

In seniority, let me pay tribute to a singular institution, the Man Ray Trust, led by the brothers of Man Ray's late widow, Juliet, with special thanks to the Trust's European administrator, Gregory Browner. The Trust's generosity in allowing me to cite correspondence and other material is duly acknowledged in its place. My gratitude must also be extended to Lucien Treillard, Man Ray's chief helper in his last years, who has shared his experience with me.

I had the extraordinary luck, thanks to an old friend and fellow Montparnasse devotee, André Bay, to meet Jacqueline Goddard, at once the photographer's model and confidante, a direct link to the Montparnasse I was seeking. I got closer to Man Ray in another way thanks to the artist, Régine Sarallier-Perrin, who occupied his now historic studio on rue Campagne-Première while I worked on the present book, who showed great patience as I measured every inch of that place.

And how could such a project get under way without the books of that extraordinary couple Billy Klüver and Julie Martin? If they consent to help you, as they did me, what an asset.

In addition to sources acknowledged in the notes, let me extend my gratitude to Pierre Belfond, who would have been my publisher had he stayed in the business; Roswitha Doerig, who made it easier to see how Man Ray used the rue Férou studio which is now hers; Jean Kisling, Guy Krohg, Peter Lyon, Malitte Matta, Jacqueline Matisse Monnier, and Francis M. Naumann.

Among the French institutions which proved invaluable resources, let me mention the Archives and Library of the Musée National d'Art Moderne (Centre Pompidou), with special thanks to Marina Garcia and Anne-Marie Zucchelli there; the Archives of the Musée Picasso (Anne Baldassari and Sylvie Fresnault); and the Bibliothèque Littéraire Jacques Doucet, lay temple of Surrealism.

In the United States: the Beinecke Rare Book and Manuscript Library at Yale University (Maureen D. Heher); the Harry Ransom Humanities Research Center at the University of Texas, Austin (Linda Ashton); the Getty Research Institute for the History of Art and the Humanities, Los Angeles (Mark Henderson); the Museum of Modern Art, New York (Museum Archives).

Also the Registrar of Vital Statistics, Borough of Ridgefield, N.J.; the Estate of Gertrude Stein (Calman A. Levin); the Philadelphia Museum of Art. And the New York Public Library reference collections and annexes—one of the best French libraries I know.

Notes

CHAPTER 1

1. Louis Aragon, *Le Paysan de Paris* (Paris: Gallimard [1926], éd. Folio, 1997), 93–95; Henri Béhar, *André Breton* (Paris: Calmann-Lévy, 1990), 129–30; Pierre Daix, *La Vie quotidienne des Surréalistes (1917–1932)* (Paris: Hachette, 1993), 115–21; *Dictionnaire Général du Surréalisme* (Paris: Presses Universitaires de France, 1982); Man Ray, *Self Portrait* (New York: Atlantic/ Little Brown, 1963), 108–11; cf. Billy Klüver and Julie Martin, "Man Ray, Paris," in *Perpetual Motif: The Art of Man Ray* (New York: Abbeville, 1988), 89–94; *New York Times*, July 14, July 23, 1921. For Man Ray's height: U.S. passport, May 5, 1955, courtesy of Eric Browner, Man Ray Trust.

2. Béhar, *Breton*, 17–19, 28–30, 47–55; Pierre Daix, *Aragon* (Paris: Flammarion, 1994), 19–20, 67–74; Marcel Duhamel, *Raconte pas ta vie* (Paris: Mercure de France, 1972), 203, 209; Adrienne Monnier, *Rue de l'Odéon* (Paris: Albin Michel, 1960; rep. 1989), 33, 38–39, 92–98; Michel Sanouillet, *Dada à Paris* (Paris: Pauvert, 1965), 458 (letter from Breton to Tzara); *Littérature* (Paris), March 1921, 1–7.

3. John Bainbridge, *Another Way of Living* (New York: Holt, Rinehart & Winston, 1968), 26; Neil Baldwin, *Man Ray, American Artist* (New York: Da Capo, 1991, from 1998 original edition), 79, 86; Man Ray, *Self Portrait*, 109–12; Jean-Hubert Martin, preface, in Man Ray, *Objets de mon affection* (Paris: Philippe Sers, 1983), 6–7; Calvin Tomkins, *Duchamp* (New York: Holt, 1998), 181–86, 209–11; "Then and Now, a Symposium on the Expatriate Tradition" (Paris: American Center for Students and Artists, May 13, 1964), from *Paris Review* (New York–Paris) 33, 1965, 160–61; interview with Peter Lyon (Paris, May 1998).

4. Pierre Bourgeade, *Bonsoir, Man Ray* (Paris: Belfond, 1972, new ed. 1990), 50; Billy Klüver and Julie Martin, "Carrefour Vavin," in *The Circle of Montparnasse: Jewish Artists in Paris (1905–1945)*, Catalogue, The Jewish Museum, New York (New York: Universe Books, 1985), 72–73; Man Ray, *Self Portrait*, 117–18; Tomkins, *Duchamp*, 237–39; letter to Tristan Tzara [September 1921], courtesy Bibliothèque Littéraire Jacques Doucet and Man Ray Trust.

CHAPTER 2

1. Jean Emile-Bayard, *Montparnasse hier et aujourd'hui* (Paris: Jouve, 1927), 11–14, 97–101, 347–48, 402–5; Gustave Fuss-Amoré & Maurice des Ombiaux, *Montparnasse* (Paris: Albin Michel, 1925), 18–19; Jacques Hillairet, *Connaissance du Vieux-Paris* (Paris: Gonthier, 1963), II, 159–60; Klüver-Martin, "Carrefour Vavin," 69–79; André Salmon, *Montparnasse* (Paris: André Bonne, 1950), 15–19.

2. Guillaume Apollinaire, "Montparnasse,"

in *Mercure de France* (Paris), 16 mars 1924, as revised in Apollinaire, *La Femme assise* (1920) (Paris: Gallimard-L'Imaginaire, 1977), 19–27; Josep Palau i Fabre, *Picasso vivo (1881–1907)* (Barcelona: Poligrafa, 1980), 200; Salmon, *Montparnasse*, 105, 198–201.

3. Emile-Bayard, *Montparnasse*, 335, 338–41, 373–79, 382; Fuss-Amoré, *Montparnasse*, 17; Romy Golan, "The 'Ecole Française' vs. the 'Ecole de Paris,'" in *Circle of Montparnasse*, 81–87; cf. ibid., 95–117.

4. Sylvia Beach and Man Ray interviews, in Jean-Marie Drot, *Les Heures chaudes de Montparnasse* (Paris: Hazan, 1995), 60, 62, from the television documentary of the same name; Emile-Bayard, *Montparnasse*, 96–97, 464–72; *Ernest Hemingway, A Moveable Feast* (New York: Bantam Books, 1965), 81; Klüver-Martin, "Carrefour Vavin," 70–73.

CHAPTER 3

1. Baldwin, *Man Ray*, 1–6; Milton W. Brown, *The Story of the Armory Show* (New York: Hirshhorn Foundation, 1963), 85–93, 224–76; Pierre Cabanne, *Marcel Duchamp (Entretiens)* (Paris: Belfond, 1977), 73–74, 82–83; Naumann, "Man Ray, 1908–1921," in *Perpetual Motif*, 52–55; Francis Naumann, *New York Dada (1915–1923)* (New York: Abrams, 1994), 76–78; Man Ray, *Self Portrait*, 3–31; Tomkins, *Duchamp*, 116–19; Francis M. Naumann and Paul Avrich, "Adolf Wolff: 'Poet, Sculptor and Revolutionist'," *The Art Bulletin* (New York), LVVII, No. 3, September 1985, 486–87.

2. Béhar, *Breton*, 58; Bourgeade, *Bonsoir, Man Ray*, 59; Daix, *Aragon*, 87; Isidore Ducasse (Le Comte de Lautréamont), *Les Chants de Maldoror* (Paris: GF Flammarion, 1990), preface, chronology by Jean-Luc Steinmetz, 289, 420; Man Ray, "The Riddle," in Musée National d'Art Moderne, *Man Ray, Photographe* (Paris: Philippe Sers, 1981), 134; Man Ray, *Self Portrait*, 33–44;

"Une enquête," *Minotaure* (Paris) 3–4, Décembre 1933, 104, 112.

3. Bourgeade, *Bonsoir, Man Ray*, 80–84; Cabanne, *Duchamp*, 101–102; Robert Lebel, *Sur Marcel Duchamp* (Paris: Trianon, 1959), 40–41; Naumann, "Man Ray, 1908–1921," 67–70; —, *New York Dada*, 78–79, 81–82; Man Ray, "Impressions of 291," reprinted in Janus, *Man Ray, L'Immagine Fotografica* (Venice: La Biennale, 1977), 211; Man Ray, *Self Portrait*, 47–49, 56, 58–61, 65–73; Tomkins, *Duchamp*, 129, 143–44, 154–68; State of New Jersey, Bureau of Vital Statistics, Certificate and Record of Marriage (Ridgefield, N.J.), May 3, 1914; Interview with Peter Lyon (Paris, May 1998).

4. Baldwin, *Man Ray*, 60–61, 84; Carolyn Burke, *Becoming Modern: The Life of Mina Loy* (New York: Farrar, Straus & Giroux, 1996), 213–14, 223–28; Marcel Jean, "Note sur la Peinture surréaliste," in Maurice Nadeau, *Histoire du Surréalisme* (Paris: Seuil, 1964), 491; Naumann, "Man Ray, 1908–1921," 75–82; Hans Richter, *Dada—Art et anti-art* (Brussels: Editions de la Connaissance, 1965), 94–97; Tomkins, *Duchamp*, 180–85.

5. Cabanne, *Duchamp*, 108, 111; Robert L. Herbert et al., *The Société Anonyme and the Dreier Bequest at Yale University* (New Haven, Conn.: Yale University Press, 1984), 1–4, 548–49; Naumann, *New York Dada*, 87–92; Man Ray, *Self Portrait*, 73–88, 99–100; *Société Anonyme, The First Museum of Modern Art (1920–1944)* (New York: Arno Press, 1972) I, 4–19; *391* (Paris) 13, July 1920.

CHAPTER 4

1. Henri Béhar and Michel Carassou, *Dada* (Paris: Fayard, 1990), 7–9; André Breton, *Entretiens* (Paris: Idées-Gallimard, 1969), 41–42, 62; Georges Hugnet, "Dada," in *Fantastic Art, Dada, Surrealism* (New York: Museum of Modern Art, 1936, Arno Press reprint, 1968), 15–22; Mark Polizzotti,

Revolution of the Mind: The Life of André Breton (New York: Farrar, Straus & Giroux, 1995), 90–91; Richter, *Dada,* 155–57, 183–85; Philippe Soupault, *Mémoires de l'oubli (1923–1926)* (Paris: Lachenal & Ritter, 1986), 35; Tomkins, *Duchamp,* 190–91; Tristan Tzara, *Oeuvres complètes* (Paris: Flammarion, 1975), I, 359–67.

2. Béhar, *Dada,* 57; Sarane Alexandrian, *André Breton par lui-même* (Paris: Seuil, 1970), 20–21; Germaine Everling, *L'Anneau de Saturne* (Paris: Fayard, 1978), 104–5, 124; Hugnet, *Fantastic Art,* 30; Richter, *Dada,* 156; Michel Sanouillet, "Dada à Paris," *Cahiers Dada Surréalisme* (Paris), I, 1966, 16; Philippe Soupault, *Ecrits sur la peinture* (Paris: Lachenal & Ritter, 1980), 252.

3. Cabanne, *Duchamp,* 121–22; Naumann, *New York Dada,* 200–206; Man Ray, *Objets de mon affection,* 20; —, *Self Portrait,* 101; Michel Sanouillet, *391 - Revue* (Paris: Terrain Vague, 1960), 95 (from *391,* XIV, 7); Tomkins, *Duchamp,* 166–67, 230, 236. Sanche de Gramont, "Remember Dada—Man Ray at 80," *New York Times Magazine* (New York), Sept. 6, 1970, 27; *New York Evening Journal,* Jan. 29, 1921, in Naumann, *New York Dada,* 199. Man Ray correspondence, Bibliothèque Littéraire Jacques Doucet (Paris), with the permission of the Man Ray Trust. "Dada soulève tout," manifesto, collection of the author.

CHAPTER 5

1. Baldwin, *Man Ray,* 49–50, 67–68; Drot, *Les Heures chaudes de Montparnasse,* 128 (1961 interview of Man Ray); Billy Klüver and Julie Martin, *Kiki's Paris* (New York: Abrams, 1989), 103–5; Klüver and Martin, "Man Ray, Paris," 94–99; Man Ray, *Self Portrait,* 111–12, 118–19, 122–26; Sanouillet, *Dada à Paris,* 294–95, 458; Tomkins, *Duchamp,* 62.

2. John Bainbridge, *Another Way of Living* (New York: Holt, Rinehart & Winston,

1968), 26–27 (Man Ray interview, 1964); Emmanuelle de l'Ecotais, "L'art et le portrait," in Ecotais et al., *Man Ray, La Photographie à l'Envers* (Paris: Seuil, 1998), 118–19; Klüver-Martin, "Man Ray, Paris," 99–100; Man Ray, *Self Portrait,* 118.

3. Edouard-Joseph, *Dictionnaire biographique des artistes contemporaines,* III (Paris: Grund, 1934): "Mendjizky"; Kiki (Alice Prin), *Souvenirs* (Paris: Henri Broca, 1929), 9–10, 75–137, 142; Klüver-Martin, *Kiki's Paris,* 59, 215, 219, 227; Klüver-Martin, foreword, in *Kiki's Memoirs* (New York: Ecco Press, 1996), 9–19; ibid., 75–138, 147; Man Ray, *Self Portrait,* 118, 140–46; Préfecture de Police (Paris), Section Hôtels, correspondence, July 1, 1998.

4. William A. Camfield, *Francis Picabia* (Princeton: Princeton University Press, 1979), 171; Daix, *Aragon,* 145; Daix, *Dictionnaire Picasso,* 667–69; Jean-Charles Gateau, *Paul Eluard et la peinture surréaliste (1910-1939)* (Genève: Droz, 1982), 39; Timothy Hilton, *Picasso* (London: Thames & Hudson, 1975), 151; Philippe Soupault, *Mémoires de l'oubli (1914–1923)* (Paris: Lachenal & Ritter, 1981), 163–65, 170, 188; Man Ray, *Self Portrait,* 113; Sanouillet, *Dada à Paris,* 298–99; correspondence, Man Ray to Tzara, Dec. 27, 1921, courtesy of Bibliothèque Littéraire Jacques Doucet and Man Ray Trust.

CHAPTER 6

1. Béhar, *Breton,* 106–9; André Breton, "Revues Surréalistes," in André Breton et Paul Eluard, *Dictionnaire abrégé du Surréalisme* (1938) (Paris: Corti, 1995), 23–24; André Breton, *Entretiens* (Paris: Idées-Gallimard, 1969), 70–71; Maurice Nadeau, *Histoire du Surréalisme* (Paris: Seuil, 1964), 36–38; Sanouillet, *Dada à Paris,* 331–37; Soupault, *Mémoires (1914–1923),* 133–36; "Then and Now" (symposium), 161–62.

2. Breton, *Entretiens,* 75–76; Germaine Everling, *L'Anneau de Saturne* (Paris:

Fayard, 1970), 134–35; Sanouillet, *Dada à Paris*, 340–46, 552–58; *Comoedia* (Paris), 16 Avril 1922: Francis Picabia, "Jusqu'à un Certain Point..."; *Les Feuilles Libres* (Paris), Avril-Mai 1922, 154–56.

3. Caresse Crosby, *The Passionate Years* (New York: Ecco Press, 1979), 233; Daix, *Dictionnaire Picasso*, 772–73, 795; Klüver-Martin, "Man Ray, Paris," 107–108; Man Ray, *Self Portrait*, 118–19, 181–82, 223; Gertrude Stein, *The Autobiography of Alice B. Toklas* (London: Penguin, 1987), 10–14, 47; Alice B. Toklas, *What is Remembered* (San Francisco: North Point Press, 1985), 110; Tomkins, *Duchamp*, 239–46; catalogue, Société des Artistes Indépendents (Paris, 1922), 150; correspondence with Ferdinand Howald, courtesy of Man Ray Trust and Ohio State University, Division of Rare Books and Manuscripts; correspondence with Gertrude Stein, courtesy of Man Ray Trust, Beinecke Rare Book and Manuscript Library of Yale University, and the Estate of Gertrude Stein.

4. Baldwin, Man Ray, 100; Sylvia Beach, *Shakespeare & Company* (New York: Harcourt, Brace, 1959), 73, 111–12; Richard Ellmann, *James Joyce* (New York: Oxford University Press, 1982), 503–4, 522–26; Brenda Maddox, *Nora* (London: Hamish Hamilton, 1988), 353; George D. Painter, *Marcel Proust* (New York: Random House, 1987), II, 162–63, 189–90, 201, 363; Man Ray, *Self Portrait*, 176–77, 186.

5. Gramont, "Remember Dada," 30; Hemingway, *A Moveable Feast*, 35, 56; Kenneth S. Lynn, *Hemingway* (New York: Simon & Schuster, 1987), 160; Man Ray, *Self Portrait*, 184–86; Centre Pompidou, Archives Man Ray (Ezra Pound).

CHAPTER 7

1. Drot, *Les Heures chaudes de Montparnasse*, 132–33 (interview with Man Ray); Klüver-Martin, "Man Ray, Paris," 108; Man Ray, *Self Portrait*, 196–99, 208–209, 214–15, 219, 244–53; Kenneth E. Silver, Introduction, *The Circle of Montparnasse*, 10.

2. Man Ray, *Self Portrait*, 160–68, 176–77, 219; Meryle Secrest, *Between Me and Life: A Biography of Romaine Brooks* (New York: Doubleday, 1974), 297.

3. Emmanelle de l'Ecotais, "L'art et le portrait," in *Man Ray: La Photographie à l'Envers*, 113; Klüver-Martin, "Man Ray, Paris," 116–19; Naumann, *New York Dada*, 216–18 (including letter from Marcel Duchamp to Man Ray, 1922); Man Ray, *Les Champs Délicieux* (Paris: Société Générale d'Imprimerie et d'Edition, 1922); Man Ray, *Self Portrait*, 128–31; *Le Coeur à Barbe* (Paris), Avril 1922; *Les Feuilles Libres*, Avril–Mai 1922, 134–35; *Littérature*, March, October 1922; February 1923; June 1924; *Vanity Fair* (New York), November 1922.

4. Man Ray, *Self Portrait*, 127, 151; Henri-Pierre Roché, *Carnets (1920–1921)* (Marseille: André Dimanche, 1990), xxv–xxxiii; Henri-Pierre Roché, "Journal" (May 8, 1922), in Klüver-Martin, *Kiki's Paris*, 227; correspondence of Kiki (Alice Prin), courtesy of Billy Klüver and Julie Martin, and the Bibliothèque Littéraire Jacques Doucet.

5. Michèle Champenois, "Rue Campagne-Première," *Le Monde* (Paris), Feb. 26, 1994; Klüver-Martin, "Man Ray, Paris," 123; Man Ray, *Self Portrait*, 146; correspondence of Man Ray with Ferdinand Howald, courtesy Man Ray Trust and Ohio State University, Division of Rare Books and Manuscripts; visit to rue Campagne-Première studio, courtesy of Régine Sarailler-Perrin.

CHAPTER 8

1. François Chapon, *Jacques Doucet ou l'art du mécénat* (Paris: Perrin, 1996), 282, 331; Daix, *Dictionnaire Picasso*:

"Max Jacob"; Emile-Bayard, *Montparnasse*, 481–83; Max Jacob, letter, in *Man Ray, La Photographie à l'Envers*, 117; Yves Peyré, *La Bibliothèque littéraire Jacques Doucet* (Paris: Doucet, 1995); Correspondence of Man Ray, courtesy of the Man Ray Trust, Bibliothèque Littéraire Jacques Doucet, and Beinecke Rare Book and Manuscript Library, Yale University; Tzara to Man Ray, 21 Août 1922, in *Marcel Duchamp* (Catalogue de Vente), Commissaire-Priseur Paul Renaud, Drouot-Richelieu, 22 Juin 1999, 94.

2. Bainbridge, *Another Way of Living*, 26; Béhar, *Breton*, 135–38; Bourgeade, *Bonsoir, Man Ray*, 52–53; Breton, *Nadja* (1928) (Paris: Gallimard Folio, 1964), 35–36; Cabanne, *Duchamp*, 114; *Dictionnaire général du surréalisme*, articles "Crevel," "Desnos," "Sommeils"; Duhamel, *Raconte pas ta vie*, 209–10; Nadeau, *Histoire du Surréalisme*, 51–56; Soupault, *Mémoires de l'oubli*, 10, 30; Breton to Man Ray, 2 Octobre 1922, in *Marcel Duchamp* (Catalogue de vente), Paris, Drouot-Richelieu, Commissaire-Priseur Paul Renaud, 22 Juin 1999, 91–92.

3. Cabanne, *Duchamp*, 114–16; Drot, *Les Heures chaudes de Montparnasse*, 183–84; Man Ray, *Self Portrait*, 233–34; Tomkins, *Duchamp*, 253, 257; on Hotel Istria: Letter from Préfecture de Police, Paris, Section Hôtels, 1998.

4. Béhar, *Breton*, 148; Daix, *Aragon*, 171; *Dictionnaire général du surréalisme*: "René Crevel," "Pierre de Massot"; Polizzotti, *Revolution of the Mind*, 192; Man Ray, *Self Portrait*, 259–63; Richter, *Dada*, 178–80; program, Théâtre Michel, 6 July 1923, Bibliothèque Littéraire Jacques Doucet; "Retour à la Raison" (Return to Reason); film, courtesy Musée National d'Art Moderne (Centre Georges Pompidou).

CHAPTER 9

1. Jimmie Charters and Morrill Cody, *This Must Be the Place* (1934) (New York:

Collier, 1989), 5; Malcolm Cowley, *Exile's Return* (1934) (New York: Viking, 1951), 164–70; Peggy Guggenheim, *Out of This Century: Confessions of an Art Addict* (1979) (London: André Deutsch, 1983), 27.

2. André Bay, *Adieu Lucy: Le Roman de Pascin* (Paris: Albin Michel, 1989), 14, 185–86; *The Circle of Montparnasse*, 113; Gaston Diehl, *Pascin* (Paris: Flammarion, 1968), 93; Hemingway, *A Moveable Feast*, 101–2; Klüver-Martin, *Kiki's Paris*, 114; Man Ray, *Self Portrait*, 247–48.

3. Berenice Abbott, *The World of Atget* (New York: Horizon Press, 1964), viii–x; Baldwin, *Man Ray*, 115–17; Guggenheim, *Out of This Century*, 41, 49, 67; Klüver-Martin, *Kiki's Memoirs*, 273–76; Klüver-Martin, "Man Ray, Paris," 115; Julien Levy, *Memoir of an Art Gallery* (New York: Putnam, 1977), 91–93; Hank O'Neal, *Berenice Abbott, American Photographer* (Paris: Philippe Sers, 1982), 8–10; Man Ray, Interview/Entretien, in *Man Ray, Photographer*, 38–39; Man Ray, *Self Portrait*, 150–53; Julia Van Haaften, ed., *Berenice Abbott, Photographer* (New York: New York Public Library, 1989), 11–15; correspondence by Man Ray, courtesy of the Man Ray Trust, the Estate of Gertrude Stein, and Beinecke Rare Book and Manuscript Library, Yale University.

4. Charters-Cody, *This Must Be the Place*, 31–32; Emile-Bayard, *Montparnasse*, 476–81; Fuss-Amoré, *Montparnasse*, 221–23; Kiki, *Kiki's Memoirs*, 152–56; Klüver-Martin, *Kiki's Paris*, 126–27, 230–31; Man Ray, *Self Portrait*, 149.

CHAPTER 10

1. Ecotais, Emmanuelle de l', "L'Art et le Portrait," 116; Klüver-Martin, *Kiki's Paris*, 110, 228; Klüver-Martin, "Man Ray, Paris," 115–16; Jacqueline Saunier-Ollier, *William Carlos Williams* (Paris: Belles Lettres, 1979), 138–39; William Carlos Williams, *The Autobiography* (New York: Random House, 1951), 190–91, 195, 199; Gertrude Stein, "Man Ray," manuscript courtesy of the Estate

of Gertrude Stein and Beinecke Rare Book and Manuscript Library, Yale University; in published form in Gertrude Stein, *Painted Lace* (New York: Oxford University Press, 1955). Man Ray correspondence with Gertrude Stein, courtesy of Man Ray Trust, the Estate of Gertrude Stein, and Beinecke Rare Book and Manuscript Library, Yale University.

2. Morrill Cody and Hugh Ford, *The Women of Montparnasse* (New York: Cornwall Books, 1983), 89–92; Daix, *Dictionnaire Picasso*: "Comte de Beaumont," "Mercure"; Hugh Ford, "The Hours Press of Nancy Cunard," in *Paris–New York: Echanges littéraires au vingtième siècle* (Paris: Centre Pompidou, 1977), 20–21; Guggenheim, *Out of This Century*, 48; Klüver-Martin, "Man Ray, Paris," 114–15; Man Ray, *Self Portrait*, 161–70, 175–76.

3. Cabanne, Duchamp, 117; Klüver-Martin, *Kiki's Paris*, 137; Man Ray, *Self Portrait*, 166; Jean Tulard, *Guide des Films* (Paris: Laffont, 1990), I, 742.

4. Charters, *This Must Be the Place*, 9–12, 27, 41, 74–78, 102–103, 183–89; Guggenheim, *Out of This Century*, 51; Hugh Ford, *Published in Paris* (New York: Collier/Macmillan, 1988), 59–60; Man Ray, *Self Portrait*, 190; Soupault, *Mémoires de l'oubli (1923–1926)*, 138.

5. *Dictionnaire général du surréalisme*, 120 (De Chirico), 396 (Tanguy); Duhamel, *Raconte pas ta vie*, 129–34, 156–57; Patrick Waldberg, *Yves Tanguy* (Brussels: André de Rache, 1977), 78.

CHAPTER 11

1. Béhar, *Breton*, 162–66, 174; André Breton, *Manifestes du surréalisme* (Paris: Gallimard Folio, 1998), 33–38; André Breton, *Poisson soluble* (Paris: Editions du Sagittaire—Simon Kra, 1924); Gérard Durozoi, *Histoire du Mouvement surréaliste* (Paris: Hazan,
1997), 68–90; Nadeau, *Histoire du Surréalisme*, 62, 240; Soupault, *Mémoires de l'oubli (1923–1926)*, 94.

2. Breton, *Entretiens*, 100–104; Camfield, *Picabia*, 206–209; Durozoi, *Histoire du mouvement surréaliste*, 80–81; Annabelle Melzer, *Latest Rage the Big Drum: Dada and Surrealist Performance* (Ann Arbor, Michigan: UMI Research Press, 1980), 189; Nadeau, *Histoire du surréalisme*, 197–200; Michel Sanouillet, *391* (Paris: Terrain Vague, 1960), 8–16; Soupault, *Mémoires de l'oubli (1923–1926)*, 96–97.

3. Maxime Alexandre, *Mémoires d'un surréaliste* (Paris: Jeune Parque, 1968), 108, 155–57; Béhar, *Breton*, 170; Breton, *Entretiens*, 109; Nadeau, *Histoire du surréalisme*, 507–11; Naumann, *New York Dada*, 219; *La Révolution Surréaliste* (Paris), 1, 1er Décembre 1924; *Le Populaire* (Paris) 17–25 Décembre 1923 (trial of Germaine Berton).

CHAPTER 12

1. Joseph Blotner, *Faulkner, a Biography* (New York: Random House, 1974), I, 443–52; Michel Cabaud et al., *Les Années folles* (Paris: Belfond, 1986), 210–11; Cody-Ford, *The Women of Montparnasse*, 33–36, 60; Ilya Ehrenburg, *Memoirs (1921–1941)* (Cleveland, Ohio: World Publishing Co., 1964), 91; Janet Flanner, *Paris Was Yesterday* (New York: Viking, 1972), xx–xxi; Fuss-Amoré, *Montparnasse*, 7–11, 185–89; Hemingway, *A Moveable Feast*, 107, 181; Klüver-Martin, "Carrefour Vavin," 71; Klüver-Martin, *Kiki's Paris*, 137; Lynn, *Hemingway*, 277.

2. Man Ray, *Celebrity Portrait Photographs* (New York: Dover Publications, 1995, from the German edition: Gütersloh, Sigbert Mohn, 1963) (Note that Man Ray's comments are translated into English from the French edition); Man Ray, *Self Portrait*, 189. The only person, man or woman, to receive a rating of "20"was Juliet

Browner. Although they didn't meet until 1940, they were married at the time Man Ray compiled this volume.

3. Cabanne, *Duchamp*, 119, 194; Guggenheim, *Out of This Century*, 50–51; Lebel, *Marcel Duchamp*, 236; Robert Lebel, *Sur Marcel Duchamp* (Paris: Trianon, 1959), 51; Robert McAlmon & Kay Boyle, *Being Geniuses Together* (San Francisco: North Point Press, 1984), 93; Man Ray, *Self Portrait*, 236; Tomkins, *Duchamp*, 254, 269–70, 276–77, 284, 375.

CHAPTER 13

1. Breton, *Entretiens*, 115–17; Drot, *Les Heures chaudes de Montparnasse*, 180 (interview with Aragon); Durozoi, *Histoire du mouvement Surréaliste*, 96–98; Gérard Legrand, "Suicide," in *Dictionnaire Général du Surréalisme*, 387; Man Ray, *Self Portrait*, 264, 284–85; Tomkins, *Duchamp*, 290–91; *La Révolution Surréaliste* 1, December 1, 1924; 2, January 15, 1925; 3, April 1925 ("Adresse au Pape").

2. André Breton, "Genèse et Perspective Artistique du Surréalisme" (1941), in André Breton, *Le Surréalisme et la Peinture* (New York: Brentano's, 1945), 90; André Breton, *Le Surréalisme et la Peinture*, illustrated edition (Paris: Gallimard, 1965), 32–33; Daix, *Picasso*, 200; Durozoi, *Histoire du mouvement Surréaliste*, 99–100; Klüver-Martin, *Kiki's Paris*, 156; Soupault, *Mémoires de l'oubli* (1923–1926), 109–11.

3. Duhamel, *Raconte pas ta vie*, 220–21; Durozoi, *Histoire du mouvement Surréaliste*, 127; Man Ray, *Self Portrait*, 264; catalogue, Galerie Surréaliste, Mars 1926: *Tableaux de Man Ray et Objets des îles* (Bibliothèque Littéraire Jacques Doucet); *La Révolution Surréaliste*, 8, 1 Décembre 1926.

4. *Dictionnaire abrégé du Surréalisme*, 6 ("cadavre exquis"); *Dictionnaire général du surréalisme*, 74–75 ("cadavre exquis"); Drot, *Les Heures chaudes de Montparnasse*, 185, 190 (interviews of Armand Salacrou, Joan Miró, Marcel Duhamel); Duhamel, *Raconte pas ta vie*, 156–63, 191, 201–202; Klüver-Martin, *Kiki's Paris*, 152; André Thirion, *Révolutionnaires sans révolution* (Paris: Laffont, 1972), 100–101.

CHAPTER 14

1. Klüver-Martin, *Kiki's Paris*, 142–43; Man Ray, *Self Portrait*, 153–54, 267–74; correspondence with Gertrude Stein, courtesy of Man Ray Trust and the Beinecke Rare Book and Manuscript Library, Yale University.

2. Baldwin, *Man Ray*, 134–36; Emile-Bayard, *Montparnasse hier et aujourd'hui*, 471, 483–84; Fuss-Amoré, *Montparnasse*, 50; Klüver-Martin, "Carrefour Vavin," 71; Françoise Planiol, *La Coupole* (Paris: Denoël, 1986), 47–60; Thirion, *Révolutionnaires sans révolution*, 149; "La Coupole fête ses 70 ans," brochure (Paris, 1997).

3. Burke, *Becoming Modern*, 346; Durozoi, *Histoire du mouvement Surréaliste*, 395; Levy, *Memoir of an Art Gallery*, 31–33, 90–93, 97; Tomkins, *Duchamp*, 274–76.

4. Alexandre, *Mémoires d'un Surréaliste*, 70; Breton, *Entretiens*, 142; Ford, *Published in Paris*, 404–17; Kenneth S. Lynn, *Charles Chaplin and His Times* (New York: Simon & Schuster, 1997), 308–11; Douglas McMillan, *Transition 1927–1938* (London: Calder & Boyars, 1975), 1–3, 12–13, 17, 20–25; Joyce Milton, *Tramp: The Life of Charlie Chaplin* (New York, HarperCollins, 1996), 270–80; Man Ray, *Objects de mon affection* (Paris: Philippe Sers, 1983), 51 ("Snowball"/ "Boule de neige"); Geoffrey Wolff, *Black Sun* (New York: Vintage, 1977), 243; *transition* (Paris), April, June, September 1927; *La Révolution Surréaliste* 9–10, 1 Octobre 1927.

CHAPTER 15

1. Arno Breker, *Paris, Hitler et moi* (Paris: Presses de la Cité, 1970), 210, 215; Henri Broca, *T'en fais pas! Viens à Montparnasse* (Paris: SCIE, 1928), 9; Alejo Carpentier, "Man Ray," in *Social* (Havana), July 1928, reprinted in Carpentier, *Chroniques* (Paris: Idées-Gallimard, 1983, 59–62); Dominique Egret, *Arno Breker* (Tübingen: Grabert, 1996), 36–37, 56; John Glassco, *Memoirs of Montparnasse* (1970), annotated by Michael Gnarowski (new edition: Toronto, New York, and Oxford: Oxford University Press, 1995), 28–31; Klüver-Martin, *Kiki's Paris*, 239; McAlmon & Boyle, *Being Geniuses Together*, 289–90.

2. Barbara Klaw, *Beauvoir's Paris* (Paris: Syllepse, 1999), 12–26, 86–101; Klüver-Martin, *Kiki's Paris*, 184, 241; Man Ray, *Self Portrait*, 274–78; screening, "L'Etoile de Mer," courtesy of Musée National d'Art Moderne (Paris).

3. Alexandre, *Mémoires d'un surréaliste*, 76; *Archives du surréalisme, IV: Recherches sur la sexualité* (Paris: Gallimard, 1990); Breton, *Entretiens*, 146; Drot, *Les Heures chaudes de Montparnasse*, 181; Duhamel, *Raconte pas ta vie*, 271; Ford, *Published in Paris*, 253–64; Klüver-Martin, *Kiki's Paris*, 183; Pierre Naville, *Le Temps du surréel* (Paris: Galilée, 1977), 145–51; Man Ray, *Self Portrait*, 264–65; Thirion, *Révolutionnaires sans révolution*, 140–42, 160–61; Ernest B. Speck, "Henry Crowder: Nancy Cunard's 'Tree,'" *Lost Generation Journal* (Salem, Mo.), Summer 1979, 6–8.

CHAPTER 16

1. Klüver-Martin, *Kiki's Paris*, 172–73, 238–39; James Lord, *Cinq femmes exceptionnelles* (Paris: Plon, 1966), 95–105 [*Six Exceptional Women*, New York: Farrar, Straus & Giroux, 1994]; Man Ray, *Self Portrait*, 278–84; Tulard, *Guide des Films*, II, 969–70; interviews with Jacqueline Goddard (née Barsotti),

correspondence; unpublished memoirs by Jacqueline Goddard, courtesy of Jacqueline Goddard.

2. *Calder* (Paris: Chêne, 1971), 201 ("Kiki de Montparnasse"); Sisley Huddleston, *Back to Montparnasse* (Philadelphia, Pa.: Lippincott, 1931), 136; Kiki, *Souvenirs* 168–70; *Kiki's Memoirs*, 24–34; Klüver-Martin, preface, *Kiki's Memoirs*, 28; Jean Lipman, *Calder's Universe* (London: Thames & Hudson, 1977), 248 ("Kiki's Nose"); Lou Mollgaard, *Kiki, Reine de Montparnasse* (Paris: Laffont, 1988), 214–233; Man Ray, *Self Portrait*, 154–56, 291–92; *Paris Montparnasse* (Paris), 3, 15 Avril 1929; Mary Blume, "Kiki of Montparnasse Back to Life," *International Herald Tribune* (Paris), June 12–13, 1999; interview with Jacqueline Goddard.

3. Morley Callaghan, *That Summer in Paris* (Toronto: Macmillan Paperbacks, 1973), 129–30; Ford, *Published in Paris*, 117–21, 144–49; Ernest Hemingway, Introduction, *This Must Be the Place*, 1–3; *Kiki's Memoirs*, 33–34, 47–61; Samuel Putnam, *Paris Was Our Mistress* (1947) (London: Plantin, 1987), 34–48, 80; Man Ray, *Self Portrait*, 156.

CHAPTER 17

1. Callaghan, *That Summer in Paris*, 196; Jane Livingston, *Lee Miller, Photographer* (London: Thames & Hudson, 1989), 27–38; Anthony Penrose, *The Lives of Lee Miller* (New York: Holt, Rinehart & Winston, 1985), 12, 22–30; Anthony Penrose, "Lee Miller Chronology," in Livingston, *Lee Miller, Photographer*, 167; Man Ray, *Self Portrait*, 168–70, 219–20; Mario Amaya, "An Interview with Lee Miller Penrose," *Art in America* (New York), May–June 1975, 54–61; copy of letter from Man Ray, October 12, 1934, on solarization, courtesy of Lucien Treillard, with permission from the Man Ray Trust.

2. Callaghan, *That Summer in Paris*, 86–87, 116, 166–68, 229; Charters, *This*

Must Be the Place, 197; Hemingway, introduction, *Kiki's Memoirs*, 47–50; Sisley Huddleston, *Bohemian Literary and Social Life in Paris* (London: Harrap, 1928), 153; Livingston, *Lee Miller*, 37–38; Penrose, *Lives of Lee Miller*, 32; Julian Street, *Where Paris Dines* (New York: Doubleday, Doran, 1929), 220–23. Albert Flamant, "André Derain," *Revue de Paris*, quoted in *The Circle of Montparnasse*, 87; unpublished memoirs by Jacqueline Goddard (née Barsotti), courtesy of Jacqueline Goddard. Amaya, "An Interview with Lee Miller Penrose," 54–61.

3. Brassai, *Conversations avec Picasso* (Paris: Gallimard Idées, 1964), 22; Breton, *Entretiens*, 150; André Breton, *Second Manifeste du Surréalisme* (Paris: Kra, 1930), 60–62; interview with Jacqueline Goddard; André Breton, "Second Manifeste du Surréalisme," in *La Révolution Surréaliste* 15 Décembre 1929, 1–17.

CHAPTER 18

1. Breton, *Entretiens*, 122–23; Breton, *Manifestes du surréalisme*; Robert Desnos, "Troisième Manifeste du Surréalisme," in Nadeau, *Histoire du Surréalisme*; 306–10; Duhamel, *Raconte pas ta vie*, 174–75; Man Ray (interview) in Drot, *Les Heures chaudes de Montparnasse*, 132; "Second Manifeste," in *La Révolution Surréaliste*, 15 Décembre 1929; *Le Surréalisme au Service de la Révolution* (Paris), 1, Juillet 1930; 2, Octobre 1930. G. Ribemont-Dessaignes et al., "Un Cadavre" (Paris, 1930), courtesy of Lucien Treillard; interview with Man Ray in Gramont, "Remember Dada."

2. Bainbridge, *Another Way of Living*, 27 (interview with Man Ray); Lynn, *Hemingway,* 170; Man Ray, *Self Portrait*, 182–83, 220–21. Amaya, "Interview with Lee Miller Penrose," 54–61; *Then and Now*, 161; correspondence Gertrude Stein–Man Ray, courtesy of Man Ray Trust and Archives

Man Ray, MNAM (Paris), Estate of Gertrude Stein and Beinecke Rare Book and Manuscript Library, Yale University; Alexander Calder, conversation with Lucien Treillard, courtesy Lucien Treillard.

3. Amaya, "An Interview with Lee Miller Penrose," 54–61.

4. Alexandre, *Mémoires d'un surréaliste*, 173; Béhar, *André Breton*, 224; Breton, *Second Manifeste*, 60–62; Daix, *Aragon*, 304–308; Putnam, *Paris Was Our Mistress,* 170, 181–82; Durozoi, *Histoire du mouvement surréaliste*, 233–35; Nadeau, *Histoire du Surréalisme*, 333–45; Thirion, *Révolutionnaires sans révolution*, 243–45; Louis Aragon, "Le Surréalisme et le Devenir Révolutionnaire," *Le Surréalisme au Service de la Révolution*, Décembre 1931, 3; Breton, "Second Manifeste," in *La Révolution Surréaliste*, Décembre 1929; [Henri Broca], "Echos," *Paris Montparnasse*, February 1930, 24–25.

CHAPTER 19

1. Luis Buñuel, *Mon dernier soupir* (Paris: Laffont, 1982), 125–28; Herbert, *Société Anonyme*, 547.

2. Alexandre, *Mémoires d'un surréaliste*, 65, 181–82; Behar, *André Breton*, 239–40; Brassai, *Conversations avec Picasso*, 1969), 46–47; Buñuel, *Mon dernier soupir*, 138–43, Daix, *Dictionnaire Picasso*: Nusch Eluard, 293; Nadeau, *Histoire du Surréalisme*, 322–23; Meryle Secrest, *Salvador Dalí* (London: Weidenfeld & Nicolson, 1986), 86–87, 91–100, 109–11, 119; Thirion, *Révolutionnaires sans révolution*, 284; Tulard, *Guide des Films*, I, 33; "L'Affaire de l'Age d'Or," pamphlet/brochure, courtesy Bibliothèque Littéraire Jacques Doucet.

3. Youki Desnos, *Les Confidences de Youki* (Paris: Fayard, 1957), 7–36, 83–91, 119, 155–58; Ford, *Published in Paris*, 188, 198–99; Nino Frank, *Mémoire brisée*, II, *Le Bruit parmi le vent* (Paris: Calmann-

Lévy, 1968), 13–33; McAlmon-Boyle, *Being Geniuses Together*, 330–31; Putnam, *Paris Was Our Mistress*, 93–95, 104–113; Man Ray, *Self Portrait*, 346.

4. Levy, *Memoir of an Art Gallery*, 121–22; Livingston, *Lee Miller, Photographer*, 37–38; Man Ray, *Objets de mon affection*, 142–43; *Man Ray, Photographe* (Pompidou-Sers), 40; Penrose, *The Lives of Lee Miller*, 28–42; Man Ray, *Self Portrait*, 255; Man Ray, "Object of Destruction," *This Quarter* (Paris), Sept. 1932, 55; Amaya, "An Interview with Lee Miller Penrose, 56–57; unpublished memoirs of Jacqueline Goddard (née Barsotti), courtesy of the author; interview with Jacqueline Goddard, 1998.

CHAPTER 20

1. Brassai, *Conversations avec Picasso*, 17–25; Breton, *Entretiens*, 181; *Dictionnaire Général du Surréalisme*: "Minotaure," 282–83; Marcel Jean, *Autobiographie du Surréalisme* (Paris: Seuil, 1978), 351–53, 374–75; Man Ray, *Self Portrait*, 254–58. *Minotaure* (Paris) 3–4, [Décembre] 1933; *Le Surréalisme au Service de la Revolution* 5, 15 mai 1933.

2. Paul Eluard, *Lettres à Gala* (1923–1948) (Paris: Gallimard, 1984), 216–25; Gateau, *Paul Eluard et la peinture surréaliste*, 229; [Man Ray,] *Photographs by Man Ray 1920 Paris 1934* (Hartford, Conn.: James Thrall Soby, 1934), 32 (Natasha); *Minotaure* 3–4, Dec. 1933, 69–76; correspondence with Lucien Treillard (on "Natasha").

3. Béhar, *André Breton*, 278; Charters-Cody, *This Must Be the Place*, 100–101; Emmanuelle de l'Ecotais, "La photographie 'authentique,'" in *Man Ray, La Photographie à l'envers*, 68; Klüver-Martin, *Kiki's Paris*, 173; Polizzotti, *Revolution of the Mind*, 407; [Man Ray,] *Photographs* (1934); Man Ray, *Self Portrait*, 225–26; Tomkins, *Duchamp*, 292–96; Bice Curriger,

"Defiance in the Face of Freedom," in *Meret Oppenheim* (Catalogue) (Zurich: Parkett, 1989), 9–29; unpublished memoir by Jacqueline Goddard (née Barsotti), courtesy of Jacqueline Goddard; correspondence with Lucien Treillard (on Meret Oppenheim).

CHAPTER 21

1. Janet Hobhouse, *Everybody Who Was Anybody* (1975) (New York: Doubleday Anchor, 1989), 138–45; James R. Mellow, *Charmed Circle: Gertrude Stein and Company* (New York: Praeger, 1974), 401–2; McMillan, *Transition*, 174–78; Gertrude Stein, *Everybody's Autobiography* (1937) (London, Virago: 1985), 21–22; "Testimony Against Gertrude Stein" (The Hague: Servire Press, February 1935), supplement to *transition* 23, courtesy of Beinecke Rare Book and Manuscript Library, Yale University.

2. Man Ray, "Sur le réalisme photographique," *Cahiers d'Art* (Paris) 5–6, 1935, 120; "Portraits," advertisement, in *Minotaure* 7, [Juin] 1935; *Programme*, "Cycle Systematique de Conférences sur les plus récentes positions du Surréalisme," Juin 1935. Bibliothèque Littéraire Jacques Doucet 8343.26.

3. Béhar, *André Breton*, 171, 173, 185, 192, 201, 290–92; Breton, *Entretiens*, 177–78; Crosby, *Passionate Years*, 315–16; Ilya Ehrenbourg, *Duhamel, Gide, Malraux, Mauriac, Morand, Romains, Unamuno—Vus par un écrivain de l'U.R.S.S.* (Paris: Gallimard, 1934), 56–59; Ilya Ehrenburg, *Memoirs (1921–1941)* (Cleveland, Ohio: World Publishing, 1964), 307; Gateau, *Paul Eluard*, 229–30; Herbert R. Lottman, *The Left Bank: Writers, Artists and Politics from the Popular Front to the Cold War* (Chicago: University of Chicago Press, 1998), 1–4, 83–98; Nadeau, *Histoire du Surréalisme*, 415–32; Man Ray, *Self Portrait*, 285–87; Myrna Bell Rochester, *René Crevel* (Saratoga, Cal.: Anma Libri, 1978), Stanford

254

French and Italian Studies XII, 122–23;
Joshua Rubenstein, *Tangled Loyalties:
The Life and Times of Ilya Ehrenburg*
(New York: Basic Books, 1996), 134–46;
"Du temps où les surréalistes avaient
raison" (pamphlet) (Paris: Editions
Surréalistes, 1935).

CHAPTER 22

1. Baldwin, *Man Ray*, 193–94 (letter to
Elsie Ray); Daix, *Dictionnaire Picasso*,
295, 535–36, 555; Pierre Daix, *La Vie de
peintre de Pablo Picasso* (Paris: Seuil,
1977), 269–70; Paul Eluard, *Les Yeux fer-
tiles* (Paris: GLM, 1936): "René
Magritte"; Jean-Charles Gateau, *Eluard,
Picasso et la Peinture*
(Genève: Droz, 1983), 13–14; Man Ray,
Self-Portrait, 227, 293; catalogue,
Surrealist Exhibition (René Magritte),
New York, January 1936. Bibliothèque
Littéraire Jacques Doucet, Paris.

2. Nadeau, *Histoire du Surréalisme*,
453–58; Man Ray, *Self Portrait*, 256–57,
Secrest, *Salvador Dalí*, 167–68.
Correspondence of Man Ray with
James Thrall Soby, Aug. 7, 1936, with
the permission of the Man Ray Trust;
courtesy, The Museum of Modern Art
Archives, New York: James Thrall Soby
papers, I.B. 25 m.

3. Guggenheim, *Out of This Century*, 191;
Antony Penrose, "Lee Miller
Chronology," 167; Man Ray, *Self
Portrait*, 292–93; Amaya, "An Interview
with Lee Miller Penrose," 61.

CHAPTER 23

1. Breton, *Entretiens*, 182; Daix,
Dictionnaire Picasso, 291; *Dictionnaire
abrégé du Surréalisme* (1938);
Durozoi, *Histoire du Mouvement
Surréaliste*, 341–44; Nadeau, *Histoire
du Surréalisme*, 173; Man Ray,
Self Portrait, 240, 287–88; Tomkins,
Duchamp, 312–13.

2. Bourgeade, *Bonsoir*, Man Ray, 56; Man
Ray, *Self Portrait*, 227–28, 294; letters

to Elsie Ray Siegler, with permission
of the Man Ray Trust, courtesy of The
Getty Research Institute, Research
Library, 930027.

3. Brassai, *Conversations avec Picasso*,
58–59; Daix, *Dictionnaire Picasso*:
Eluard, 296; Daix, *La Vie de Picasso*, 139;
Janet Flanner, *Paris Was Yesterday
(1925–1939)* (London: Angus &
Robertson, 1973), 220–21; Gateau,
Eluard, Picasso et la Peinture, 62;
Polizzotti, *Revolution of the Mind*, 464;
Robert D. Valette, *Album Eluard* (Paris:
Veynier/Tchou, 1983), 164.

4. Brassai, *Conversations avec Picasso*,
58–60; Breton, *Entretiens*, 193–94;
Daix, *Aragon*, 365, 375, 387–396;
Curiger, *Meret Oppenheim*, 42; Daix,
Dictionnaire Picasso, 800, 901–909;
Youki Desnos, *Les Confidences*, 194–96;
Esten, *Man Ray: Bazaar Years*, 106–107;
Nadeau, *Histoire du Surréalisme*, 175,
466–77 ("Ni de Votre Guerre, Ni de
Votre Paix!"); Anaïs Nin, *Journal
(1934–1939)* (Paris: Stock, 1970), 360;
The Diary of Anais Nin (1934–1939,
New York, Harcourt Brace); Man Ray,
Self Portrait, 295–98; letter of Man Ray
to Elsie Ray Siegler, Sept. 6, 1939,
courtesy Man Ray Trust and The Getty
Research Institue for the History of
Art and the Humanities; letter of
Man Ray to Picasso, Sept. 6, 1939,
Man Ray Trust and Archives, Musée
Picasso, Paris.

CHAPTER 24

1. Ehrenburg, *La Nuit tombe*, quoted in
Herbert R. Lottman, *The Fall of Paris*
(New York: HarperCollins, 1992), 281;
Guggenheim, *Out of This Century*, 196,
209–20; Man Ray, *Self Portrait*, 297–98;
Mary Blume, "Saga of a Statue:
The Struggle of Rodin's Balzac,"
International Herald Tribune (Paris),
Aug. 15–16, 1998.

2. Breker, *Paris, Hitler et moi*, 106–107;
Lottman, *The Fall of Paris*, 392–97;
Man Ray, *Self Portrait*, 300–14;

Tomkins, *Duchamp*, 318–19; letter of Man Ray to Picasso, June 18, 1940, courtesy of Man Ray Trust and Archives, Musée Picasso, Paris.

3. Bainbridge, *Another Way of Living*, 27; Brassai, *Conversations avec Picasso*, 58–76; Daix, *La Vie de Picasso*, 294–95; Man Ray, *Self Portrait*, 314–24; Virgil Thomson, *Virgil Thomson* (New York: Knopf, 1966), 319–20.

4. Daniel Bénédite, *La Filière marseillaise* (Paris: Clancier Guénaud, 1984), 115–27; Varian Fry, *Surrender on Demand* (1945) (Boulder, Colo.: Johnson Books, 1997); Guggenheim, *Out of this Century*, 227–50; Conseil Général des Bouches du Rhône, Varian Fry, catalogue (Arles: Actes Sud, 1999).

CHAPTER 25

1. Bainbridge, *Another Way of Living*, 27–28; Baldwin, *Man Ray*, 241–44; Breton, *Entretiens*, 195–96, 246; Duchamp, *Entretiens*, 144–45, 149; Guggenheim, *Out of this Century*, 274–76; Lebel, *Marcel Duchamp*, 241; Levy, *Memoirs of an Art Gallery*, 255–56; Man Ray, "Bilingual Biography/ I and Marcel," in *Ce que je suis et autres textes* (Paris: Hoëbeke, 1998), 90–93; Man Ray, *Self Portrait*, 327–62; Tomkins, *Duchamp*, 332, 339–40; carbon copy of letter of Man Ray to unknown correspondent, April 20, 1942, from Lucien Treillard, with permission of the Man Ray Trust.

2. Baldwin, *Man Ray*, 256; Maria Lluisa Borràs, *Picabia* (Paris: Albin Michel, 1985), 424–25; Camfield, *Picabia*, 255–62; Daix, *Dictionnaire Picasso*, 296–97; Youki Desnos, *Confidences*, 205–8, 229–31; Egret, *Arno Breker*, 41–45; Jean Lescure, *Poésie et Liberté* (Paris: IMEC, 1998), 310, 320–21, 338–39; Man Ray, *Self Portrait*, 241, 355–56, 363–67; Pierre Seghers, *La Résistance et ses poètes* (Paris: Seghers, 1974), 181–82, 329, 462–63; Michael Kimmelman, "Picasso's Politics," *New York Times*,

reprinted in *International Herald Tribune*, February 6–7, 1999; catalogue, *Paul Eluard Centenaire* (St. Denis: Musée d'Art et d'Histoire, 1955), 11–12; letter of Man Ray to Picasso, 1944, with permission of Man Ray Trust, courtesy of Archives, Musée Picasso, Paris.

3. Bainbridge, *Another Way of Living*, 28; Béhar, *André Breton*, 236–37 (photograph); *Kiki's Memoirs*, 36; Lebel, *Marcel Duchamp*, 248–52; Man Ray, in *Hommage à Marcel Duchamp* (Alès: Pierre-André Benoit, 1969); Man Ray, *Self Portrait*, 157–58, 206, 213, 229–31, 375–87; Arturo Schwarz, *Man Ray, The Rigour of Imagination* (New York: Rizzoli, 1977), 324; Andreas Freund, "Paris Museum Honors Man Ray with Art Display," *New York Times*, Jan. 7, 1972; Gramont, "Remember Dada," 25; Daniel Masclet, "Man Ray L'Enchanteur," *Photo-France* (Paris), Nov. 1951, 25–48; visit to rue Férou studio, courtesy of Roswitha Doerig; talks with Gregory Browner, Jacqueline Goddard, Peter Lyon, Malitte Matta, and Lucien Treillard, 1998.

Index

Page numbers in *italics* refer to illustrations.

Photograph Credits

Jacket front

1. Louis Aragon and André Breton 2. Tristan Tzara 3. *Violon d'Ingres* 4 and 42. René Crevel 5. *Object of Destruction*
6. Joan Miró 7 and 31. Kiki 8 and 50. Salvador Dalí 9. Philipe Soupault 10 and 44. Paul Eluard 11 and 45. La Coupole
12. Alberto Giacometti 13 and 30. Self-portrait with camera 14. Yves Tanguy 15. Peggy Guggenheim 16. Victor Brauner
17. Tristan Tzara kissing Nancy Cunard 18. Guy Rosey 19. Lee Miller 20 and 40. Pablo Picasso 21 and 47. Self-portrait